P9-CKA-475

P9-CKA-475

RHS
CHELSEA
FLOWER SHOW
A CENTENARY CELEBRATION

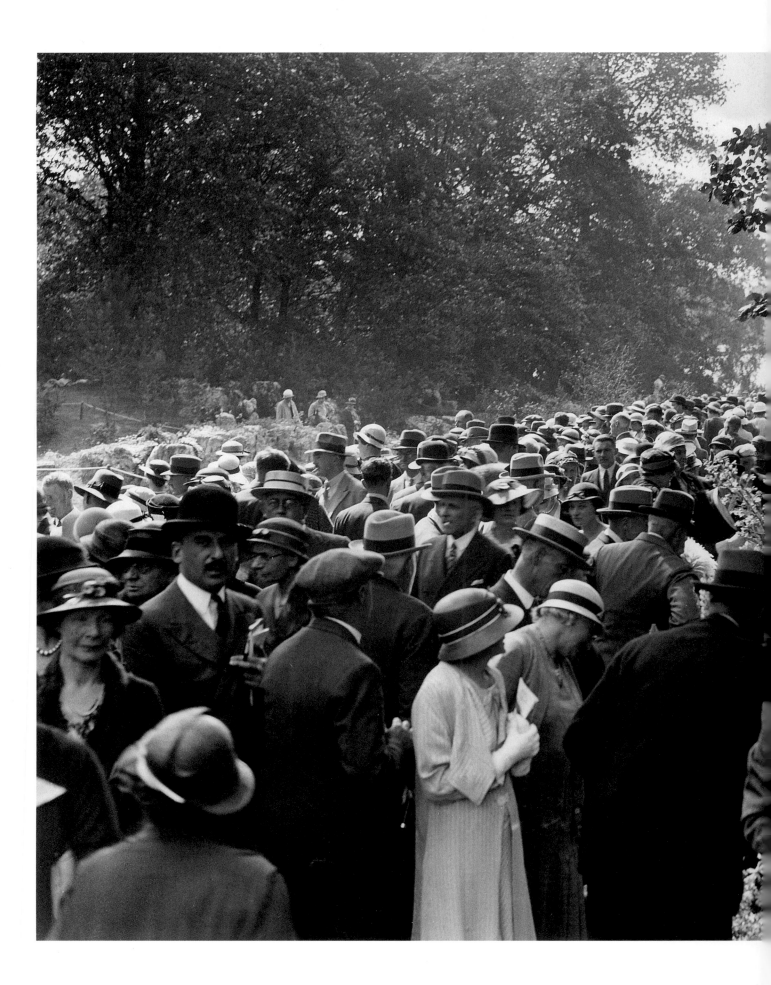

Royal
Horticultural
Society

RHS
CHELSEA
FLOWER SHOW
A CENTENARY CELEBRATION

BRENT ELLIOTT

F

FRANCES LINCOLN LIMITED
PUBLISHERS

Frances Lincoln Ltd
www.franceslincoln.com

RHS Chelsea Flower Show:
A Centenary Celebration
Copyright © Frances Lincoln 2013
Text copyright © Brent Elliott 2013
Photographs copyright © see page 194

First Frances Lincoln edition: 2013
Brent Elliott has asserted his right to be
identified as the author of this work in
accordance with the Copyright, Designs and
Patents Act 1988 (UK).

All rights reserved. No part of this
publication may be reproduced, stored in a
retrieval system or transmitted in any form,
or by any means, electronic, mechanical,
photocopying, recording or otherwise,
without either permission in writing from
the publisher or a licence permitting
restricted copying. In the United Kingdom
such licences are issued by the
Copyright Licensing Agency, Saffron House,
6–10 Kirby Street, London ECIN 8TS.

A catalogue record for this book is available
from the British Library.

ISBN 978-0-7112-3451-2

Printed in China

9 8 7 6 5 4 3 2 1

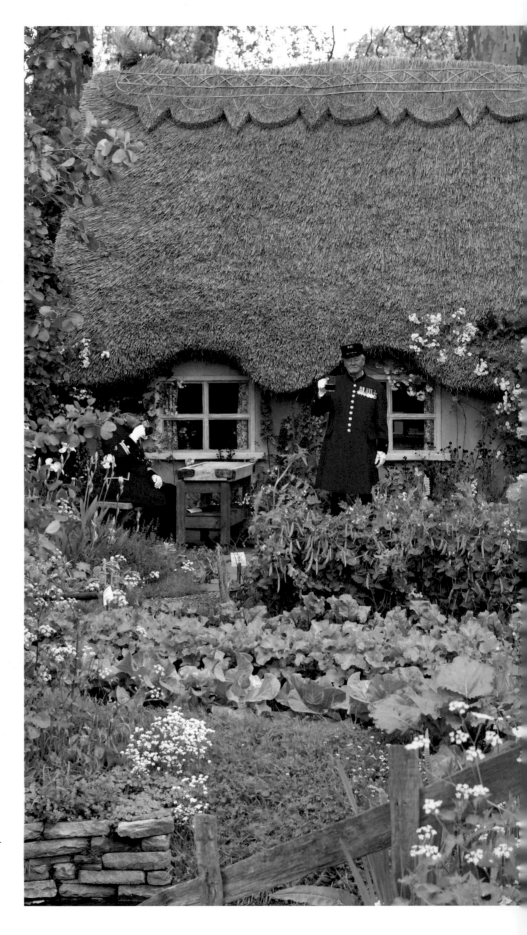

PREVIOUS PAGES Crowds at the Chelsea Show,
1934.
RIGHT The Ecover Chelsea Pensioners' 2005
garden, designed by Julian Dowle.

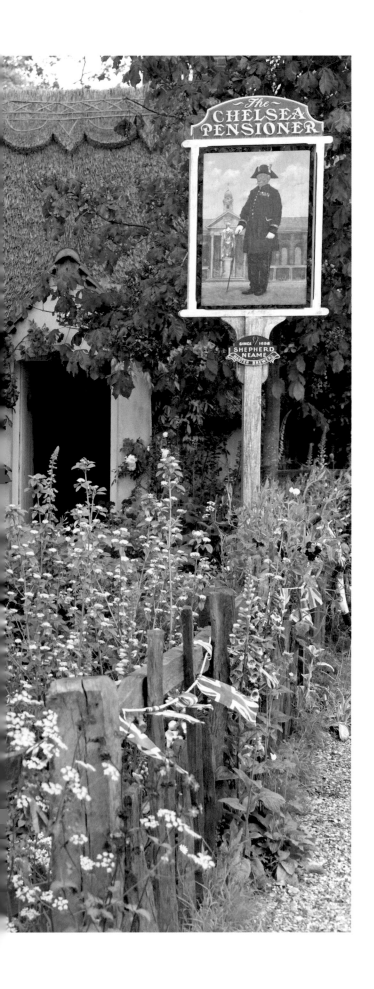

CONTENTS

INTRODUCTION

Every May, the horticultural world descends on a 12-hectare site in Chelsea. In the week before the Spring Bank Holiday, nurserymen, garden designers and contractors, television gardeners, celebrities, dignitaries and the royal family all pass through the grounds of the Royal Hospital Chelsea, where dozens of model gardens and hundreds of exhibits of plants have been prepared for their attention. For a week, gardening makes it on to the front pages of the major British newspapers, and the television schedule is filled with daily commentary.

The event is, of course, the RHS Chelsea Flower Show. Chelsea is not the world's largest flower show – the RHS Hampton Court Palace Flower Show, which the RHS has been running for the past twenty years, is considerably larger – but it is without doubt the most prestigious. Honoured and emulated around the world, it has been the peak event of the British gardening world for generations, even before the television cameras encroached and it developed an additional audience among those who did not themselves venture through its turnstiles.

'Chelsea' is now one of those names which, like Goodwood, denote both a place and a time. The time is now the third week of May. Although in its early years the date of the show varied somewhat, it soon settled down to the week before the Whitsun Bank Holiday (since 1971, the less fluctuating Spring Bank Holiday). The place is the grounds of the Royal Hospital Chelsea, home of the Chelsea Pensioners; but it is not the Royal Hospital's show. The show is the work of the Royal Horticultural Society, which has been holding flower shows of one sort or another since 1827.

This year, 2013, is the centenary year for the Chelsea Flower Show, but it is a centenary rife with ambiguities. There have not yet been a hundred Chelsea Shows: after criticism for continuing to hold a show largely devoted to ornamental horticulture at a time of wartime privation, the RHS cancelled the show for the years 1917 and 1918, and, warned by experience, cancelled the show for the whole of the Second World War, staging it again only in 1947. So the 1913 show will actually be the 92nd Chelsea Show.

LEFT The Brewin Dolphin garden at the 2012 Chelsea Show, designed by Cleve West.

Nor was 1913 the first time the RHS had been involved in holding a show in the grounds of the Royal Hospital. The year before, the Society had cancelled its Great Spring Show, held for the previous quarter-century in the Temple gardens, in order to work together with other organizations on the Royal International Horticultural Exhibition; it was the success of that collaborative show that persuaded the Society to move the show from the Temple to Chelsea henceforth. And that fact hints at yet another: Chelsea is the current incarnation of the RHS Great Spring Show, first held in the Society's short-lived Kensington garden in 1862. A quarter-century at Kensington was followed by a further quarter-century at the Temple, before the show came to rest in what appears to have become its permanent home; it was often said in the 1980s that the show had outgrown the capacity of the Hospital grounds, and should move to another location, but no equally suitable location was ever found, and the show has managed to adapt itself to its Chelsea lodgings.

Over the past hundred years, there have been close to 6,000 exhibitors at the show, not counting all those people and local societies which have taken part in competitions at Chelsea, whether for window boxes, hanging baskets or flower arrangements. Of these, over 200 exhibitors have been foreign; Chelsea is an international event, and every continent and most major groups of islands have contributed a display to the show in the course of its history. The show is now twice the size it was when it began; in its first year it had 244 exhibitors, and in 2012 it had 433. The exhibits fall into three primary categories. There are the show gardens, the feature that seems to attract the greatest attention in the media; varying in size, these are displayed along the main avenues and roads, and are sometimes funded by the garden designers themselves, but more often subsidized by commercial organizations or charities. Their numbers have fluctuated immensely: at their lowest point, in 1916, there were only four gardens, while at their highest, in 2003, there were 67. The second category is sundriesmen: stands for greenhouse manufacturers, retailers of garden tools and chemicals, artists, booksellers and specialist societies. These are the only stands which are allowed to sell their goods to visitors during the show. The final category takes us out of the open air, into the Great Pavilion, where it is common to find first-time visitors, who knew what to expect from the show gardens as a result of the television coverage, dumbstruck by the spectacle of the nursery stands.

For much of the show's history, the displays in the pavilion (and its predecessor, the Great Marquee) were staged by a mixture of nurserymen, seedsmen and amateur gardeners, primarily the owners and head gardeners of great country houses. But during the second half of the twentieth century,

the amateurs gradually fell away, leaving the pavilion to the professionals. The firms who bring plants rather than sundries are not allowed to sell them at the show, until the closing bell rings on the last day; what Chelsea brings is primarily prestige and publicity rather than profit, and such are the costs of mounting an exhibit at Chelsea that there are few amateurs today willing or able to run to the expense. Many nurseries exhibit once, or a few times, only. But there are long-lasting firms, Chelsea regulars, whose annual displays are eagerly awaited by visitors: Hilliers, for example, who after their sixtieth consecutive Gold Medal entered the *Guinness Book of Records*. In 2012 there were three firms exhibiting who had been present at the initial Chelsea Show in 1913: Blackmore & Langdon, the delphinium and begonia company from Bath; Kelways, the perennials nursery from Langport, Somerset; and the orchid growers McBean's. But even for these firms there were occasional gaps in their attendance; no single firm has been present at every Chelsea Show.

For the Royal Horticultural Society, Chelsea is the centre of an annual cycle of shows that includes Hampton Court and Tatton Park in July, as well as the shows in its Westminster headquarters at other points in the year. Chelsea may be the Society's most prominent show, but it is still very much a spring show, and the other seasons produce many plants that cannot make a good showing in May (tree fruits, for example, have never been prominent at Chelsea).

This is not the first book to be devoted to the history of the Chelsea Flower Show. The first was *The Chelsea Flower Show* by Hester Marsden-Smedley (1976), an amiable meander through one long-term visitor's memories, very useful for aspects of social history that might otherwise have been left undocumented. Then in 1982 Faith and Geoff Whiten published *The Chelsea Flower Show*, telling the story of the show from the point of view of a team of garden designers, providing a great deal of behind-the-scenes material. In 2000, Leslie Geddes-Brown published *Chelsea: The Greatest Flower Show on Earth*, bringing a practising journalist's eye to the event and its surroundings, and updating the social history element in particular. Also in 2000 John Morland published *Chelsea Gold*, a book describing several of the show gardens which had received Gold Medals in recent decades. I have profited from all these works, but this book is very much an historian's work, concentrating on the development of the show and the trends it both reflected and stimulated in the wider world of gardening.

There is much more to say about Chelsea than can be said here; I can provide only an outline, but I hope that it will provide an illuminating context for visitors to the show.

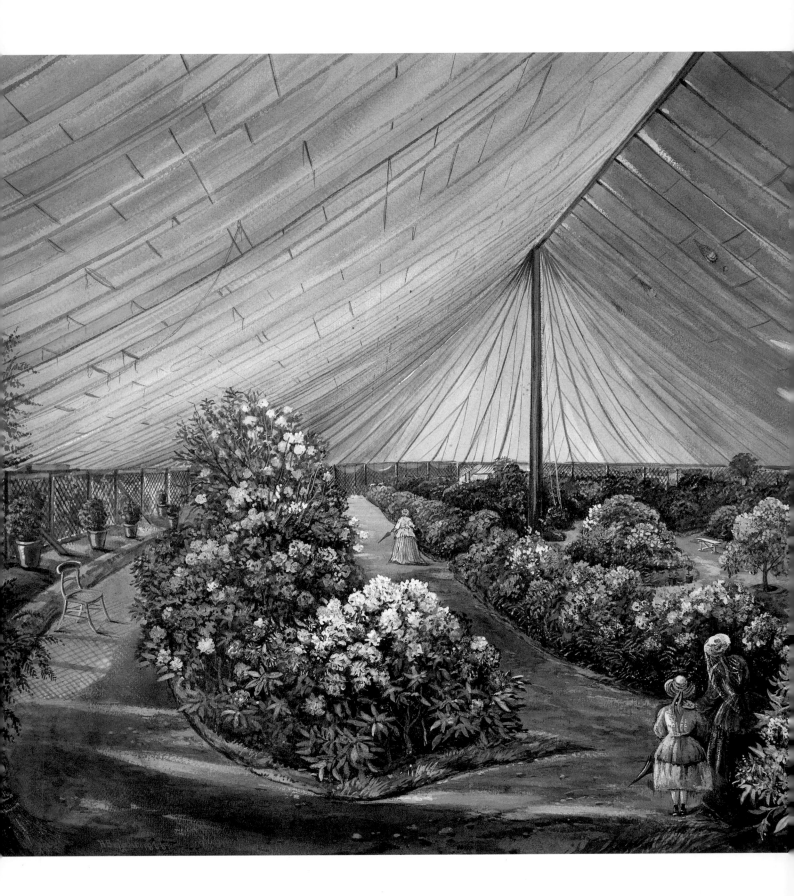

1
BEFORE CHELSEA 1827–1913

The Horticultural Society of London held its first flower show in 1827; it was initially proposed to be called a 'Horticultural breakfast', but by the time the organization was well under way the title had been changed to a 'Horticultural fête'. Let us compare this pioneering event with the RHS Chelsea Flower Show today, and see how recognizable it was as a modern flower show.

The site was the Society's new garden in Chiswick, roughly comparable in size to the grounds of the Chelsea Hospital: each is about 12 hectares, though only a portion of the Chiswick garden was used for the actual show. In 1827 'There were thirty hospital tents, thirty marquees, three state tents, and one horse tent, the latter of which was 200 feet in length'; today there is one gigantic pavilion, 12,000 square metres in area, with some smaller structures for specialist activities such as flower arrangements. In 1827 'Some of the marquees were adapted for dancing, in case the weather had been wet'; no such opportunities at Chelsea, ever. Today at Chelsea there are some 200 toilets provided; neither press nor Council minutes reveal what the latrine arrangements at Chiswick were. In 1827 the catering consisted of two long tents with tables 'covered with chickens, hams, tongues, lamb-tarts, jellies, pastry, creams, wines, &c.'; but no smörgåsbord at Chelsea – instead, either enclosed restaurants or convenience food stalls with seating areas. In 1827 there were three military

LEFT A painting by A. Bright, believed to show part of the marquee for the International Horticultural Exhibition of 1866.

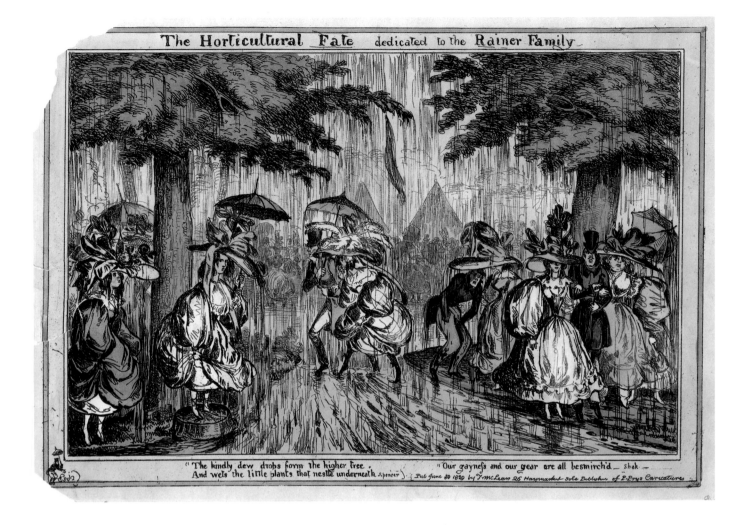

bands in different parts of the gardens; at Chelsea, the music has been largely confined to the bandstand in Ranelagh Gardens, but until the 1990s, the nature of the music would have been familiar – the brass band repertoire, only recently replaced by jazz, rock and steel bands. As for the exhibits, in 1827 they were confined to 'a large marquee, ornamented with festoons of flowers, bays and other shrubs, and containing a rich display of pines [pineapples], melons, grapes, strawberries, cherries, and other fruits, all of the finest qualities, and in the highest perfection' – an indication of the primary interests of many of the Society's early members: how to augment the culinary provision of the country house kitchen garden. Displays of fruit and vegetables may still be found at Chelsea, but greatly subordinated to displays of ornamental plants, not to mention model gardens. Most importantly, in 1827, there was only one major exhibitor: most of what was displayed was the produce of the Society's own garden, augmented by those of its aristocratic patrons, whereas Chelsea today

is dominated by commercial nurseries. In 1827 the event lasted for one day only, 23 June, while the RHS Chelsea Flower Show has recently grown into a five-day event towards the end of May, not counting the opening day for the press and the royal family. Oh yes, and in 1827 the attendance was counted as 2,843; Chelsea aims for 40,000 people per day.

That event at Chiswick back in 1827 was deemed a great success, even though it ended with the Society suing its caterer. It brought in a profit of some £500 – the equivalent of some £43,000 today, according to the most recent retail price index comparison I have found. Not everyone was pleased with the idea of the Horticultural Society holding such an event; some, perhaps thinking of the reputation of such commercial pleasure gardens as Vauxhall and Cremorne, feared for the effects on the morals of the garden staff of seeing the aristocracy in full dissipation. But a further fête was scheduled for the following year, when it was reported that the coaches

LEFT Cartoon by Paul Pry (William Heath), entitled 'The Horticultural Fate', showing the 1829 fête being washed out.

of the guests extended for 2 miles, from Kensington to Turnham Green. By 1829, *The Times* could say that the fête 'forms one of the principal attractions of the fashionable season'. In that year, however, came the first appearance of what became known as 'Chiswick weather', and the fête was disastrously rained out. The *Morning Post* reported: 'when the doors were opened, what a rush took place! The standing nearly ancle-deep in water, coming from wet gravel; shrieks were dreadful, and the loss of shoes particularly annoying! Even when parties got possession of standing room at the several tables, what was even then their situation? . . . the tents were erected in a valley, to which all the water from the high grounds found its way.' No fête was held in 1830.

In 1833 a new type of flower show was devised, by the Society's secretary, the botanist George Bentham (nephew of the utilitarian philosopher Jeremy Bentham, whose preserved body you may see in University College). He proposed holding three flower shows (in May, June and July), to which nurserymen and Fellows of the Society would be invited to send displays of plants. This could be seen as extending the principle of the Society's meetings – to which people brought individual plants of interest – on a larger scale. The exhibits would be judged before the show opened, and tickets were sold to the public.

The shows proved a great success, and for over twenty years such shows became the Society's major source of income apart from membership subscriptions. In 1836 the *Gardener's Magazine* reported that 12,000 tickets had been sold that year, and that, far from the dissipation feared a decade earlier, the show presented a scene of 'elevating, humanising, and rational enjoyment'. 'The principal part of the English aristocracy are present, and mix indiscriminately with the tradesman, the mechanic, and the gardener. This scene may be enjoyed by men,

women, and children, for five or six hours, at 3s. 6d. each [£16 today].'

The Chiswick shows were administered by Dr John Lindley, the Society's assistant secretary, an industrious and indefatigable botanist who did the work the Society now has five different departments for. His role covered general administration; running the shows; editing the Society's publications; running the school of horticulture at Chiswick, the Society's training scheme for gardeners; and identifying the plants the Society's plant collectors sent back from abroad, naming them if they were new to science. In addition to his work for the Society, he wrote several books on botanical matters; served as Professor of Botany at University College for over thirty years, and at the Chelsea Physic Garden for eighteen; and edited various magazines, above all, from its beginning in 1841, the weekly newspaper the *Gardeners' Chronicle*, which he edited until 1863. (So for over a decade he was holding down four full-time jobs simultaneously.)

Lindley developed the Chiswick flower shows into a smoothly running enterprise, but his abrasive manner also caused problems with the public and exhibitors. On one notorious occasion, at the end of the year's shows the exhibitors clubbed together to buy a decorative plate as a tribute to Lindley, but because the letter of presentation bore the letterhead of a magazine that had frequently criticized him, he refused to accept it. He also introduced a one-way system to manage the crowds, and insisted that the line keep moving and not pause. The results were eventually catastrophic for the Society. In the early 1840s the rival Royal Botanic Society began holding flower shows in the inner circle of Regent's Park, followed in the 1850s by shows at the Crystal Palace. These shows were nearer to central London than Chiswick, which was not yet accessible by

railway, and exhibitors came to prefer the more relaxed ways of the rival establishments. By 1855 ticket sales for Chiswick had fallen below 1,000, the profits had fallen tenfold from £3,000 per annum to £300, and Lindley was paying some of the money prizes out of his own pocket to keep costs down. In 1857 the Chiswick shows were stopped altogether, Lindley sadly recognizing that 'the Society's garden . . . is beaten by distance'.

With the gate receipts went a large part of the Society's income. Between 1857 and 1859 the Society, desperate to keep afloat financially, sold off its collection of exotic greenhouse plants, its herbarium, and its library, in a four-day sale at Sotheby's. Ten days after the library sale was completed, the *Gardeners' Chronicle* announced that the Society's finances had turned a corner, and money was now pouring in for the new garden the Society was getting in Kensington. The Society's new President was Prince Albert, who developed a rescue plan that entailed, in 1861, a new royal charter and a change of name to the Royal Horticultural Society. Albert had, a decade earlier, instigated and helped to organize the Great Exhibition of 1851. The Royal Commissioners for the Great Exhibition had used the profits of that event to buy up a portion of Kensington for the development of a new cultural centre, which would eventually include the Victoria and Albert Museum, the Natural History Museum and other institutions. In the middle of this land lay the perfect site for a garden, and Sir Charles Wentworth Dilke, who was both a Royal Commissioner and a member of the Society's Council, proposed that it be leased to the Society for a new garden – not a replacement for Chiswick, which would continue to be the Society's experimental and research garden, but specifically a site for flower shows, where being nearer to central London they could compete on more equal terms with the rival shows. And the second

Great Exhibition could also be held there. The Kensington garden was planned by William Andrews Nesfield, and the surrounding arcades designed by Sydney Smirke and Francis Fowke. The opening ceremony, which included the first competition for flower arranging, took place on 23 June 1861, and proved to be Prince Albert's last public appearance in London before his death that autumn.

Shows at Kensington began in the summer of 1861, following the format of the former Chiswick shows. But the following year a major innovation took place: a Great Spring Show, held in May 1862. Not the best timing for a flower show, since the second Great Exhibition was in progress, taking up most of the garden; but even though it consisted of 'two enormous ill-constructed tents', it attracted around 10,000 visitors, and was so well received that it was followed by a Great Summer Show in July. For several years the two Great Shows formed part of the London season, just as the Chiswick shows had. What made these shows different from their predecessors was the nature of the exhibitors. At Chiswick, and at the major rival shows, amateur exhibitors dominated the proceedings. At Chiswick, displays by commercial nurseries gradually increased in number, and in the last years their presence helped to finance the shows, while at the Crystal Palace nurseries were excluded from taking part in any competitions. At the Great Spring and Summer Shows, nursery stands soon came to outnumber the amateur exhibitors. All over the country, in the third quarter of the nineteenth century, flower shows were being founded by local organizations, and in 1875 the floral decorator John Wills predicted that soon 'a flower show will be held in every village in the United Kingdom'; these local shows were largely the preserve of amateurs. Kensington, uniquely, provided a venue where nurserymen could display the best of their produce.

In 1866, the Great Spring Show was cancelled. The RHS was collaborating with a number of other organizations, most notably the Royal Botanic Gardens, Kew, and its fellow botanic gardens around the country, on staging the first International Horticultural Exhibition to be held in Britain. The plan for this show was drawn up by the landscape gardener John Gibson (who was later to re-landscape Ranelagh Gardens for the Chelsea Hospital), and it entailed an enormous tent, 563 × 293 feet in size, covering 1.4 hectares. The exhibition, which brought exhibitors from all over western Europe, lasted four days and was attended by 82,000 people. The profit from the show was over £5,000 (in today's terms, about £490,000). The Society thought that with this sum it could help to repair the errors of the past, and managed to persuade the other organizers of the exhibition that it would be a good use of this money to buy the private library of John Lindley, who had died the previous December, as a partial replacement for the library that had been sold in 1859. And so the Lindley Library Trust came into being, at first as a joint venture of the RHS and three other organizations, with the RHS Council finally being made the sole trustee in 1910.

Managing the garden in Kensington soon came to be a heavy burden for the RHS. The air pollution of London played havoc with the plants; endless disputes took place with the Royal Commissioners over little matters like the rent; the Society's membership split into pro- and anti-Kensington factions. The Royal Commissioners kept insisting on holding exhibitions of their own within the garden, to the disgruntlement of the large proportion of the membership who lived locally. Tensions mounted so high that at the annual general meeting in 1873, the members refused to accept Council's annual report, and Council resigned in its entirety, from the President

on down. The year 1874 was a quiet one, because the Commissioners declined to regard the new Council as legally elected. Another stormy AGM in 1875 resulted in half of Council resigning, the President refusing to accept a vote of thanks as he stormed off the podium. Eventually the Society took the Commissioners to court, and lost their case on appeal. It became obvious that the original thirty-year lease would not be renewed, and a new administration under Sir Trevor Lawrence made the abandonment of Kensington its goal. The Great Spring and Summer Shows were discontinued in the mid-1880s, while the Commissioners' exhibitions – medicine and health, fisheries, the colonies – became so popular that the District Railway opened a tunnel from South Kensington station to the garden's entrance.

In 1888, the Kensington site was finally abandoned (it would soon be occupied by the Imperial Institute and the Science Museum). The loss of its central London garden was potentially a major humiliation for the Society, and one Sir Trevor Lawrence was determined to circumvent. Even as the contents of the garden were being cleared, he was approaching the Benchers of the Inner Temple with a proposal to stage a Great Spring Show, to demonstrate to the world that the Society was springing back to normal. The gardens of the Inner Temple were a well-known open space in the City of London, where according to legend and Shakespeare the two factions in the Wars of the Roses had chosen their respective flowers. Everything about the first Temple show was hasty and makeshift: the decision to apply for the Temple site had been taken on 27 March, permission granted on 10 April, and the show itself was held for two days, on 17–18 May – two months from initial decision to dismantling. Fortunately the Society still held some of its Kensington tents, and was able to use two of them to house the forty-two exhibitors who agreed at short

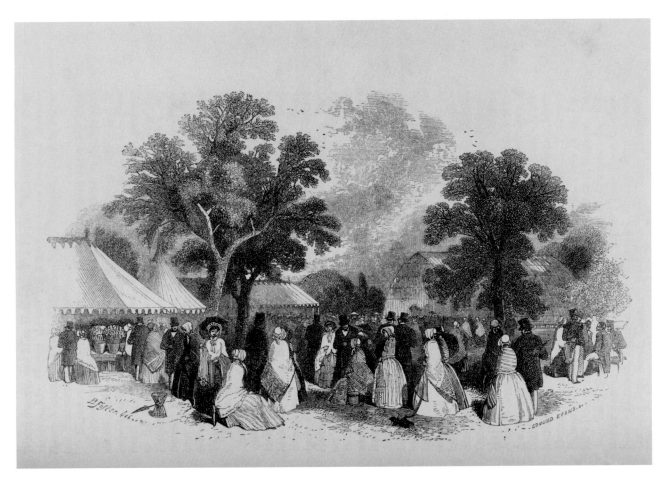

THE OPENING EXHIBITION OF FLOWERS AND FRUIT IN THE GARDENS OF THE ROYAL HORTICULTURAL SOCIETY

LEFT, ABOVE A wood engraving from *The Florist*, 1848, showing the crowds at one of the Chiswick shows; notice the multiple tents and the great glasshouse on the right.
LEFT, BELOW A view at the opening of the RHS garden in Kensington in 1861, from the *Illustrated London News*.

notice to take part. One of them was Sir Trevor Lawrence, displaying orchids from his glasshouses. The event was a success, and achieved its aim of brightening the image of the RHS. The *Gardeners' Chronicle* commented, 'That a Society supposed to be under a cloud should yet be able, time after time, to command such splendid service from the exhibitors is a proof of vitality from which the best auguries may fitly be drawn.'

The idea of returning to Chiswick for the Society's shows was never seriously considered. The suburbs had grown up around the garden by this time, and it began to suffer from air pollution – so badly, that the Royal Society commissioned a study of air pollution in the 1890s using the Chiswick garden as its test case. Most of the Society's shows, now being held nearly every two weeks, were accommodated in the Scottish Royal Volunteers' Drill Hall on Buckingham Gate. As the Society's centenary approached, Council debated whether to celebrate by acquiring a new garden to replace polluted Chiswick or by building its own exhibition hall, so as to hold its shows on its own premises. Naturally, tempers flared, and Council members resigned in protest; but in the end the Society got both. Wisley, the garden of its former treasurer George Fergusson Wilson, came on the market after his death in 1902 and was bought by Sir Thomas Hanbury, who presented it to the Society as a gift; so the centenary fund could safely go towards the new exhibition hall. When a good site had become available on Vincent Square, near Pimlico, the banker and orchid grower Baron Henry Schröder had bought it, so that the Society would not lose the chance; and a new office and hall were duly opened in 1904. The Westminster shows have carried on there ever since.

Meanwhile, the Great Spring Show at the Temple had become an annual event. From that first speedy assembly of two used tents, it grew steadily for a decade: four tents by 1893, five by 1897; the number of exhibitors rose from 48 to a peak of 120. By the later standards of Chelsea, it remained a small show. It continued the tradition of Kensington: 'The Temple Shows differ from all others,' wrote the *Journal of Horticulture* in 1898. 'There is no schedule of specified classes, but varying amounts of space are allocated to applicants, and they occupy it with the best products at disposal.' The exhibitors were a mixture of nurseries, amateurs and charitable organizations.

At first the exhibits at the Temple were confined to the tents. But within a few years a new development was taking place. Rock gardens were becoming one of the greatest horticultural enthusiasms of the day, and several nurseries devoted to alpine plants created miniature rock gardens on tables, to show their plants in the appropriate setting. In 1893, Henry Selfe-Leonard of the Guildford Hardy Plant Nursery was granted permission to create a rockery outside the tents, in the open air. He was soon followed by the other alpinists – Backhouse of York, and Pulham and Son, exhibited open-air rock gardens during the 1890s, and other firms followed in the twentieth century. And once the barrier had been breached, other nurseries began to apply for space for other sorts of garden. The firms of Barr and Sons of Covent Garden, and James Carter & Co. of Raynes Park, imported bonsai specimens in addition to their normal businesses with bulbs and seeds, and by the end of the century they were exhibiting small-scale Japanese gardens in the open air. Then came topiary, with the firms of Cutbush and Cheal. And eventually model tree and shrub gardens.

Over a period of more than eighty years, the Society had been holding one sort or another of public display of plants and horticultural produce. As early as 1829, one of the highlights of the fête was the first flowering of *Clarkia*

RIGHT, ABOVE A view at the Temple show for 1896: the Gold Medal-winning display of orchids by Sander & Sons of St Albans.
RIGHT, BELOW A view at the Royal International Horticultural Exhibition of 1912, from Reginald Cory's *Horticultural Record*: a Japanese garden, probably either Barr and Sons or James Carter & Co.

pulchella, a plant brought back from America by the Society's collector David Douglas. The Chiswick shows had been the occasion of the first flowering of *Deutzia scabra* (1834), and of *Laelia superbiens* (1848). The Temple shows had seen the first displays of *Gloriosa rothschildiana* (displayed by Walter Rothschild in 1904), and of the kiwi fruit, *Actinidia chinensis* (displayed as an ornamental plant in 1907).

After two decades, the Temple shows were not only a fixture of the London season and the biggest horticultural event of the year but also a pain in the neck for the poor lawyers of the Temple, who had to endure traffic congestion, noise, litter and the loss of their open space for a month every spring. So there was little sorrow there when the Society cancelled its Great Spring Show for 1912. Once again, as forty-six years earlier, the RHS joined forces with a group of other organizations to stage an international show. T. Geoffrey W. Henslow was the committee secretary, Gurney Fowler (the RHS treasurer) its chairman, and Sir Jeremiah Colman of the RHS Orchid Committee its treasurer. The search for a venue was carried out by Harry Veitch, the director of the Veitch Nurseries in Chelsea; he made an arrangement with the Royal Hospital for the use of their facilities. The Royal International Horticultural Exhibition duly took place in the Hospital grounds on 22–30 May 1912.

The size of the Royal Hospital grounds allowed a much larger exhibition than anything the RHS had previously been involved with. There were 428 competitive classes, with eighty-odd prizes awarded by nurseries, nobility, local and country authorities, as well as the normal RHS medals. There were special sections for Dutch, Belgian and French exhibitors, the largest foreign groupings, as well as segregated areas for displays of orchids, stove plants, cut flowers, fruit and vegetables. The press competed with superlatives: the orchid display in particular was the best ever seen in Britain. 'One German was heard to say, in slow, measured tones, "This is the happiest day of my life."' (Who knows? A few years later he and some of the exhibitors may have been shooting at each other in Flanders.)

The exhibition turned a profit of some £25,000 (over £2 million at today's prices), which was distributed to three charities: the Gardeners' Royal Benevolent Institution, the Gardeners' Orphan Fund, and the RHS, to help finance the forthcoming publication of its *Index Londinensis*, an index to published botanical illustrations. Reginald Cory, a Welsh coal millionaire who was beginning to organize dahlia trials at his garden the Dyffryn, financed the publication of *The Horticultural Record*, a massive book about the exhibition, with coloured photographs of several exhibits.

Above all, the size of the site and the ease of laying out the exhibition there persuaded the RHS that the Royal Hospital could provide a good home for its Great Spring Shows in the future. Sir Trevor Lawrence wrote to the Inner Temple, saying that their gardens would not be required for a show the following year, and preparations began to stage the Great Spring Show in its new home, where it would quickly become known as the Chelsea Flower Show.

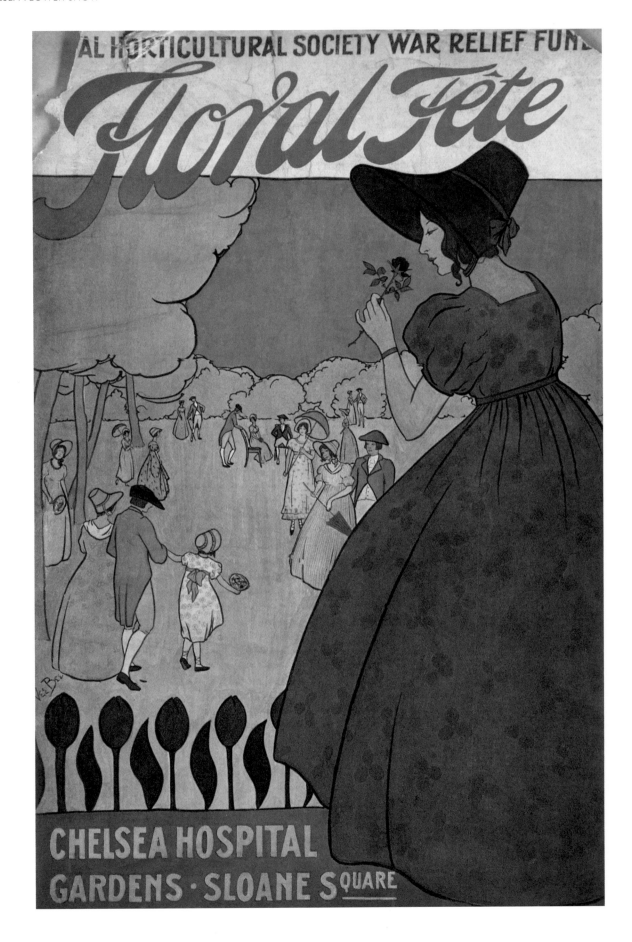

2
FIRST FLOWERING
AT THE ROYAL HOSPITAL
1913–16

The Royal Hospital Chelsea occupies a trapezoidal piece of land bounded on the south by the Thames Embankment, on the east by Chelsea Bridge Road, and on the north by Royal Hospital Road. The Hospital was built by Sir Christopher Wren in the 1680s, as a home for disabled or retired soldiers – the army counterpart to the naval hospital at Greenwich. The grounds were designed as a gigantic formal garden by London and Wise, but were heavily simplified by John Gibson in the 1860s: the canals were filled in, and the great avenue was left surrounded by lawns, for ease of maintenance and sports provision. In 1853 a tall obelisk, designed by Cockerell, was erected in the middle of the avenue, to commemorate the battle of Chillianwallah five years earlier, when the power of the British army had been checked by the Sikh army, though both sides claimed victory. To the east of the grounds were the house and garden of the Hospital's first treasurer, the Earl of Ranelagh; these were bought and converted into a commercial pleasure garden, Ranelagh Gardens, in the eighteenth century. John Gibson also landscaped these in the 1860s, and after use as a football ground, they were acquired by the Hospital.

The large flat site was eminently suitable for exhibition purposes, and indeed the RHS had held a three-day summer show there in 1905 before Harry Veitch arranged its use for the Royal International Horticultural Exhibition in 1912, and thereafter for the RHS Great Spring Shows.

From the first, the show went under a double name. The first catalogue announced it as the Royal Horticultural Society's Great Spring Show; but the words 'Chelsea Show' appeared in an inset box at the top of the page. Even before the second show had taken place, the plant collector and author Reginald Farrer had written a caustic remark about colour massing in a rock garden being 'a neat unalloyed exhibit like those on "rock-works" at the Chelsea Show' (he himself had designed a rock garden there in 1913,

LEFT The front cover of the programme for the RHS Floral Fête of 1919, held at Chelsea Hospital Gardens in aid of the war relief fund.

15

no doubt, to his taste, better arranged). Show catalogues during the interwar years had the words 'Chelsea Show' emblazoned on their covers, changed to 'Chelsea Flower Show' in 1947; the last catalogue to insist in its preface that the official name was the 'Great Spring Show' was that of 1988. No change of policy was involved, merely different marketing strategies.

The first Chelsea Shows were three-day events, held in a single marquee, which had to be tall enough to accommodate the obelisk (known to exhibitors as the monument site). The marquee was erected by Piggotts, who handled Chelsea tentage until the end of the century; the timber supports for it weighed collectively 70 tons. Outside the marquee, along the southern boundary, lay model gardens, as previously at the Temple; most of them were rock gardens – including, in 1913, the work of the nurseries of Backhouse of York, Cheal's of Crawley, the Craven Nursery (R. Farrer), Clarence Elliott, the Guildford Hardy Plant Nursery, Pulham and Son, George Whitelegg and John Wood, as well as firms now remembered for horticultural specialities other than alpines, such as Robert Wallace of Colchester (usually bulbs), George Reuthe (normally trees and shrubs) and Cutbush of Highgate (topiary – which they displayed as well). Wood's rock garden received a Gold Medal – the only garden to do so before the war. There were other gardens as well, labelled in the catalogue as 'Formal Gardens', even when they were tree and shrub or Japanese gardens: these were the work of Barr and Sons of Covent Garden, Carter's of Raynes Park and Notcutts.

The magazine *The Garden* greeted the rock gardens as not only beautiful but also instructive: 'we might be pardoned for believing them to be a true bit of [alpine] scenery. Hence the object of their being is achieved; the teaching value is sound, which, after all, is the one great reason for holding such exhibitions at all.' Such statements proved very helpful a few years later, when the RHS was under pressure to explain the education value of Chelsea in order to escape Entertainment Tax.

Flanking the marquee on the east was an avenue devoted to sundries: stalls erected on either side of the avenue, to display and sell horticultural wares other than plants – tools, equipment, chemicals, furniture and ornaments. Sundriesmen, like nurserymen, were not allowed to sell directly; within the tent, nurseries could take orders but not sell plants for the duration of the show.

Under the marquee nurseries and seed houses exhibited their plants. Some long-lasting firms who were there in the first year included the carnation specialists Allwood Bros; Bakers of Codsall, Forbes of Hawick, Kelway's and Amos Perry for perennials; Barr and Sons, Robert Wallace and R.H. Bath, bulb merchants; Blackmore & Langdon, who had begun exhibiting their delphiniums at the Temple in 1902, the year after they were founded; Bunyard's and Laxton's for fruit; the rival rose firms of Benjamin and Frank Cant, and of William and George Paul; Henry Cannell and Charles Turner for bedding plants; Stuart Low, Henry B. May, and Veitch for greenhouse plants; James Douglas for auriculas; Engelmann for carnations; George Jackman for clematis; Notcutts and L.R. Russell for trees and shrubs; the great seed firms of Sutton's, Carter's, Dobbie's, Bees', Peed's and Webb's. Along one side of the marquee were arranged in one sequence the stands of the orchid nurseries Armstrong and Brown, Charlesworth, Cypher, McBean's, Mansell and Hatcher, and Frederick Sander.

In those early years, there were also many amateur growers, usually the proprietors of great estates, who staged displays of plants from their gardens, among them Sir Jeremiah Colman and Sir George Holford of

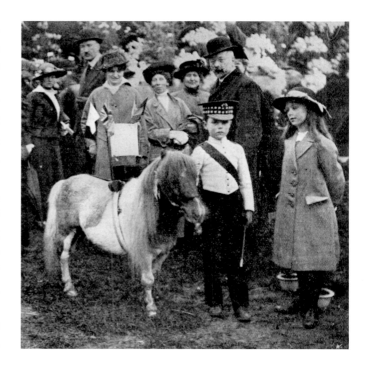

BELOW Viscount Dalrymple, with the pony Cafe Caramel, 31½ inches high and five years old, collecting on behalf of the Horticultural war relief fund and Lady Lansdowne's Officers' and Families Fund, 1913.

Westonbirt (orchids), Vicary Gibbs (vegetables), John McWatt (primulas) and Leopold de Rothschild (Malmaison carnations). There was also one foreign firm, the rose growers Robichon of Orléans.

It would be many years before visits by the royal family became an annual tradition. The King and Queen did not attend the show in 1913, but the Queen's mother did: Queen Alexandra, accompanied by two of her children, Princess Louise, Duchess of Fife, and Princess Victoria.

The Garden greeted the first Chelsea Show as 'A great and unqualified success'; the magisterial *Gardeners' Chronicle* began its review with grumbles about the stands being too close together, a complaint resolved satisfactorily the following year, when the *Chronicle* made up for its earlier pettiness by proclaiming it 'Equally good in quality and far better arranged than the International Show of 1912'. Chelsea was already, in these first years, twice as large as the last Temple show two years before, with 244 exhibitors as opposed to 121.

Only a few months after the second Chelsea Show, Europe descended into war. At first there was no significant impact on horticulture: everyone expected the war to be over quickly, and the 1915 Chelsea, while somewhat reduced in the number of exhibits, was treated as a normal event. The major impact of the war was the introduction of fundraising – not yet the professional fundraising that arrived with the issue of war bonds: Chelsea's contribution was made by a boy with a Shetland pony and a bucket for cash. (The boy was the eight-year old Viscount Dalrymple, later the 13th Earl of Stair.)

But the next year things were different. A bill of compulsory conscription had been passed in January 1916, and by the time of Chelsea gardens and nurseries were losing staff to the trenches. The last of the great nurseries on the King's Road, William Bull's orchid firm,

which had held its own private show to accompany Chelsea, closed that year. Only one formal garden (by Ernest Dixon – a pool surrounded by rhododendrons) and three rock gardens were on show. The show made a profit of only £400, as opposed to over £1,000 the year before. There was a widespread feeling that ornamental horticulture was an inappropriate frivolity in wartime, though the RHS tried hard to spread the message that people should continue spending on their gardens in order to keep the nurseries from going under. The government suggested that the show should be subject to Entertainment Tax, and the RHS Council saw 'an agitation to suppress the Society's shows'. In the end there seemed no recourse but to cancel Chelsea for the duration of the war.

RHS CHELSEA FLOWER SHOW AND THE ROYAL HOSPITAL

Given that the RHS alienates the Royal Hospital from its gardens and sports facilities for six weeks each year, disrupting the life of the disabled and elderly Chelsea Pensioners, it is understandable that the Hospital has laid down rules to minimize the inconvenience inflicted on them: heavy works during the course of build-up are allowed only between 7.00 a.m. and 8.00 p.m. (though quieter work, such as planting, especially under the tents, can continue for longer), and the grounds must be vacated and put back to normal within a strict deadline.

Since an incident in 1926 when a dilatory nurseryman caused a breach of the rules, exhibitors have had to sign an undertaking binding them to abide by the schedule.

The RHS has carried out various improvements to the Hospital grounds as part of successive contracts, organizing the laying of a new drainage system in the 1920s, and again upgrading the water mains in the 1980s; repairing wartime damage to the grounds; carrying out tree surgery on the elm avenue; resurfacing the road system in the 1970s.

The first lease negotiated by the RHS was for five years; at subsequent renewals this was extended to fifteen years. When the Second World War interrupted the show, the Society still had to pay half the rental fee for the duration. In the 1980s, overcrowding and increasing size triggered a long debate about moving to another site, such as Regent's Park; but consultants always agreed eventually that there was no equally good alternative, and the thought of moving from Chelsea was abandoned.

LEFT, BELOW Three Chelsea Pensioners at the RHS Chelsea Flower Show in 1935.
BELOW *Survivals of the Past: The Pensioners of the Royal Hospital Chelsea*, a poster for London Transport by Dora M. Batty, 1924.

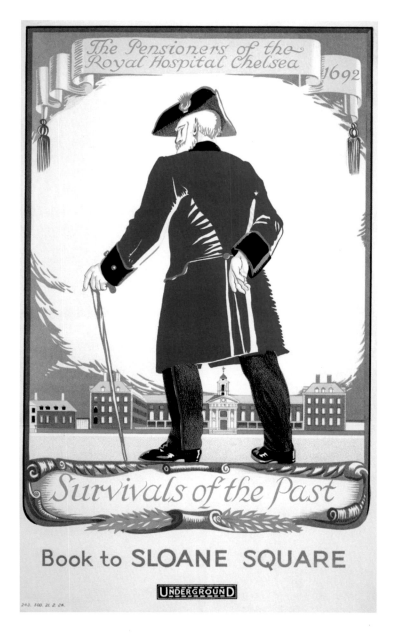

The Pensioners of the Royal Hospital Chelsea

1692

Survivals of the Past

Book to **SLOANE SQUARE**

UNDERGROUND

MY CHELSEA

For us 'The Show' really starts in late April. To begin with there are the irritations: the loss of our beloved Ranelagh Gardens for six weeks; the bleeping of reversing vehicles which wake us up that bit too early at the weekend; and the various other minor inconveniences associated with build-up. Then, at last, and to our endless surprise, order and beauty suddenly emerge from apparent chaos, like a butterfly appearing from a chrysalis. Now the heart quickens in anticipation, and we eagerly seize the opportunity to view the show before it opens to the public. What joy it invariably brings, and what pride we share in the achievement! The greatest horticultural show in the world is right here in our back garden. 'Our' show is about to open.

Then the hordes arrive, and for five days cut a swathe across the heart of the Hospital, occasionally testing the patience of elderly Chelsea Pensioners as they go about their daily lives. But nobody minds this very much. Rather, the overwhelming sentiments are those of pride that we are hosting this great event, and amazement as we marvel at what has been achieved in so short a time. And year after year we go home saying, 'That was the best show ever.' This 'Royal Show' and the Royal Hospital are, indeed, a happy combination.

The Lieutenant Governor
Major General Peter Currie

THE DEVELOPMENT OF THE SHOW GROUND AT THE ROYAL HOSPITAL

The showground is shown here in three stages of its complicated development over the course of a century.

The main illustration below shows a projected plan by W.E. Bissett for the layout in 1921. The plan that was published in the Chelsea catalogue does not show the geometrical paths of the formal gardens area seen here at the far right, so they may have been wishful thinking. In this projected plan the main tent is drawn to show the layout of individual exhibits, some on tables and some as island stands.

On the opposite page, above, is the published plan for 1929, showing how refreshment facilities had spread over more of the Royal Hospital grounds, reaching into the neighbouring Ranelagh Gardens (at the top), the main tent had been divided into two unequally sized tents, and a cluster of special-interest tents were

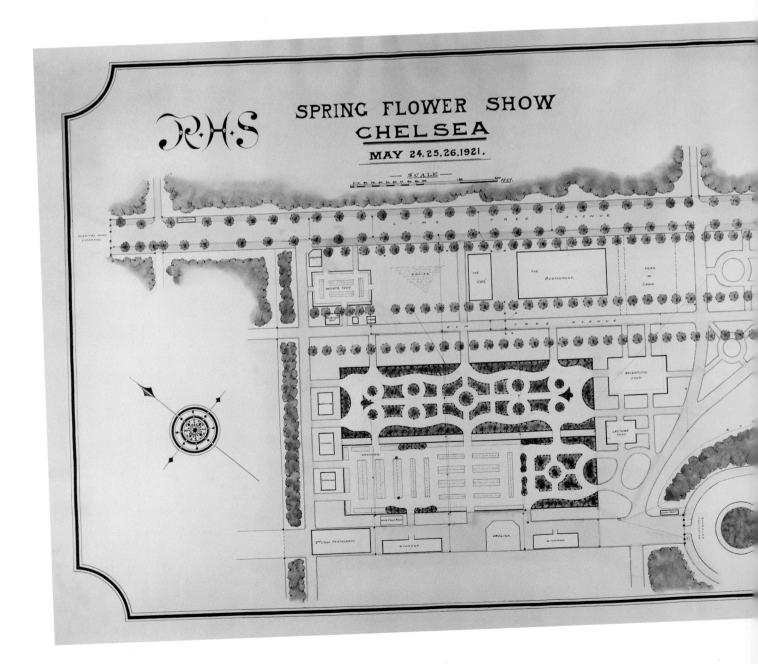

arranged on the west (at the bottom) – roses, orchids, cacti, new plants, art and science. A separate plan published in the catalogue gave details of the layout within the tents.

The plan shown below on this page is from 1988. It is drawn at a different angle from the other two; north is now at the top. The Great Marquee dominates the site, and the stands are no longer so picturesquely arranged as in Bissett's plan.

The tent for flower arrangements is on the Western Avenue, that for garden design on the Main; there is space allotted for hanging basket and other competitions, an increased number of catering tents, a separate restaurant for the exhibitors, and private hospitality chalets for meetings and fundraising ventures. A system of colour-coding distinguishes the show gardens (dark green) from the various categories of sundriesmen.

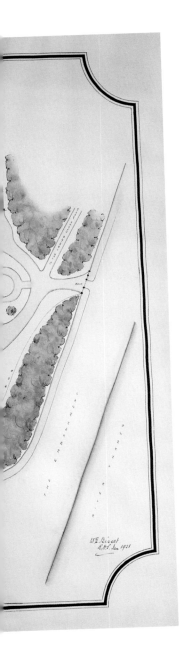

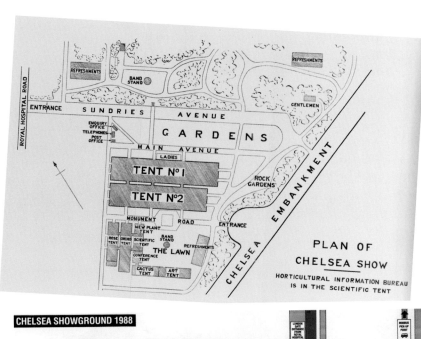

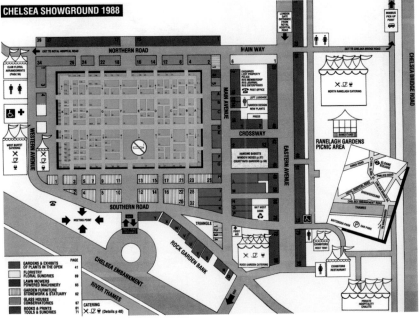

RANELAGH GARDENS
AT THE ROYAL HOSPITAL

Ranelagh Gardens, a rectangle of land flanking the east side of the Royal Hospital grounds, had been a commercial pleasure garden in the eighteenth century, but closed in 1803. The Hospital acquired the site in 1826, and turned part of it into allotment gardens. Re-landscaped by John Gibson in the 1860s, it served for a generation as a site for football pitches, before being treated as a woodland garden.

From the beginning the Chelsea Show used Ranelagh Gardens as a place for visitors to sit, relax, picnic and listen to the bands in. (The most frequently played composer, during the brass band era, was Johann Strauss Jr, followed closely by Arthur Sullivan.) In 1922 the refreshment tents were moved into Ranelagh Gardens, thus helping to reduce congestion in the main showground.

In the 1990s, to improve circulation into Ranelagh Gardens, the Society installed a new set of steps, constructed in Haddonstone's artificial stone, and named the Sweetingham Steps in honour of the show manager Mavis Sweetingham. In the year 2000 the exhibits were extended into Ranelagh Gardens for the first time. The catering facilities were moved into a more central position, yielding their site to a relocated floral arrangement pavilion, and seventeen sundriesmen's stands moved into 'North Ranelagh', with a sequence of courtyard gardens in 'South Ranelagh'.

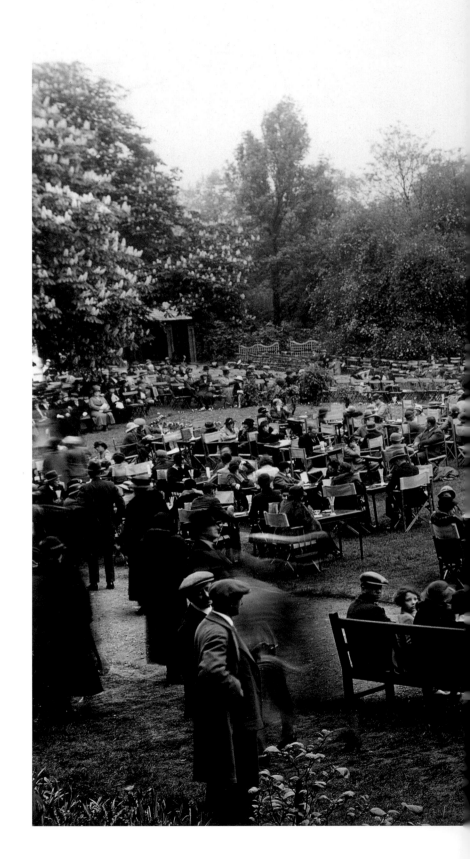

THE CRAZE FOR ROCK GARDENS

Rock gardens designed by nurseries specializing in alpine plants had come to dominate the open-air exhibits at the Temple show, and because of the number of such gardens on display at Chelsea, a portion of the southern perimeter of the Chelsea showground came to be called the Rock Garden Bank – and the name carried on even after the rock gardens had largely vanished. During their heyday, rock gardens were so popular that designers like Percy Cane and Ralph Harcock had to try their hands at them, and in the 1950s Ambrose Congreve of Winkfield Manor Nurseries frequently exhibited two gardens, one rock and one formal.

The 1950s also saw the beginnings of a decline in the popularity of rock gardens. Their numbers diminished until the point when at the 1968 show nobody applied to stage one and RHS Wisley Garden stepped in to fill the gap. During the 1970s and 1980s first Douglas Knight, who began his series of gardens in Westmorland slate in 1987, and then Paul Temple and Peter Tinsley, revived the making of rock gardens, but the days when this genre of gardening had dominated the grounds of the show were by then a distant memory.

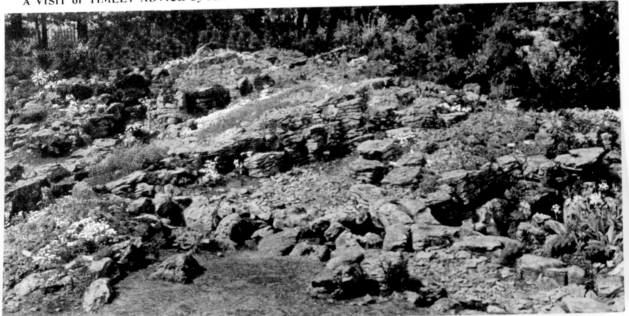

SEND FOR CATALOGUES, PLANS or ESTIMATES FOR OUTDOOR PLANTING or GARDEN CONSTRUCTION. A VISIT or TIMELY ADVICE by Mr. WOOD MAY SAVE ENDLESS EXPENSE and DISAPPOINTMENT.

Showing a portion of my Exhibit constructed at the R.H.S. Chelsea Show, 1913. Awarded the R.H.S. Gold Medal.

Photographed by Colin Campbell, and Reproduced by the courtesy of *The Illustrated London News*.

J. WOOD, LANDSCAPE ARCHITECT AND ROCK GARDEN SPECIALIST. BOSTON SPA, LEEDS.

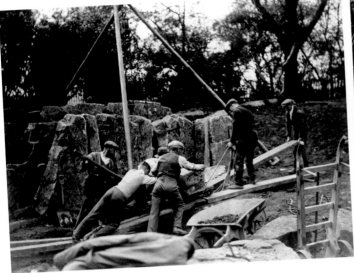

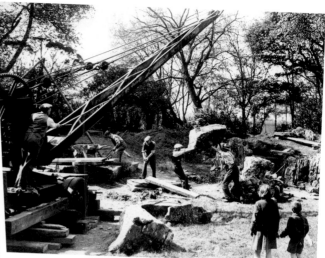

OPPOSITE The only garden to win a Gold Medal before the First World War was this rock garden by John Wood of Boston Spa, in 1913 (illustration from the 1914 catalogue). At the 1912 Royal International Horticultural Exhibition, Wood had exhibited what was claimed to be the first rock garden to show the stratification of Yorkshire limestone, and this became the trademark of his early years.

THIS PAGE Various rock gardens being assembled at Chelsea between the years 1924 and 1936. Cranes were brought on site in order to lift the heavy boulders into place; afterwards earth would be piled up so that the rocks appeared as outcrops, to be planted with alpines, turf and sometimes such additional features as ornamental grasses and conifers.

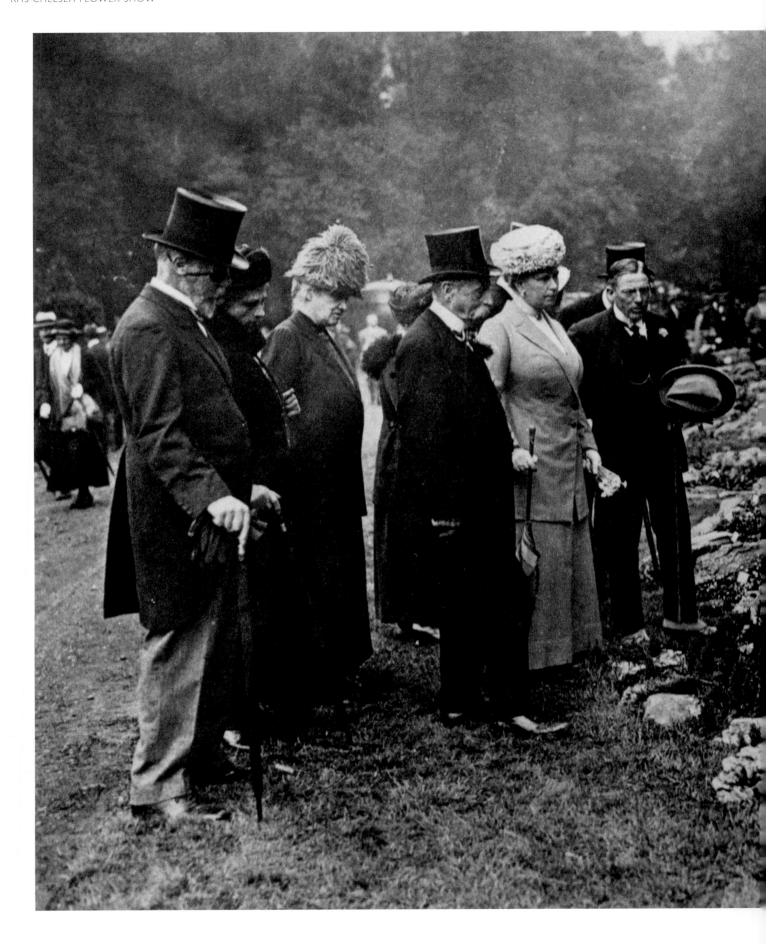

LEFT Queen Mary with entourage at the first Chelsea Show, 1913, looking at a rock garden. She is flanked by the RHS President, Lord Grenfell, and, with his hat in his hand, George Whitelegg, the designer of the rock garden.

EDUCATION RATHER THAN ENTERTAINMENT

When in 1916 the government had approached the RHS with a demand for the payment of Entertainment Tax, not only on Chelsea but on the Westminster shows as well, the matter was temporarily resolved by the discontinuation of shows. Once the war had ended, however, the Society recommenced its shows and at the beginning of 1919 it was hit once again by the government's tax demand. At a time of straitened resources, this new blow threatened the continuation of the Chelsea Show.

William Wilks, the Society's secretary, wrote to Austen Chamberlain, the Chancellor of the Exchequer, in tones of moral outrage, calling for 'Justice – plain, simple, straightforward Justice' and insisting that the RHS was a scientific organization, whose shows were an educational benefit for the public. After all, it had held important conferences, translated Mendel into English and helped to establish the science of genetics. Lord Balfour of Burleigh, an RHS Council member, had a personal meeting with Chamberlain to try to win him over. Between them, they were successful: in March Chamberlain announced that the show would not be subject to the tax, 'so long . . . as the Show continues to contain the features now claimed for it and does not include a band or other extraneous attraction'. Of course, the show did include a band, and probably some other extraneous attractions, but this condition seems to have been forgotten by everybody.

After backing down on taxes, Austen Chamberlain became active in the RHS's affairs, trying to get the Society to exclude giant vegetables from competitions. Eventually, he and Herman Senn, the chef of the Reform Club, formed part of a committee set up to organize vegetable displays at RHS shows.

But the Society took its educational duties seriously. Every Chelsea catalogue thereafter for seventy years had an introductory section stating that the primary purpose

of the show was scientific and educational. (Since 1989, the catalogues have dispensed with that statement, for reasons of marketing rather than a change of policy.) In 1919 planning time allowed only for lectures, but from 1920 a special tent was erected to house scientific exhibits: in that year it included displays on measuring plant growth rates (Imperial College), cross-fertilization of fruit trees (John Innes), fruit stocks (Wye College), soil fungi (Rothamsted) and photographic apparatus (the photographer Reginald Malby), as well as an exhibit by W.R. Dykes of tulip drawings by his future wife, which would adorn his posthumous *Notes on Tulip Species*. From 1922 the scientific tent included an advisory stand.

Today the scientific or educational section is found in one corner of the Great Pavilion: research organizations and horticultural colleges put up poster papers or mount demonstrations on matters of horticultural science. These have included early explanations of chromosome counting, means of pest control, warnings about new invaders like Colorado beetle, studies of particular environments or categories of plants, and most recently issues of biodiversity and conservation. In earlier years scientifically minded amateurs frequently contributed displays, and as late as the 1990s Dr Henry Oakeley staged a photographic display about the orchid genus *Lycaste* in the South American rainforest.

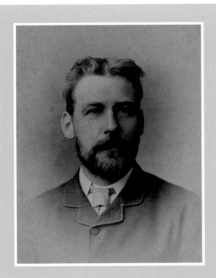

NAME Edwin Beckett
PROFESSION Head gardener
EXHIBITED 1913–30

EDWIN BECKETT (1853–1935) became head gardener to the Hon. Vicary Gibbs at Aldenham House, Watford (now the Haberdashers' Aske School), in 1884, having already won prizes at RHS shows for his vegetables. The partnership of Gibbs and Beckett became famous for horticultural excellence, both being awarded the RHS's Victoria Medal of Honour: Aldenham House had a celebrated tree collection, and a stilt garden before Hidcote did, while Beckett was regarded as the most successful exhibitor in history, with over seventy Gold Medals to his credit. Beckett was one of the directors of the Royal International Horticultural Exhibition in 1912, and a member of the RHS fruit and vegetable committee for thirty-five years. He wrote his generation's standard book on *Vegetables for Home and Exhibition* (three editions, 1899–1927). Every year during the later 1920s he predicted that that year's vegetable exhibit would be his last; the press were so used to this wolf-crying that when he produced no exhibit in 1931 they were shocked.

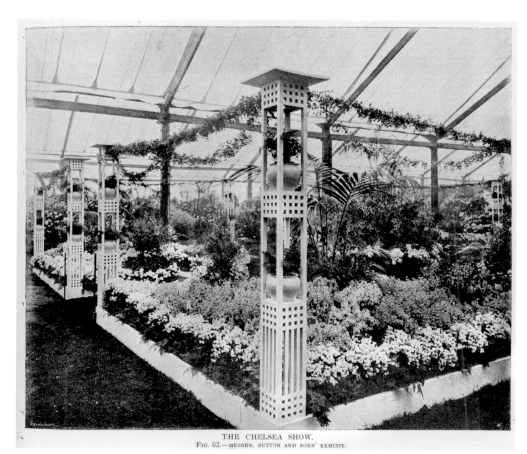

THE CHELSEA SHOW.
FIG. 92.—MESSRS. SUTTON AND SONS' EXHIBIT.

LEFT The exhibit by Sutton's Seeds at Chelsea in 1915.
BELOW The exhibit by the seed house of Webb & Sons at the first Chelsea Show, 1913, showing the mounded style of displaying annual and perennial flowers.

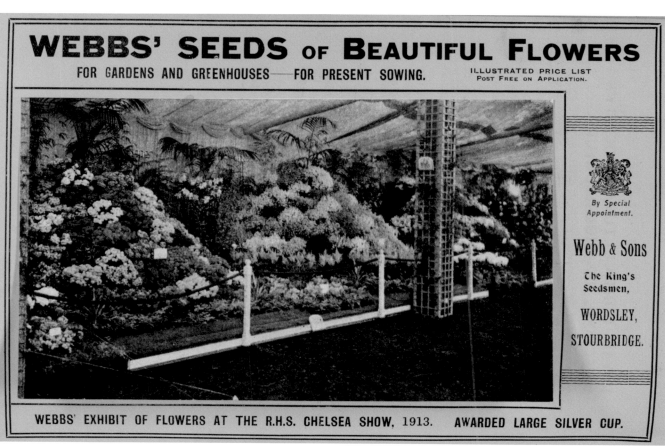

WEBBS' SEEDS of BEAUTIFUL FLOWERS
FOR GARDENS AND GREENHOUSES—FOR PRESENT SOWING.
ILLUSTRATED PRICE LIST
POST FREE ON APPLICATION.

By Special Appointment.

Webb & Sons
The King's Seedsmen,
WORDSLEY,
STOURBRIDGE.

WEBBS' EXHIBIT OF FLOWERS AT THE R.H.S. CHELSEA SHOW, 1913. AWARDED LARGE SILVER CUP.

SUNDRIES STANDS

Sundriesmen – basically all those who provide gardening products other than plants – have exhibited at the Society's shows since Kensington, so naturally they appeared at Chelsea in 1913: lawnmower manufacturers (Ransomes, Shanks); the Four Oaks Spraying Machine Company; the creators of Jeyes' Fluid; retailers of garden tools and chemicals; not to mention Pattissons, famous for their horse boots (so that horses pulling gang mowers would leave little trace on the lawn). Sundriesmen come and go, and leave fewer traces of their existence than nurseries, which may at least be commemorated in plant names. Who now remembers the Hardy Patent Pick, Acme Patent Ladder or Ichthemic Guano Companies?

In 1913 there were 94 sundries stands, mostly in the marquee; in 1927 the figure suddenly jumped to 144, and most were relocated to the eastern avenue (Sundries Avenue); today there are over 300. In addition to the categories listed above, there were manufacturers of greenhouses, garden buildings and garden ornaments, all of whom eventually left Sundries Avenue to be accommodated along Northern Road and other thoroughfares. There were also booksellers, both current (Hatchards exhibited for thirty-seven years, and over-investment in their Chelsea stands may have precipitated the collapse of Berger & Tims) and second-hand (the great natural-history booksellers Wheldon & Wesley exhibited for twenty years), and stands promoting particular magazines: the *Gardeners' Chronicle* first took a stand in 1920, to be followed by *Amateur Gardening, Popular Gardening* and in more recent times *Country Life, Garden News, Gardens Illustrated* and *English Garden*.

Gardening – as long as you're not getting paid for it – is considered a 'leisure' activity, but what about leisure as commonly understood? Not all sundriesmen have catered for activities involving plants. There have been few firms

HEDGE CLIPPING

made Easy
with the

"LITTLE WONDER"

A PRACTICAL machine that will clip any variety and shape of hedge five to ten times as fast as the hand shears.

It will do better work and make finer hedges with much less effort

Ten feet high hedges may be clipped right from the ground. Easily adjusted for top-cutting.

Strong, durable, efficient—a perfectly made and finished labour-saving machine that saves you money every time it trims a hedge. The "LITTLE WONDER" Hedge Clipper is in use at the Royal Horticultural Society's Gardens at Wisley and has been granted

THE AWARD OF MERIT BY THE R.H.S.

Used in the Royal Horticultural Society's Gardens and by the Southern Railway.

You are cordially invited to visit our STAND No. 102 in the Sundries Avenue for demonstration and particulars.

JOH. HANSEN, F.R.H.S.,

ASTOR HOUSE, 93, ALDWYCH, LONDON, W.C.2.

LEFT AND BELOW Advertisements from Chelsea catalogues, showing interwar products from the Atco mower, first launched in 1921, to an experiment doing for wheelbarrows what horse boots did for the gang mower.

BOTTOM LEFT Thomas Green & Son launched their Silens Messor or silent mower in 1859: it was the first chain-driven mower. As late as 1935, the company was still marketing new variants on that basic model.

BOIL SYSTEM

AUTOMATIC WATERING

FOR

HARD TENNIS COURTS

With the B.O.I.L. System, a regulation Hard Court, 120 ft. x 60 ft., is saturated in 15 to 20 minutes, or damped down in a few moments, by simply turning on a valve. This system of irrigation, suitable for all porous Hard Courts, red, green or grey, keeps the Court in perfect condition and reduces cost of upkeep. It gives dustlessness and resilience and maintains good colour. Frost proof and drip proof.

COMPLETE INSTALLATION
for one standard Tennis Court fixed ready for service within 50 miles of London.

£29 10s. 0d.

MAY BE SEEN ON THE EN TOUT CAS COMPANY'S STAND at this Exhibition.

BRITISH OVERHEAD IRRIGATION LTD.

UPPER HALLIFORD, SHEPPERTON, MDLX.
'PHONE: SUNBURY 84. 'GRAMS: "IRRIGATION," SHEPPERTON.

TYPE "A."

TYPE "G."

"OXFORD ROADLESS" BARROWS.

STAND No. 66.

JOHN ALLEN & SONS (OXFORD) LD.

COWLEY, OXFORD.

RIGHT The enquiries team at the first Chelsea Show, 1913, featuring (seated, second from left) S.T.Wright, the director of Wisley, and (standing, left) John Hutchinson, the librarian. The enquiries stand has become much more professional-looking since then.

in Chelsea's history devoted to children's play equipment – Wicksteed of Kettering, the pioneer manufacturers of playground furniture, exhibited only once, in 1932 – though in recent times we have had the Children's Cottage Company and JC Climbing Frames. But sports and games in the garden have been catered for: lawn sundriesmen like Pattissons marketed croquet equipment, and machines for marking white lines on grass; and between the wars there was a flourishing crop of designers of tennis courts, some of whom, like the En-Tout-Cas Company of Leicester, showed model gardens that incorporated small-scale courts. One journalist responded: 'Some of the exhibits in this section appear to have "strayed" from the Sundries Avenue . . . pigmy hard tennis-courts set in full-scale garden surroundings cannot be considered models.' After the Second World War the tennis courts dwindled (though En-Tout-Cas continued to exhibit into the 1960s), to be succeeded by swimming pools. Attempts at including swimming pools in model gardens were resisted by Council, who ruled that they belonged firmly in Sundries, and might disqualify a garden from getting a medal if too large. The late twentieth century brought the further refinement of electronically operated hot tubs, not to mention barbecues, smoke pits and other resources for open-air cuisine.

Clothing has made an appearance in Sundries Avenue. In 1933, the year after a notoriously flood-ridden Chelsea when boxes were seen floating in the pathways, appeared a stand offering rain capes and mackintoshes; then came gardening gloves, and in the 1990s, stands offering a full range of garden clothing.

Recent years have also brought sundries stands devoted to biodiversity. The Potters Art Guild had shown bird baths as early as 1913, but those were really garden ornaments, and it was a long time before specialist services devoted to garden wildlife appeared. CJ Wildbird Foods first sold their bird feeders and seed mixes at Chelsea in 1999; there are stands advising on wildlife pond management; and for the past decade the Wildlife Trusts have had a promotional stand.

~ CHELSEA SHOW. 1913 ~

BELOW A display of photographs of recent garden design by the firm of Milner, Son & White, 1937.

DESIGNERS' GARDEN PLANS

Sundries Avenue has also included stands of commercial artists, displaying paintings and other artworks (including, in recent years, batiks and tapestries). At the very first Chelsea, Edith Helena Adie had a stand; her paintings of Reginald Cory's garden, the Dyffryn, have been used in that garden's restoration. The artists were at first fitted into the marquee; for much of the interwar period they were housed in a separate art tent;

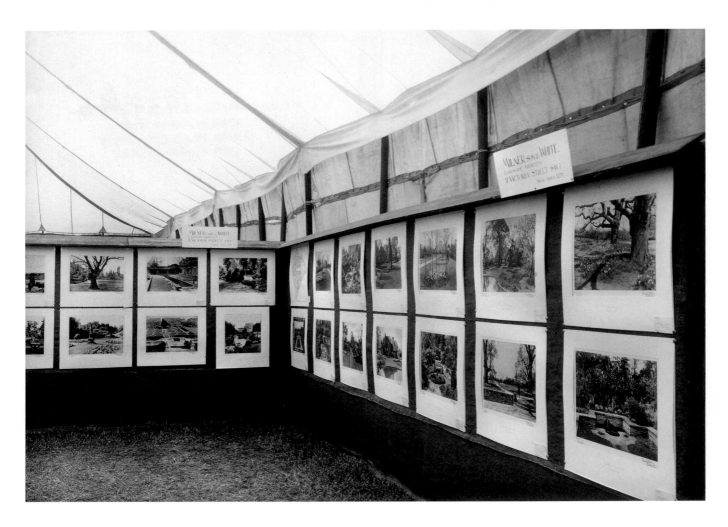

since the Second World War they have had stands in the avenue. In recent years, they have included botanical artists such as Bryan Poole, Rosanne Sanders and Patricia Dale.

Works of art have not been the only paper exhibits at Chelsea. In 1913 there was an unusual display from the firm of Robert Wallace of Colchester, best known for their bulbs (they later merged with their Covent Garden rival to become Wallace and Barr) but with a profitable line in garden design as well. Wallace had both a model garden and a nursery stand under the marquee, but also staged an exhibit of plans for new gardens. The idea caught on; next year he was joined by the Bromsgrove Guild, a company of Arts and Crafts designers, and by the landscape architect Edward White.

In 1915 the number of plans increased, and included plans from the students at the Glynde College of Lady Gardeners. After the war, Thomas Mawson joined the throng, and even Walter Godfrey and Inigo Triggs, well known for their writings on architectural gardens, each exhibited plans once. They were survivors of the Edwardian period; younger designers of the 1920s and 1930s included George Dillistone, author of *The Planning and Planting of Little Gardens* (1920); Violet Solly, author of *Gardens for Town and Suburb* (1926); Richard Sudell, who became the secretary of the Institute of Landscape Architects; and Brenda Colvin, the future author of *Land and Landscape* (1949). The most frequent exhibitor of all was Percy Cane, who regularly showed plans and photographs of his gardens for over fifty years (1919–72). In the late 1930s, the art tent in which they were housed was replaced by a garden design tent.

After the Second World War, a new generation of designers appeared in the Garden Plans section, which is now in a corner of the pavilion. Ralph Hancock, best remembered for his roof gardens (Derry and Toms in Kensington, Radio City Music Hall in New York), showed plans half a dozen times in addition to his model gardens. Sylvia Crowe exhibited plans regularly through the 1950s. John Brookes, Kenneth Midgley, Cliff Tandy, Peter Youngman, Bodfan Gruffydd, Derek Lovejoy, Anthony du Gard Pasley, and Muriel Stockdale Smith, author of *A Book of Garden Plans* (1973), all showed work during the third quarter of the century. And in the last quarter of the century came designers like Jane Fearnley-Whittingstall, Paul Miles, Graham Burgess, Anthony Noel, Peter Rogers, Robin Williams, Julian Dowle and others who are flourishing today. Hester Mallin, promoter of balcony gardens in high-rise buildings, used displays of photographs to make her case, and in 1978 the Friends of Highgate Cemetery showed photographs of their conservation work.

Despite these famous names, most plans have been exhibited not by landscape architects but by nurseries, which offered garden design services as part of their repertoire and employed designers among their staff. Naturally the rock garden designers – Gavin Jones, Whitelegg, Clarence Elliott – were among the number, but so were nurseries like Bakers of Codsall, Waterer's, Notcutts and Hillier's. Even among those who were professional garden designers, many are now completely forgotten: no archives hold their plans, no books survive to show their style and no articles on their work have yet been traced. Raymond Berrow, A.S. Gilliam, Hugh Seaton – if you know anything about their gardens, you should be writing a dissertation.

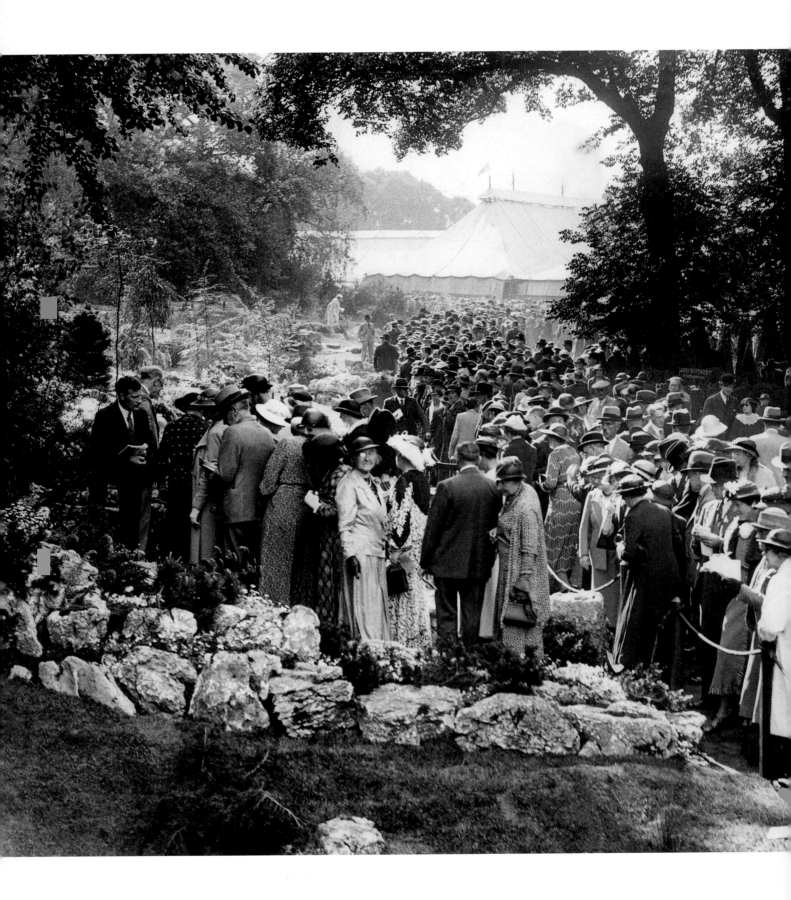

3
BETWEEN
THE WARS
1919–39

Once the First World War had ended, the RHS lost no time in trying to return to normal. The Great Spring Show was scheduled for May 1919. 'In these times of transport and labour difficulties', wrote the *Gardeners' Chronicle*, 'it was only to be expected that the show would not be equal in extent to those of pre-war times', and there were fewer outdoor gardens than there had been before the war. The following year *The Garden* wrote: 'If there were difficulties about exhibitors' passes in and out of the show grounds – we speak sympathetically with those inconvenienced – think not too harshly of the new secretary, who has yet to learn the ropes of office.' A gap of only a couple of years had had a bad effect on the Society's procedural memory. Perhaps this is sufficient to explain why, in 1921, a shows committee was established for the first time. There were other problems than internal efficiency to deal with: the railway companies were introducing restrictions on what they would carry, and some exhibitors feared they could no longer afford the cost of transporting their goods to the show. It was seriously proposed that Chelsea should be cancelled in 1921. Fortunately, the railways were persuaded by the President, Lord Lambourne, to agree terms for transport, and things went ahead smoothly. By 1923 everyone felt that Chelsea had returned to its pre-war standard.

Labour disputes, however, and eventually mass unemployment, continued to make life difficult for the

LEFT The Rock Garden Bank in 1936, showing the crowds examining the rock gardens.

show. In 1926 the General Strike again prompted debate about cancelling the show, but in the end it was merely postponed for one week. In 1930, the Society made a point of hiring as much casual labour as possible, and after the show ended the contents of the fruit and vegetable displays were sent to St Luke's Church, Chelsea, which was running an Occupational Centre for the Unemployed.

In 1925 the Society made the experiment of extending the show for a run of five days, Tuesday to Saturday; but thereafter it returned to three days. Fearing the consequences for their plants of the extended time, some prominent orchid growers had refused to exhibit, and those who attended had smaller displays. From 1932 the schedule ran as follows: on the Tuesday the judging took place, followed by the royal visit. (On one occasion, when judging overran, the judges stood to attention as George V passed by; he admonished them, 'You're judging, and that makes you much more important than I.') Wednesday morning was reserved for Fellows of the RHS; the general public were admitted from noon on Wednesday, for two and a half days.

Another innovation was the private view, first attempted in 1932. Hester Marsden-Smedley recalled: 'Those who possessed a sense of humour were amused at a "private view" attended by 15,000 or 16,000 people, but there were others who did not suffer patiently the long wait in car or cab entailed by the dislocation from Piccadilly to Pimlico.'

The first Chelsea Show had been staged in a single tent. After the war, the provision of tents increased erratically. Orchid growers lobbied for a separate tent for orchids, and then complained of crowding within it; a tent for roses was added in 1928; from 1920 until 1934 a special tent was erected for the display of pictures; scientific exhibits and displays of garden designs had separate, though connected, tents. (It was noted in 1925 how sparsely attended the scientific

tent was.) In 1930, the two double-spanned marquees were turned into a single four-spanned marquee, gaining extra interior space by covering over a road; in 1937, the rose, orchid and other tents were replaced by a second four-span marquee. Through all these changes the Chillianwallah monument lay outside the tents: the experience of having to erect a tent tall enough to enclose it, back before the First World War, was probably still remembered.

Outside the marquee, in Sundries Avenue in 1927 the number of sundries stands suddenly jumped by nearly 50 per cent, and thereafter showed a slow but inexorable increase. Tools, machinery, chemicals, greenhouses and greenhouse equipment, promotional stands for organizations and booths for leading gardening magazines all jostled for space. Like the nurseries, the sundriesmen were there to meet their customers and take orders, and not to sell directly.

Open-air gardens were initially concentrated on the Rock Garden Bank on the southern perimeter of the showground. As the geography of the tents shifted, so formal gardens moved into the Main Avenue, or into the row between the tents. The great rock garden makers – Pulham & Son, Clarence Elliott, Gavin Jones, John Wood, B.H.B. Symons-Jeune, George Whitelegg, Walter Ingwersen – vied with each other annually for scale, novelty and planting.

Once the show had ended, the RHS had the responsibility of returning the grounds to their normal condition for the benefit of their hosts. For Chelsea's first decade, the landscape gardener Edward White, the designer the RHS habitually recommended to enquirers, undertook that responsibility. In 1924 he announced that he would not do it any longer, and the nurseryman Edward Cheal succeeded him until the Second World War. (After the war, Thomas Hay, superintendent of the Central Royal Parks, took it over for a few years, until Wisley assumed the role in 1950.)

BELOW Two Chelsea posters (left, 1927, and right, 1938) by 'Shep' (Charles Shepherd, the head of studio at the Baynard Press).

All this came abruptly to an end with the declaration of war in 1939. This time the Society needed no pressure: Chelsea was formally discontinued for the duration of the war, and the RHS put its efforts into the 'Dig for Victory' campaign, demonstrating to the public how to grow more food at home.

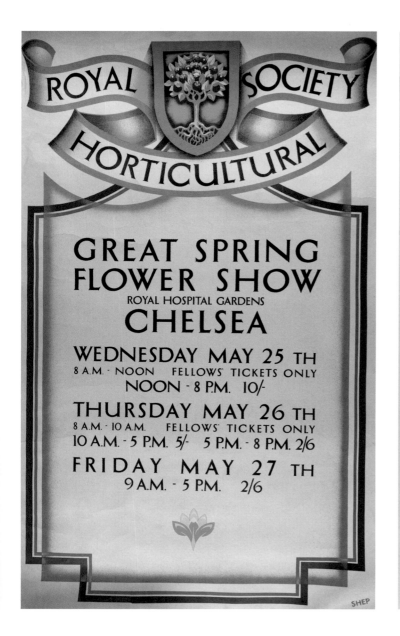

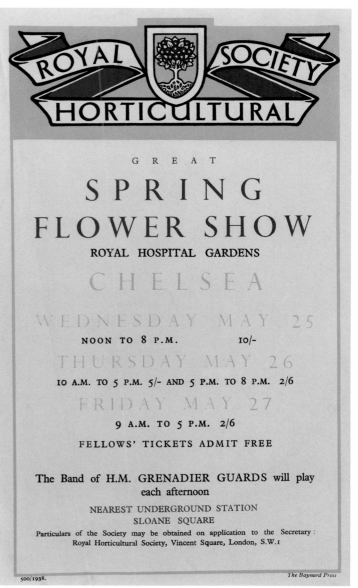

SIGNIFICANT PLANTS

Chelsea 'is the richest spotting ground in the whole world for new, forgotten or neglected plants', wrote Arthur Hellyer in 1984. Forgotten plants whose revival Chelsea assisted included old roses (Bunyard in the interwar years); *Begonia rex* (promoted by Maurice Mason in the 1950s and 1960s); and, most remarkably, auriculas. Once among the most popular English exhibition flowers, the subject of generations of competitions among local societies, these had fallen so far from fashion that in the mid-twentieth century the only nursery still selling named cultivars was James Douglas of Great Bookham. Brenda Hyatt bought his stock, and in 1982 staged an exhibit at Chelsea, with the plants individually framed; this burst of publicity kick-started the auricula revival. Neglected plants include hostas, whose popularity was boosted by a display staged by Wisley in 1968.

As for new introductions, *Saxifraga* 'Tumbling Waters', introduced by Symons-Jeune in 1920, has continued ever since to be the most popular saxifrage cultivar. Many species of Asiatic primulas were launched at Chelsea: *Primula florindae* and *P. sherriffae* were first shown the year they were introduced, in 1926 and 1935 respectively, as was *Meconopsis delavayi* in 1913. Sir Frederick Stern exhibited *Lilium mackliniae* in 1950, four years after he had received it from the plant hunter Frank Kingdon-Ward. *Azara lanceolata*, known to botanists since Darwin, was not introduced into England until James Comber brought it to Nymans in Sussex in 1927; four years later it was shown by Nymans.

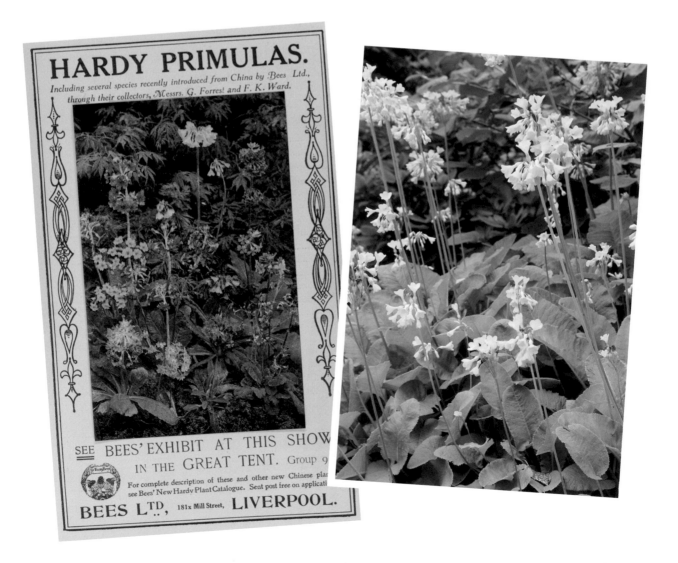

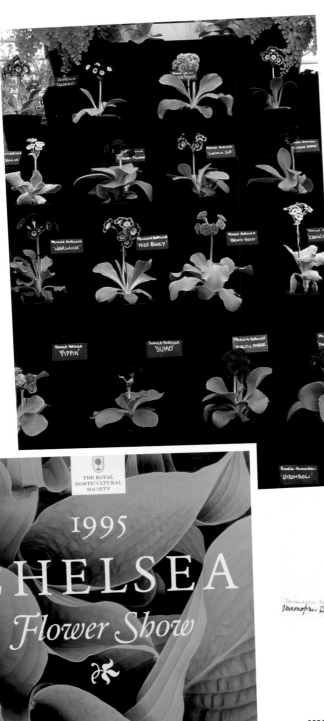

Meconopsis Delavayi Edinburgh May 15-

OPPOSITE An advertisement for hardy primulas from Bees Ltd, reproduced from the 1914 Chelsea Show catalogue, with a portrait of *Primula florindae*, which received a First Class Certificate when shown in 1926 by Oliver & Hunter, to whom Frank Kingdon-Ward had sent it.

THIS PAGE Clockwise from top left: a display of auriculas by Pops Plants, 2005, continuing the fashion started by Brenda Hyatt; *Meconopsis delavayi*, which received a First Class Certificate when first shown in 1913, by Isaac Bayley Balfour of the Royal Botanic Garden Edinburgh – painted by Lilian Snelling, who at that time worked in Edinburgh; a poster for the 1995 Chelsea Flower Show, featuring a photograph of hostas by Clive Nichols.

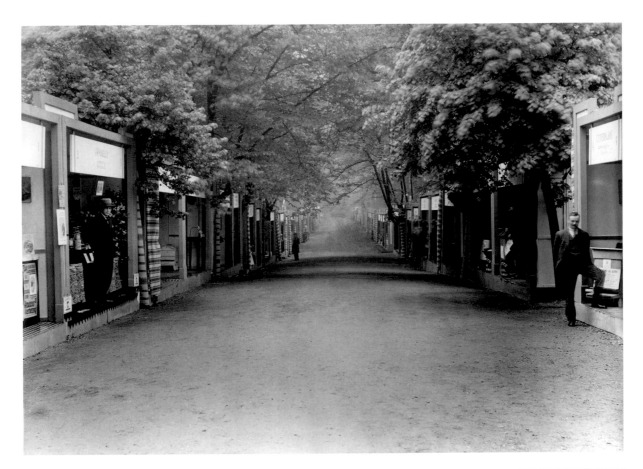

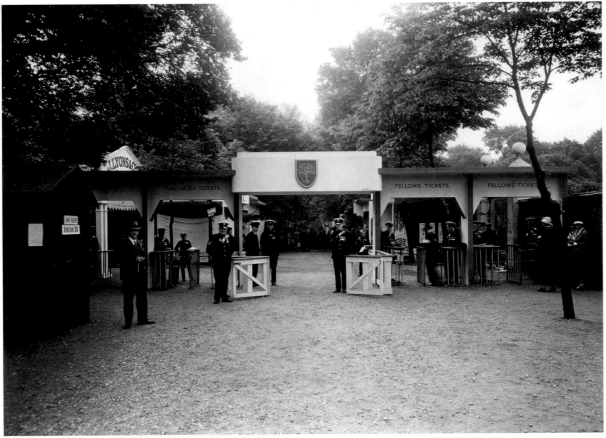

LEFT, ABOVE Sundries Avenue in 1932, preparing for the arrival of the crowds.
LEFT, BELOW The entrance turnstiles in 1934, with separate gates for Fellows' tickets and purchased tickets. At the rear on the left is a stall for J. Lyons & Co., who provided the Chelsea catering for decades.
RIGHT Show tickets, 1939.
BELOW Cartoon by W.K. Haselden for the *Daily Mirror*, 20 May 1936: 'Dreams at Chelsea Show'. (*Plus ça change.*)

STRICTLY NON-TRANSFERABLE I.G.

ROYAL HORTICULTURAL SOCIETY

ADMIT

TO THE

GREAT SPRING FLOWER SHOW

IN

THE ROYAL HOSPITAL GARDENS, CHELSEA
ON TUESDAY AFTERNOON, MAY 16th, 1939
Between the hours 2 to 8 p.m.

Admission will **only** be obtainable on the presentation of this card together with your Fellow's Transferable Pass (green).

TO BE GIVEN UP AT THE GATE. **Please Turn Over**

Admission permits similar to this have been posted to all Fellows and Associates.

For other times of admission see Fellow's Passes.

An A.A. leaflet dealing with road approaches, parking facilities and traffic arrangements will be found in the May Journal.

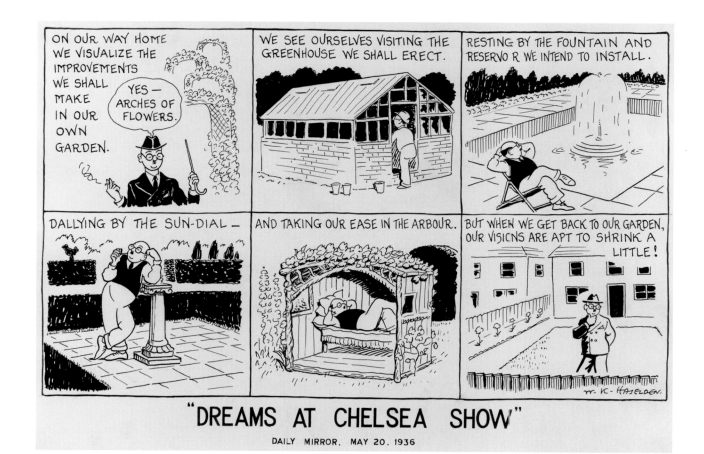

"DREAMS AT CHELSEA SHOW"

DAILY MIRROR, MAY 20, 1936

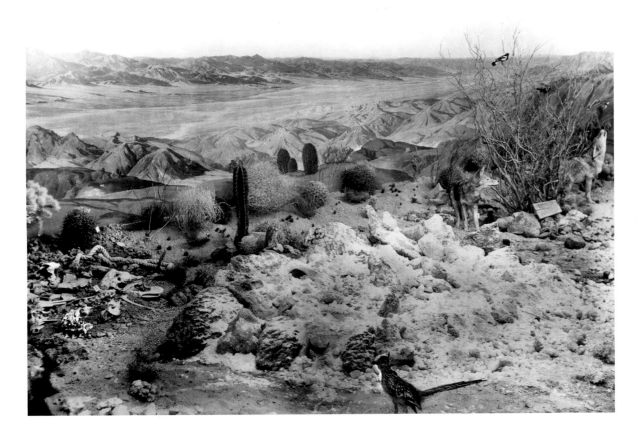

EXHIBITS IN DIFFERENT STYLES

In 1929, Mrs Sherman Hoyt, the doyenne of the Garden Club of America's California Conservation Committee, staged a display of Californian desert plants in the marquee at Chelsea. Nothing like it had ever been seen there. Her cacti and succulents were displayed in three groups, with painted backdrops representing different types of Californian scenery – Death Valley, a desert garden and a redwood grove. The Death Valley scene had a 'ground work of colemanite (crude borax), with a salt crater, lime stalactites, and other rock characteristics. Cacti were scattered about sparingly, and occupying a central position was a large Larrea glutinosa [purple sage], around which prowled two coyotes [with] the skeleton of a burro.' Mrs Hoyt was awarded the Lawrence Medal for best exhibit of the year, and made an Honorary Fellow. After the show, the entire display was acquired by the Royal Botanic Gardens, Kew, where a new glasshouse was erected to accommodate them, painted backdrops and all: the Sherman Hoyt House, which instructed visitors for fifty years before being demolished and the

exhibits incorporated into the new Princess of Wales Conservatory.

Mrs Hoyt's desert tableau is probably the most famous single exhibit that the marquee has ever housed. Something of an attempt to rival it was staged nearly a decade later, with the Empire Exhibit of 1937, arranged by John Coutts, the curator of Kew, to celebrate the coronation of George VI. This contained displays of plants, ornamental as well as economic, from Australia, New Zealand, Canada, Newfoundland (not yet a province of Canada), the West Indies, Palestine, South Africa, West and East Africa, India, Burma, Fiji, the Seychelles, the Falkland Islands, and miscellaneous mandated territories. No painted backdrops, but the South African exhibit tried to give the effect of an arid landscape for a display of succulents.

Most nurseries do not aim at such pictorial effects: a specialist dealing in lilies or gladioli seldom aspires to simulate a landscape, but aims at a geometrical arrangement or a means of highlighting individual specimens. Smaller plants lend themselves better to the

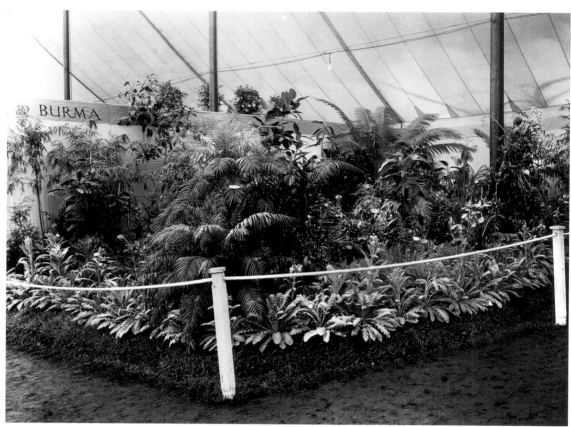

creation of a scene; rock gardens first appeared on tables at the Temple show before moving outdoors, and 'table rock gardens' continued to be a recognized category in press reviews of the show even after the Second World War. Stands arranged around the perimeter of the marquee have always tended to use tiered arrangements of shelves, sloping back to the canvas to take advantage of the height offered. Stands in the interior of the marquee, if the size of the plants rules out table display alone, have tended either to use backdrops against which their stock can be seen (like Mrs Hoyt's, if less elaborate) or to create corridors within the stand so that visitors can get closer to the plants. This model was pioneered by the great seed houses, in particular by Sutton's, who at the Royal International Horticultural Exhibition of 1912 took advantage of the enlarged space offered them to mass their flowers into 'mountain-high mounds of annuals'. In this they were followed by the other big seed houses (Carter's, Daniels, Webb's). Tree and shrub nurseries like Hillier's, who first exhibited in 1922, developed the corridor principle further.

Outside in the open air, some exhibits which did not count as gardens still had distinctive styles of layout. During the Edwardian period, the rival firms of Cheal and Cutbush had developed a retail trade in ready-made topiary specimens; Cutbush in particular became known for open-air stands in which topiary figures were displayed in crowded assemblages. Progressively during the interwar years the gardening press turned against topiary – William Robinson spent his last decades campaigning against it – and promoting the wild and woodland garden instead; in the postwar years exhibitor John Klinkert of the Kew Topiary Nursery was the last surviving topiary retailer, and his nursery closed in the early 1960s. By that time topiary was already being nurtured again by historical revivalists, but out of sight of the gardening press.

ABOVE Left: Mrs Sherman Hoyt's exhibit, 1929. Centre and right: South Africa and Burma, both from the 1937 Empire Exhibit.

The rejection of topiary was the most successful part of a campaign spearheaded by *The Garden,* the magazine Robinson had founded, against formal gardens more generally. In 1914, *The Garden* had responded to the second Chelsea Show by saying, 'We hope the day will never arrive when this great show will more closely resemble a stone-mason's yard than a series of natural gardens . . . We cannot conceive anything less gratifying to the mind or eye than well-designed rock gardens cheek by jowl with glaring white and gold pillars and teak-wood seats.' This campaign was not destined to be successful, and *The Garden* itself had to acknowledge from time to time the merits of formal gardens, both individually and as a collection. But then the term 'formal garden' was really just the shows committee's category for everything that was not a rock garden. Rock gardens had been the first type of show garden to appear, and anything else was called a formal garden because it had to be laid out in a narrow and confined site. The press occasionally queried the usefulness of characterizing a Japanese garden or an irregularly planted collection of trees and shrubs as a 'formal garden', but it was not until the 1950s that the term finally declined. Among the 'formal gardens' at Chelsea were various styles whose formality is not evident to the eye: tree and shrub gardens, and Japanese-style gardens. In 1914 Notcutts' azalea garden, 'free from stone', and Pulham's balustraded terracotta courtyard both counted as formal gardens.

Gardens in an Arts and Crafts manner continued to be shown at Chelsea throughout the interwar period, with crazy paving, ornaments based loosely on sixteenth- to eighteenth-century historical styles and pergolas or other structures in traditional materials. Increasingly as the 1930s progressed, the crazy paving was succeeded by purely rectilinear patterns, more classically styled

BELOW Cutbush's advertisement leaflet from one of the early Chelsea Shows.
RIGHT One of Cutbush's two exhibits at the first Chelsea Show, 1913.
FAR RIGHT Carters' display of annual flowers at Chelsea, 1925.

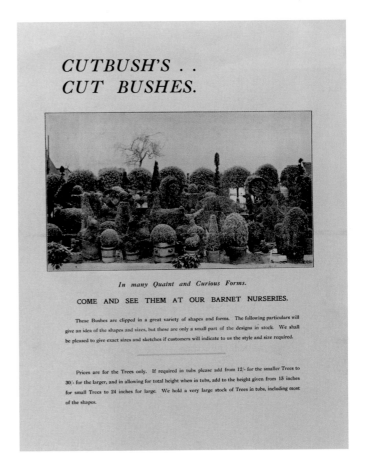

CUTBUSH'S . .
CUT BUSHES.

In many Quaint and Curious Forms.

COME AND SEE THEM AT OUR BARNET NURSERIES.

These Bushes are clipped in a great variety of shapes and forms. The following particulars will give an idea of the shapes and sizes, but these are only a small part of the designs in stock. We shall be pleased to give exact sizes and sketches if customers will indicate to us the style and size required.

Prices are for the Trees only. If required in tubs please add from 12/- for the smaller Trees to 30/- for the larger, and in allowing for total height when in tubs, add to the height given from 15 inches for small Trees to 24 inches for large. We hold a very large stock of Trees in tubs, including most of the shapes.

By Special Appointment.

WM. CUTBUSH & SON,

View of our Exhibit at Chelsea Show, 1913. Photographed by
Colin Campbell, and reproduced by the courtesy of
The Illustrated London News.

ALPINE, BOG, AND HERBACEOUS PLANTS.
DESCRIPTIVE CATALOGUES UPON APPLICATION.

HIGHGATE NURSERIES, LONDON, N.
And BARNET, HERTS.
THE LARGEST NURSERIES NEAR LONDON.

SEEDSMEN BY APPOINTMENT.

CARTERS FLORAL EXHIBIT, CHELSEA, MAY, 1925.
2 Gold Medals Awarded to Carters Exhibits.

CARTERS EXHIBIT
OF FLOWERS IN THE LARGE TENT.
A special list of Seeds for sowing now and through the Summer can
be obtained at the Exhibit, or post free from Raynes Park, S.W.

VISITORS should not
fail to inspect our
Garden in the Grounds
and our Exhibit in the
Sundries Avenue.

Carters
TESTED SEEDS

Seedsmen to H.M. THE KING,
RAYNES PARK, LONDON, S.W. 20

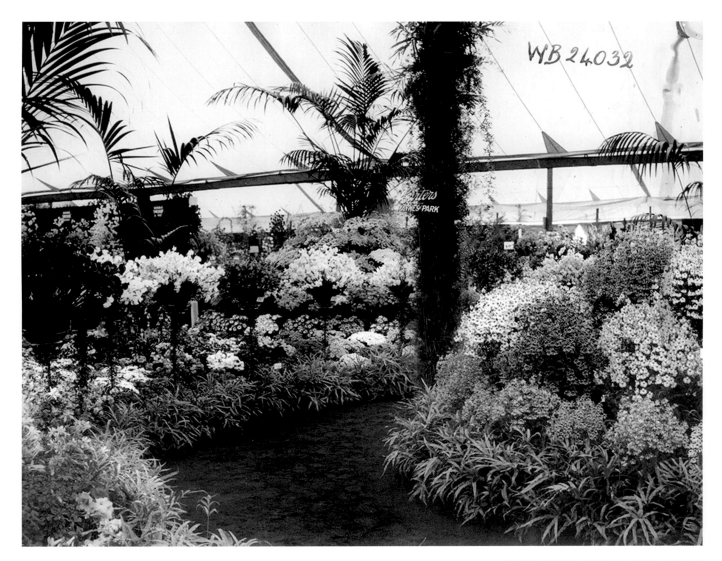

WB 24032

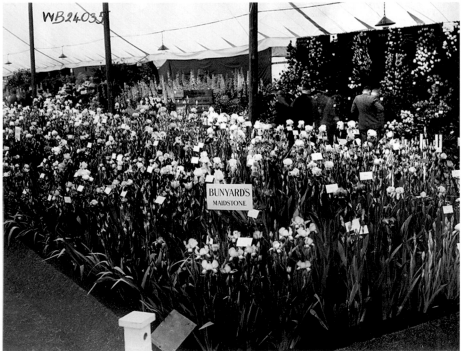

WB 24035

BUNYARD'S
MAIDSTONE

ABOVE AND RIGHT, ABOVE Stands of two rival seedsmen: James Carter & Co. of Raynes Park (left) and Sutton's of Reading (right), both in 1930. Carter's were most famous for their lawn seed, Sutton's for their vegetables; but both covered a wide range of subjects, and featured a style of creating huge mounded masses of perennials and annuals.

LEFT Bunyard's of Maidstone, a firm most famous for fruit (including the introduction of the 'Golden Delicious' apple), but here in 1930 with a stand of irises.

RIGHT, BELOW A scene in the marquee in 1934, possibly looking past Maurice Prichard's stand towards that of Kelway's.

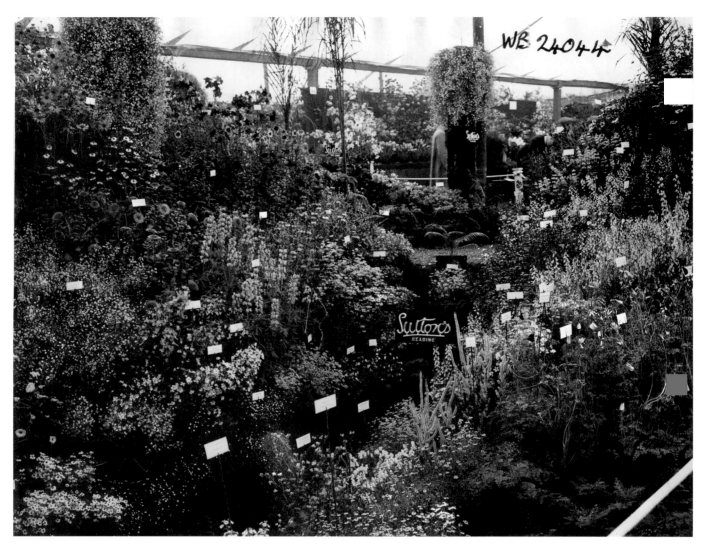

WB 24044

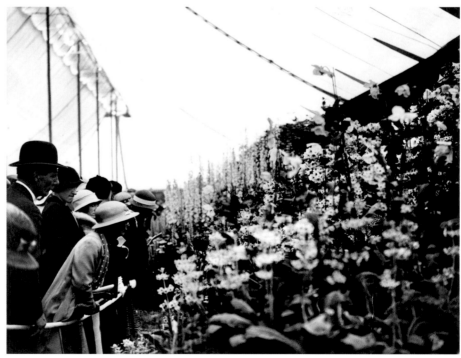

buildings and balustrading appeared, and the rustic element was reduced – formal gardens by a more rigorous definition. In 1931 Edward White complained that 'The work of the judges would be much easier, and a desirable form of garden art would be encouraged, if in competitive entries *architecture* was invited to take a back seat,' while Giffard Woolley grumbled that 'Some of the exhibits in this section appear to have "strayed" from the Sundries Avenue.' In other years the press observed with gratitude that the quantity of stone and paving had been reduced, with a greater emphasis on lawns.

One nursery developed a significant and solitary theme during the interwar years: James MacDonald of Harpenden specialized in ornamental grasses and displayed them at every Chelsea from 1913 to 1939, initially in a marquee stand, but from 1920 onwards frequently in a show garden. In 1921 the *Gardeners' Chronicle* noted that 'It would scarcely be expected that Grasses alone would make an effective garden, but Messrs. MACDONALD AND SON were able, by using their specially-prepared lawn fabric

and a variety of ornamental varieties, to make a novel and attractive garden.' A press photograph shows a lawn with clumps of grasses at the corners and in geometrically positioned beds within; the journalist observed that MacDonald's garden, despite the absence of stonework, deserved more than most of the other gardens to be called formal. After the departure of MacDonald, it would not be until the 1970s that ornamental grasses became widely popular, as part of the foliage revival.

During the interwar years the open-air rock gardens were probably the most popular feature of the show, and photographs (such as that on pages 36–7) show huge crowds observing them. Graham Stuart Thomas was later to refer nostalgically to these gardens as 'great works of art', and over the decades the rock gardens were the subject of intense debate and stylistic change. The show's move to Chelsea, after the cramped circumstances of the Temple, allowed larger sites and a sudden freedom for adventure on the part of designers; by 1914, wrote the *Chronicle*, 'Now that the Chelsea site has provided so

LEFT A grass garden by James MacDonald, from 1923.

much scope for artistic effect, the rock gardens resemble "corners of the Alps".' The only garden to receive a Gold Medal before the First World War was a 1913 rock garden by John Wood of Boston Spa, a variation of a theme he had established at the Royal International Horticultural Exhibition the year before: the accurate stratification of Yorkshire limestone. Clarence Elliott later reminisced, accurately or otherwise, that 'I twitted him . . . saying that, so like a piece of Yorkshire moorland was his exhibit, all one expected to see on it was a goat. Next year he proved my contention by having two goats browsing on his Chelsea Rock Garden; hence, no doubt, the R.H.S. rule that animals are not allowed on exhibits.'

Wood's example was followed so enthusiastically that he later complained of too much uniformity of stone, and praised Maurice Prichard for using Purbeck stone in a composition that relied on bamboo and water plants rather than alpines; he himself made his 1939 rock garden out of Welsh slate ('a reproduction of vertical cliff face . . . Water flowed down by a well-worn gulley into a pool surrounded by rugged vertical rocks'). In 1928 the shows committee issued a plea to exhibitors to pay more attention to other types of stone: 'Apart from the generally accepted principle that the ideal course is to use a local stone, the heavy cost of carriage makes it impossible for all except the wealthy to use mountain limestone in gardens remote from a limestone formation.' There ensued a volley of correspondence for and against limestone, and for and against the interference of the committee. But one important exhibitor responded in a novel manner: Gavin Jones's 1929 rock garden employed Snowdonia granite, imported in huge blocks that he later featured on the cover of one of his catalogues (see page 68). One critic complained that no one could want such enormous rocks in a domestic garden, while John Wood

carped that Jones's planting was 'rather too pretty. I think other plants should have been used on the lower strata to preserve the note of spiritual and artistic unity.'

Spiritual and artistic unity: these are not the terms in which critics generally discuss Chelsea gardens today, but they should be borne in mind when assessing the landscapes of this earlier generation. Not only were the type of rock, its geologically accurate stratification, and the alpines and other plants used to adorn it features to be considered. Attention was also paid to the realism of the way in which the rockworks emerged from the turf, to accompanying streams or water features. In 1924 a rock garden by T.R. Hayes of Keswick was described as an 'ambitious scheme with waterfall, stream, moraine, and every other refinement', the vocabulary suggesting that the garden had overreached itself in incorporating too much.

Rivalry and contention among rock garden designers was so fierce that a humorous article in 1929 offered this vision of the future: 'One feature of the old Chelsea, the rock gardens, are no longer to be seen as after the fatal affray in 1946, when three Gold Medal artist designers were drowned in their own pools and the subsequent disappearance from the country of the Bronze Medal winners, this competition was cancelled for lack of entries.' Unimaginable as it would have seemed then, rock gardens would indeed disappear from Chelsea – at about the time that Chelsea began to sprout new designs that few in the interwar years would have recognized as gardens.

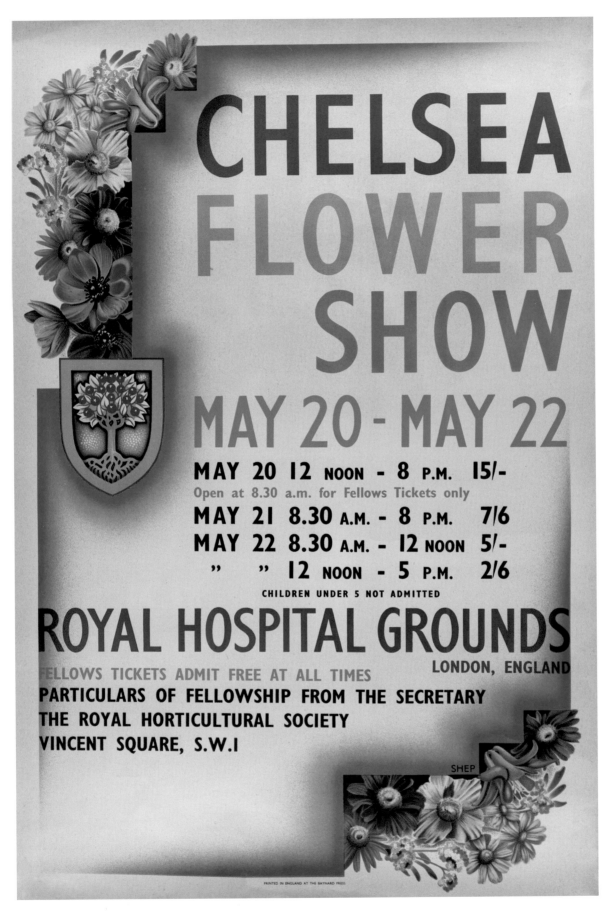

LEFT AND RIGHT Two interwar Chelsea posters, 1931 (left) and 1936 (right): both printed by the Baynard Press, and probably designed by 'Shep' (Charles Shepherd), the firm's head of studio, whose signature appears on the posters.

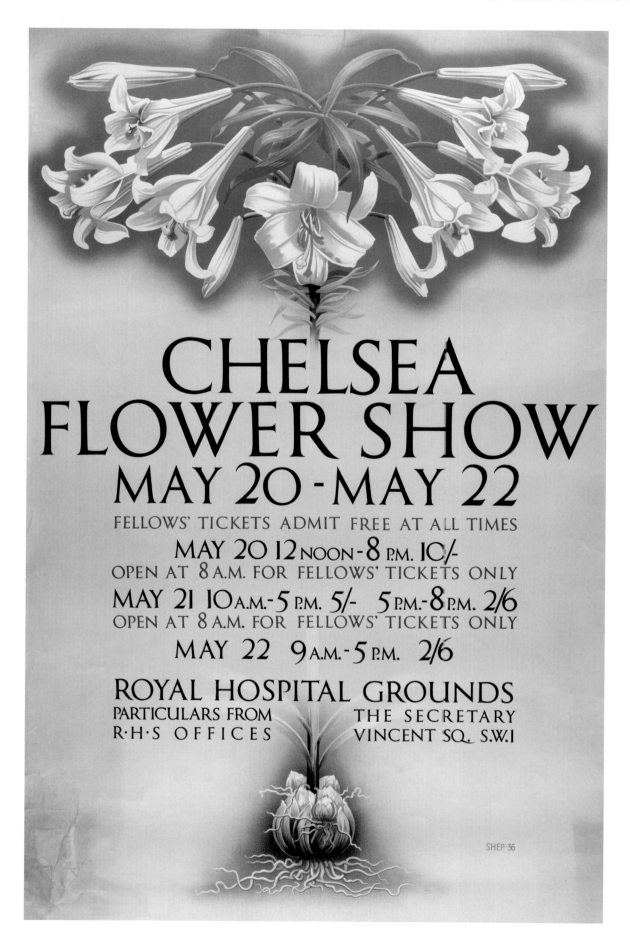

CHELSEA
FLOWER SHOW
MAY 20 - MAY 22

FELLOWS' TICKETS ADMIT FREE AT ALL TIMES
MAY 20 12 NOON - 8 P.M. 10/-
OPEN AT 8 A.M. FOR FELLOWS' TICKETS ONLY
MAY 21 10 A.M. - 5 P.M. 5/- 5 P.M. - 8 P.M. 2/6
OPEN AT 8 A.M. FOR FELLOWS' TICKETS ONLY
MAY 22 9 A.M. - 5 P.M. 2/6

ROYAL HOSPITAL GROUNDS
PARTICULARS FROM THE SECRETARY
R·H·S OFFICES VINCENT SQ. S.W.1

SHEP-36

MY CHELSEA

It was thirty-five years ago that I received a request to help man the entry gates at Chelsea, although in those early days you were never quite sure what you would be asked to do. It could be anything from acting as escort to the royal party's walkabout to attaching the one-way signs to the posts in the old marquee, spending the night in the marquee as a security guard or acting as secretary to one of the judging panel.

My current role includes marking out the grounds in preparation for the build, the logistics for the breakdown, and coordination of the bus services from Battersea car park to the show grounds. Also overseeing the mobility bus service provided by the RHS and once reuniting Rose (ninety years old) from Niagara, USA, with her carer, after she decided to wander off and disappear for one and a half hours, thus missing her coach.

There are many unsung heroes – far too many to mention – with whom I have had the pleasure of working and whose only aim is to make Chelsea a wonderfully pleasurable experience for everyone who visits.

I have worked closely with four show managers, each of whom I have great admiration for. Their skills and input have been responsible for the smooth evolution from the Chelsea of thirty-five years ago to the Chelsea of today.

Many people ask which was the best Chelsea. I can honestly say there have been so many good shows, and with such improvements, that I genuinely believe the best is yet to come.

David Hawes, RHS show facilities assistant

SYLVIA CROWE

Sylvia Crowe (1901–97) was one of the greatest landscape architects of the twentieth century. She studied at Swanley College after the First World War, and then under Edward White, who represented professional landscaping on the RHS Council. From 1928 to 1939 she worked as a garden designer for the nursery of William Cutbush and Son in Highgate, originally a bulb firm but in the Edwardian period one of the major retailers of topiary, gradually adding garden design to its services. The firm's clientele consisted mainly of small suburban gardens; most of its records were destroyed during the Second World War, so there is now no way of identifying most of the sites Sylvia Crowe was involved with. During the years she worked for them, Cutbush exhibited model gardens at Chelsea nearly every year, and some at least of them were her creations; as was standard with gardens laid out by nurseries, her name never appeared as the designer in the Chelsea catalogues. But she is known to have been responsible for the Gold-Medal-winning garden in 1937, which incorporated a bluebell wood and a stream flowing into a pond. And the 1931 Cutbush garden – 'made to appear more extensive than it actually was by '"dishing" the centre to make slopes and mound running to a lightly planted backdrop of birches' – sounds much like her work.

On one occasion she included a concrete summerhouse in the Cutbush garden, earning the enthusiasm of her coeval Geoffrey Jellicoe, who assisted her in her career. After serving as an ambulance driver in the Second World War, she went into private practice as a landscape architect, and went on to supervise the landscaping of roads, reservoirs and new towns, as well as spending two years (1957–9) as President of the Institute of Landscape Architects; but unlike some of her contemporaries, she continued to design private and corporate gardens throughout her career.

BELOW The garden designer Seyemon Kusumoto preparing a garden building for his 1936 garden.

SEYEMON KUSUMOTO

Seyemon Kusumoto, *c.*1895–1968, whose name was invariably misrendered as 'Seyomon' in Chelsea publicity, was a Japanese garden designer. He exhibited plans for gardens at Chelsea from 1930 to 1939, resuming in 1949. In 1936 and 1937 he designed Japanese-style show gardens for Chelsea. He stopped exhibiting in 1952, but continued his garden design practice from offices in Edgware into the late 1950s at least. His most famous garden in England is Cottered Hall in Hertfordshire; he also designed the grounds of Du Cane Court, an art deco housing estate in Balham. It is estimated that he was involved with about 200 gardens in this country.

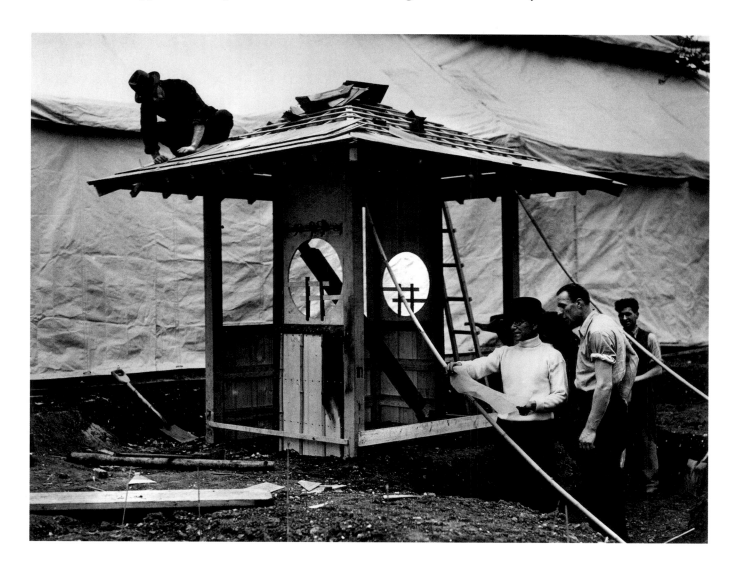

GREENHOUSES AND CONSERVATORIES

The making of greenhouses for protected cultivation was revolutionized in the nineteenth century by the introduction of wrought iron as a material, and by improvements in the quality of glass. By the end of the century, the great debate over curvilinear versus ridge-and-furrow roofs had been reduced to a matter of aesthetic preference; heating had gone from braziers and tan pits, through steam and hot-water heating, to gas, with electricity on the horizon; automatic watering systems were being experimented with. Great manufacturing companies like Messenger of Loughborough, Duncan Tucker of Tottenham and Richardson of Darlington (later Amdega) exhibited regularly at Chelsea.

But while there was never a reduction in the need for utility greenhouses, the market for ornamental glasshouses and conservatories collapsed after the First World War, a casualty of changing fashions in planting and architecture, and the cult of the open air. Manufacturers had to diversify — Messenger into glazed roofs for garages, Boulton & Paul into windows; many went under. But a revival of interest in Victorian building and planting brought about a new enthusiasm for conservatories, beginning in the 1970s.

The revival peaked at the end of the century, and since then the number of companies competing in Northern Road at the Chelsea Show has declined once more.

Erected in 30 minutes

THE B. & P. ONE-MAN GREENHOUSE

This substantially made small house is supplied in complete sections which are easily handled and quickly put together.

Best red deal is used, the principal rails and styles being mortised and tenoned for strength. Glazing is simple—all glass is accurately cut to size.

Size : 7 ft. long × 5 ft. wide ; 4 ft. high at sides, 7 ft. to ridge.

PRICE : **£4 19 6** *Carriage paid to nearest Railway Station in England or Wales.*

Paint for two coats, and putty and sprigs, 10/- extra.
If sent painted one coat and paint for further coat supplied, with putty and sprigs, 20/- extra. Stages for both sides, 15/- extra.

The One-Man House and other designs, large and small, are fully described in Catalogue 430. Please write for a copy. Garden Frames : Catalogue 432.

● See this house and others in Monument Road

BOULTON & PAUL, LTD., NORWICH
London Showrooms : 13⁹, Queen Victoria Street, E.C.4

NO WOOD NO PAINT NO PUTTY

DO NOT MISS

THE
CONCRETE GREENHOUSE
IN MONUMENT ROAD

C. RAWSON & CO.
FRIETH RD. MARLOW BUCKS

OPPOSITE AND THIS PAGE Advertisements from Chelsea catalogues show the range of glasshouses available between the wars: Duncan Tucker the most traditional, Boulton & Paul claiming rapid assembly, innovative materials and techniques from the Concrete Greenhouse Co. and Skinner, Board. Top right: an exhibition of glasshouses at Chelsea in 1937. Right: visitors inspecting one of the greenhouse ranges available in 1976. Below: the Alitex stand in 2011.

C. WHITE
Horticultural Builder
SEDILIA WORKS
BROMLEY COMMON
KENT
'Phone: HURSTWAY 1168

ALL-WEATHER GARDEN HOUSES, SUMMER-HOUSES, TENNIS PAVILIONS, REVOLVING HOUSES
CATALOGUES ON APPLICATION

"BECKENHAM" ALL-WEATHER REVOLVING HOUSE

VISIT MY STAND IN MONUMENT ROAD

PIGEON COTES, BIRD AVIARIES, GARDEN AND POTTING SHEDS, BARROWS, etc.

GREENHOUSES, CONSERVA-TORIES, GARDEN FRAMES, Etc.

TEAK GREENHOUSES A SPECIALITY

RIGHT Two gardeners carrying tubs of
rhododendrons, 1931.

COUNTRY HOUSE EXHIBITORS

It was not only Chelsea but the entire gardening world that tried to return to normality after the First World War. Calls for the unionization of gardening staff were being heard in the worlds of nurseries and public parks, but private estates were largely immune. The country house garden may have lost staff during the war, but it did not lose its operating structure: an estate steward, under whom was a head gardener, under whom were separate departments for kitchen garden, orchard, glasshouses and pleasure grounds. Flower gardens may have disappeared during the war, but most houses were quick to re-establish them, and the kitchen garden – the most important, most highly staffed department – remained little affected. More and more new staff members went to horticultural colleges rather than training through apprenticeship as of old, but a gardener's CV was not complete without work experience at a country house. Head gardeners were still recognized professionals and frequently men of consequence in their local communities – as was Edwin Beckett of Aldenham House (see page 28), who served terms as chairman of the local parish council.

If a private garden exhibited at Chelsea, it was the proprietor's name that featured in the catalogue, and with many smaller country houses it was indeed the proprietor whose horticultural enthusiasm determined the content of an exhibit. But with the great estates it was still largely the head gardener who reaped the fame. Besides Beckett, there were F.C. Puddle of Bodnant, G.F. Johnson of Waddesdon and Francis Hanger of Exbury (later curator at Wisley), not to mention those estates where the orchid grower came virtually to outrank the head gardener – examples being James Shill at Dell Park, Baron Schröder's garden, and H.G. Alexander at Westonbirt (who after his employer's death founded his own company, Westonbirt Orchids, and exhibited as a nurseryman).

Nurserymen heavily outnumbered amateur exhibitors at Chelsea, but the idea that exhibits from country houses might one day disappear was not yet thinkable in the interwar years.

ROYALTY BETWEEN THE WARS

The King and Queen did not attend the first Chelsea after the war ended; once again it was Queen Alexandra who came to the opening, along with her daughter Princess Victoria, and her sister Marie, otherwise known as Maria Feodorovna, former Tsarina of Russia, who had fled from the Bolsheviks and thus escaped the fate of her children and grandchildren. This was the only Chelsea between the wars that Queen Mary missed.

Prince Arthur, Duke of Connaught (1850–1942), became a royal patron in 1924; the Princess Royal, who had formally opened the RHS New Hall while she was still Viscountess Lascelles, became a royal patron in 1929. The Prince of Wales was also a frequent visitor to the show; one RHS staff member recalled in later years: 'On the afternoon of the last day of a Chelsea Show the then Prince of Wales turned up

with Mrs Simpson. The press was at the time banned from any reference to her. We had not a top hat nor a frock coat in the place [presumably to disguise them] so we surrounded them ourselves and gradually steered them to an exit gate. Later that evening H.R.H.'s Equerry phoned to "apologise for H.R.H. having been not quite himself". As they were both half-seas over we thought H.R.H. was being quite himself.'

In 1936, the Prince of Wales became Edward VIII, and abdicated soon after; his brother became George VI. The following year's Chelsea had a special Empire Exhibit to celebrate his coronation. Queen Elizabeth's younger brother, Sir David Bowes-Lyon, was an RHS official, and would serve as the Society's President during the 1950s; so the annual presence of the monarch at Chelsea became virtually a fixed ritual.

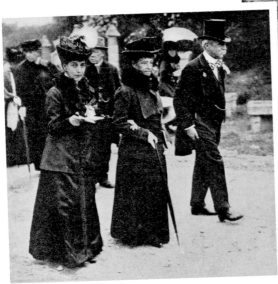

OPPOSITE Queen Mary, 1937.
THIS PAGE Clockwise from top left: the Duke of Connaught, 1926, with Admiral Sir Alexander Ramsay and his wife, and the RHS President Lord Lambourne; the Princess Royal with Lord Lambourne, 1927; George VI and Queen Elizabeth, 1937; the Duchess of Gloucester, 1939, with RHS assistant secretary Arthur Simmonds; George V with officials, 1930; Queen Alexandra and Maria Feodorovna, former Tsarina of Russia, with Lord Lambourne, 1919.

DIVERSE WATER FEATURES

The nineteenth century saw a revival of ornamental fountains in English gardens, and show gardens at Chelsea have kept the divergent traditions going. On the one hand, the interest in Renaissance revival has resulted in fountains incorporating sculptural figures. On the other hand, the tradition inaugurated by Sir Joseph Paxton, of fountains that relied solely on patterns of water jets without sculpture, has been well represented at Chelsea. The most recent innovation in this mode, which would have pleased Paxton greatly, is the 'jumping jet', in which the jet of water is cut off at the nozzle, giving an effect likened to a glass rod being fired through the air. These were first used at Chelsea by Piet Oudolf and Arne Maynard in their Evolution garden in 2000, and went on to have a great vogue in the next decade.

Even the Renaissance fashion for water jokes has appeared at Chelsea, in the form of the water trees exhibited by Quist Ltd since 2005.

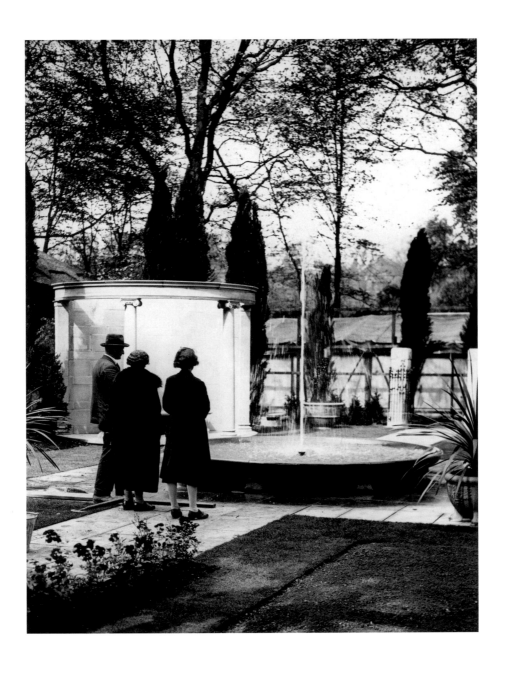

OPPOSITE A fountain in a formal garden in 1930.
THIS PAGE Clockwise from top left: the Fleming's Nurseries and Trailfinders Australian Garden by Jamie Durie, 2008; the Cancer Research UK garden by Robert Myers, 2009; a jumping jet in Piet Oudolf and Arne Maynard's Evolution garden, 2000; and the Off-Shore Garden, one of Sarah Eberle's three 'Credit Crunch' gardens of 2009.

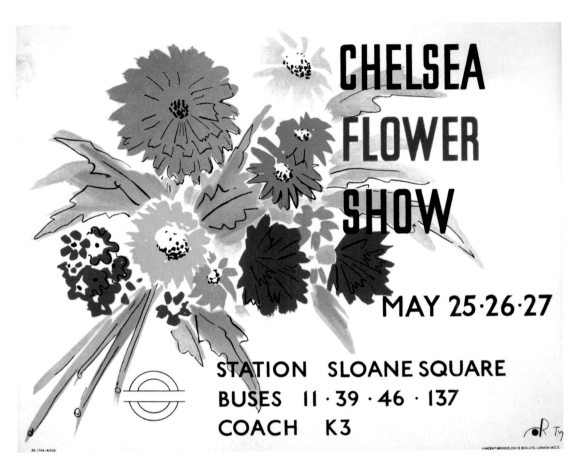

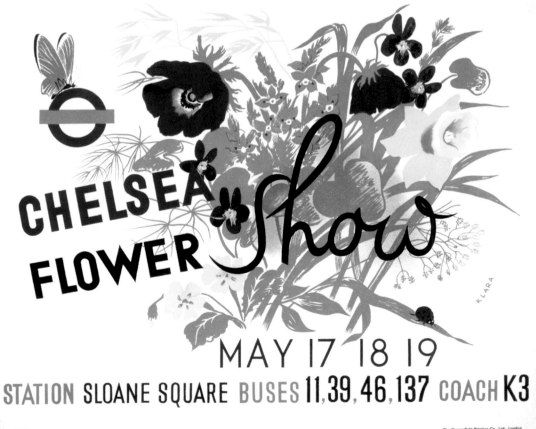

LEFT Two posters advertising bus routes for the Chelsea Flower Show, published by London Transport. Above: 1938, by 'T.V.Y.' Below: 1939, by 'Klara'.
RIGHT The National Farmers' Union stand in 1958, showing home-grown produce arranged in the manner established by the seedsman E.R. Janes.

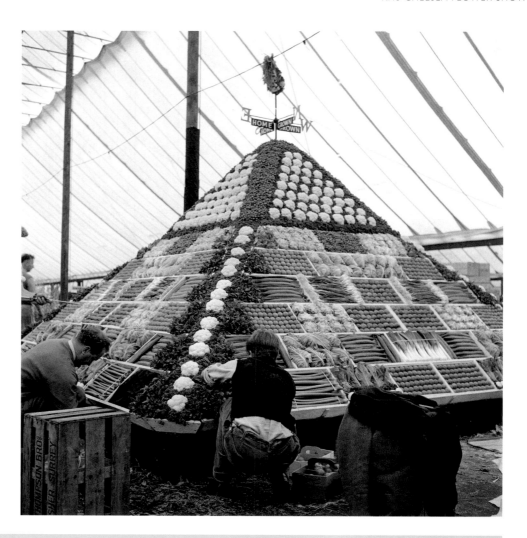

NAME E.R. Janes
PROFESSION Seedsman
EXHIBITED 1919–49

EDWIN RIDGEWAY JANES (1885–1958) was a famous seedsman and exhibitor. After an early period as a lecturer in horticulture at Reading University, he became manager of the seed trial grounds at Sutton and Sons, the great seed establishment near Reading. For the next thirty years he created all of Sutton's exhibits at Chelsea and other shows, overseas as well as in Britain. He did not originate the style of great mounds of flowers that Sutton's had innovated at the Royal International Horticultural Exhibition in 1912, but this became a style particularly identified with him. In 1948 he helped to arrange the National Farmers' Union stand, with its huge display of vegetables arranged in a pyramidal structure, which established the style that their displays followed thereafter. Janes was particularly interested in breeding sweet peas, and twice served as chairman of the National Sweet Pea Society. When he retired he was awarded the Victoria Medal of Honour by the RHS. In his retirement he wrote two manuals for Penguin Books on *Growing Vegetables for Shows* and *Flower Growing for Shows*, the latter appearing posthumously.

OUT AND ABOUT AROUND CHELSEA

At first, the major impact of the Chelsea Show on the streets of Chelsea consisted of traffic problems; the RHS issued maps to show where visitors could park locally (this would not be tolerated today).

In the late 1920s, two prominent Chelsea residents, the Countess of Lovelace and Jacqueline Hope-Nicholson, started holding tea parties for celebrities and titled guests on the occasion of the show. When the show caterers were asked if this damaged their trade, they replied that visitors to the show often needed 'a good tea inside the grounds to fortify them for the journey to, say, Cadogan Square'. The custom of tea parties continued into the 1970s.

In the twenty-first century, local businesses began to decorate their premises florally in May, and stage events (botanical art exhibitions and other sales) to tie in with the show. The Sloane Association launched Sloane in Bloom in 2006 (renamed Chelsea in Bloom in 2011) as a contest for retailers to adopt horticultural themes.

In 2011 the gardening journalist Tim Richardson conceived the idea of the Chelsea Fringe Festival: 'horticultural "happenings" or installations which spring up in unlikely parts of the city' to coincide with the show. In 2012 the first Fringe duly took place, with events ranging from garden openings to performances to outbursts of guerrilla gardening.

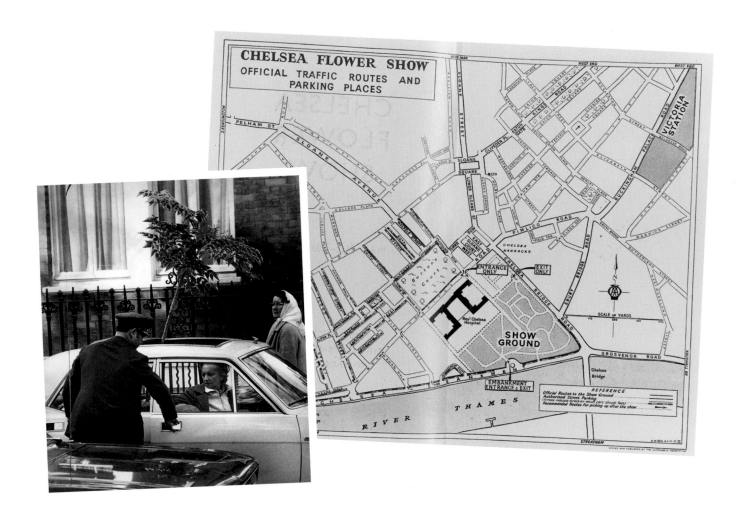

OPPOSITE Left: how to transport a tree in a car, 1974. Right: a map of traffic routes and parking places around Chelsea, 1920s. THIS PAGE Local shops competing with their displays for Sloane/Chelsea in Bloom. Clockwise from top left: Hackett, 2012; the couturier Paula Ka, 2010; the shoe shop French Sole, 2010; Jo Malone's shop in 2011; the gigantic flower erected by the jeweller Cartier in 2010.

BUILDING THE SHOW GARDENS

The Society's contract with the Royal Hospital allows contractors to enter the site three weeks before the show. They have a little over a fortnight in which to take the gardens from lawn to finished product. Faith and Geoff Whiten said in their account that when they arrive 'all that is to be seen of our garden are a few wooden pegs banged into the grass'. Then, as work begins in the background on erecting the Great Pavilion, the garden makers get to work. The process begins with the arrival of heavy lorries bringing materials. Modern materials have somewhat reduced the burden of work – literally, because plastic containers are much lighter than the wooden tubs that once had to be used

to transport larger plants. Cranes have been used since the interwar years at least, and are now easier to manipulate than their predecessors. There are mains connections for toilets at two points in the grounds (show visitors are accommodated in Portakabins). All mains connections for water features have to be established before any building can take place.

At the end of the show, all the building works have to be undone, and all materials removed from the site, within five days. The RHS now runs a recycling scheme for distributing unwanted hardcore and other materials to other building projects – in 2012, to local projects run in tandem with the Olympics.

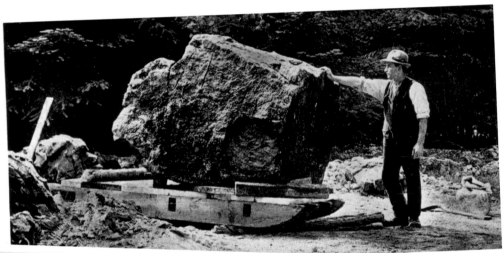

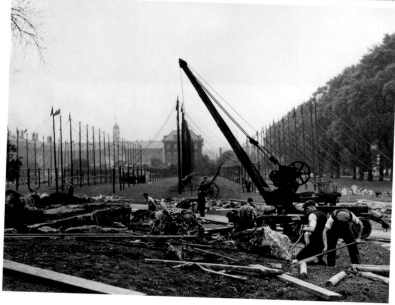

I have been involved with the RHS Chelsea Flower Show since 1994. My first garden was Christopher Bradley-Hole's Explorer's Roof Garden. Since then I have built twenty-three show gardens, twenty of which have won Gold. Eight of the gardens have won Best in Show.

My best moment was the Chanel garden in 1999. We didn't get Best in Show but we should have, in my opinion. We were told by the selection panel that we wouldn't get the hornbeam into leaf, but we did, with the help of a large glasshouse and a lot of positive thinking. And the parterre was all built in advance – a first at Chelsea.

Chelsea is so deep within my DNA that I don't know what I would do without it; it's been part of my life for nearly twenty years, so it's difficult to remember life before it. I have been lucky enough to work with a lot of very talented designers over the years and it's been fascinating seeing how the show has developed. The gardens are much more sophisticated than they used to be and the budgets are vast in comparison to twenty years ago. And the sponsors are pretty focused on winning, too!

But for me, building a show garden is the best example of how to build a team. The focus tends to be on the designer, but in reality these show gardens only come to life if the forty or fifty people working on the garden really buy into the vision and work as a team. Without that, you are lost.

It's quite an emotional moment when you see a year's work finally come to fruition. Then in a flash of an eye, it's all gone. You pause for breath and then, after a few minutes' rest, you start worrying about the next year. It never stops.

Mark Fane, garden builder and nurseryman (Crocus)

OPPOSITE Above: a seven-ton granite rock being moved to form part of Gavin Jones's 1929 rock garden. Below left: Chelsea 1936: workmen assembling a rock garden, with the supporting pillars for the marquee behind them. Below right: a stone construction from the 1938 Chelsea Show.
LEFT Diarmuid Gavin's Westland Magical Garden, the tower in the course of assembly, 2012.
Right: constructing a garden, 1996.

4

FROM AUSTERITY TO A BRAVE NEW WORLD 1947–60

In 1946 the shows committee recommended that Chelsea be resumed as soon as possible, despite the labours of reconstruction and the continuation of rationing. It was expected that there would be fewer exhibitors than before, but the space could be filled with a demonstration of garden machinery, and with a competition for professional flower arrangers. The Society canvassed the surviving firms among its former exhibitors, and found a sufficient number willing to make the effort. Though many felt it to be premature ('even the most hopeful horticulturists had mental reservations,' said the *Gardeners' Chronicle*), the RHS Chelsea Flower Show was held again in 1947.

The show was a triumph. The *Chronicle* described it as 'a superb display and one that, more than any of its forerunners, tells a brave and beautiful story of difficulties surmounted and a determined effort to keep the fair flag of British horticulture at the masthead and not at half mast'. There were only two-thirds the number of exhibitors, and fewer orchid stands, a fact somewhat disguised by scattering them through the marquee and not clustering them together as before. Lord Aberconway, the RHS President, staged a huge display of rhododendrons from his garden at Bodnant; the RHS, of fuchsias from RHS Garden Wisley Wisley; Kew, of palms and bromeliads. There was even a foreign exhibitor, Plant Publicity Holland, who staged a bulb garden. This was one of only four gardens that year; the others were the work of Percy Cane, Astolat Nurseries and George Whitelegg (so that there was one rock garden at least).

Subsequent years were the great years of exhibits from Wisley, with the curator, Francis Hanger, in his element. In 1954 he filled a large site with Ghent azalea hybrids, all raised at Wisley since the war and many still unnamed; in 1955 it was a massive bog garden. But his greatest achievement was the Himalayan garden he staged as Chelsea's contribution to the Festival of Britain in 1951, for which the new RHS Garden Wisley development on Battleston Hill was depleted of

LEFT Hydrangeas from the Milton Hutchings nursery in Hillingdon being brought to the site in 1955. Hutchings did not exhibit at Chelsea; these plants would have been used for the planting of one of the display gardens.

rhododendrons; twenty-three lorryloads of plants were taken to create a Himalayan gorge, flowering on time after being kept in dark storage for five weeks. And how was Hanger's success recognized by his superiors? By complaints that he had taken up so much space in the Wisley glasshouses with plants for the show that the permanent plants had suffered: 'after the 1951 Chelsea I remember Mr. Bowes-Lyon looking into the vinery and saying that the grapes grown therein were the worst he had ever seen'. At least the plants returned to Battleston Hill and after an interval resumed their normal growth rates.

In 1949 the show was extended by a further day: Tuesday became a full-day private view for the Society's Fellows, and the judging and the royal visit were pushed back to the Monday. The sociology of the private view is revealing: only a few years after the Women's Land Army had played such an important role in maintaining the country's farms, and female gardeners had been employed at Wisley to make up for the reduction in male staff, the invitations that were issued to practical gardeners specified that they would admit 'the gardener and his wife'. Let it not be said, however, that women were entirely sidelined at Chelsea: flower arranging was admitted to the marquee for the first time in 1947. Admittedly, this was in part a device for filling empty space, but once established it was never again removed.

The greatest change to Chelsea after the war was in tentage. The 1940s saw the resumption of the prewar pattern: two tents, separated by an open avenue, both sited north of the Chillianwallah monument. In 1951 the two tents were replaced by a single marquee on a grander scale than had ever appeared at Chelsea before: supported by 278 tent posts, covering 1.5 hectares of ground, the marquee spent years in the *Guinness Book of Records* as the world's largest tent. Effectively doubled in size, it now covered the Chillianwallah monument, and the 'monument stand', the largest single stand within the marquee, became both the coveted trophy and the operational headache of a different nurseryman each year.

THE ROYAL HORTICULTURAL SOCIETY

Established 1804 *Incorporated 1809*

SCHEDULE

OF THE

GREAT SPRING SHOW

TO BE HELD IN THE

ROYAL HOSPITAL GARDENS,

CHELSEA

On WEDNESDAY, THURSDAY and FRIDAY,
MAY 21, 22 and 23, 1947.

Copies of this Schedule may be had on application to :
The Secretary, The Royal Horticultural Society, Vincent Square,
London, S.W.1.

LEFT Front cover of the show schedule for the 1947 Chelsea Show. **FAR LEFT AND BELOW** Samples of admission tickets and official stickers for the 1947 Show. The tickets with green and red stripes were for members of affiliated societies.

HARRY WHEATCROFT (1898–1977) was one of the most famous rose growers of the twentieth century. With his brother Alfred, he started growing roses in 1919, at Gedling in Nottinghamshire, later moving to Ruddington. Wheatcroft Bros first exhibited at Chelsea in 1924, and after an intermittent start, became an annual fixture at Chelsea until 1970. In the years after the Second World War Harry Wheatcroft became a media personality, with television appearances and regular press coverage: his flashy suits and neo-Victorian whiskers made him easily the most identifiable of Chelsea exhibitors. He acted as the English representative of the French rose-breeding house of Meilland, and introduced their rose 'Peace', probably the twentieth century's most famous and best-selling rose, into England; a lifelong socialist and pacifist, he was particularly pleased to be associated with this name. In 1962 he moved to Edwalton and started his own separate firm, Harry Wheatcroft and Sons, which continued to exhibit for nearly a decade after Harry's death. He wrote five books, beginning with *My Life with Roses* (1959) and culminating in an autobiography, *The Root of the Matter* (1974).

NAME Harry Wheatcroft
PROFESSION Nurseryman
EXHIBITED 1924–77

FLOWER ARRANGING AT CHELSEA

The RHS had held the first public competition for 'table decoration' at the opening of its Kensington garden in 1861, and had promoted flower arranging over the subsequent eighty years, including competitions at its Westminster shows. Between the wars, Constance Spry and some professional florists had stands at Chelsea in Sundries Avenue, displaying florists' sundries but also showing specimen arrangements. In 1947, to help fill the space left by exhibitors still recovering from the war, a portion of the marquee was devoted to flower arrangements for the first time; thereafter flower arranging became a regular feature. In 1956 it was allocated its own separate tent; Constance Spry described this as 'the pinnacle year' for the rise of the flower arranging movement.

The RHS convened a meeting of regional societies in 1954 to discuss the future of flower arranging, and as a result set up a floral decoration committee to judge the displays at its shows. (The first chairman of the committee, Lord Digby, later remarked that the great thing about flower arranging was that its creations didn't last long.) The regional societies now began to band together, and in 1958 formed the National Association of Flower Arrangement Societies of Great Britain (NAFAS). Since the end of the 1960s NAFAS has exhibited regularly in the marquee, different regional societies taking responsibility for the displays in different years. Amateur competitions in their separate tent or pavilion have continued, with a second facility eventually being added for professional florists. Today in addition to the competitions and floristry displays in the marquee there are workshops held throughout the show by floral decorators from around the country.

Styles of flower arrangement have varied greatly over the years, Constance Spry's massed groupings competing with Japanese ikebana. The spiky American modernist school, with its experimental geometry and found objects, arrived in the 1950s, but took several years before becoming accepted.

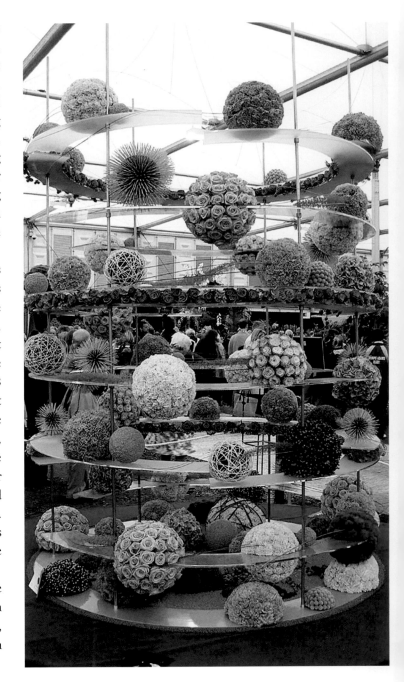

BELOW, LEFT The Interflora exhibit, 2010.
BELOW, RIGH᠆ Inside Out, Inside In: the NAFAS exhibit, 2009.

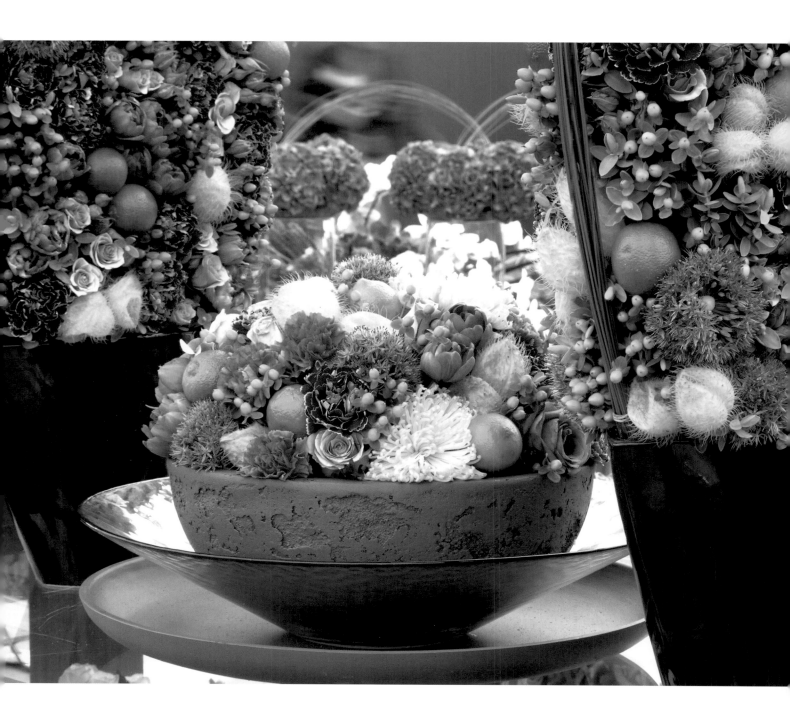

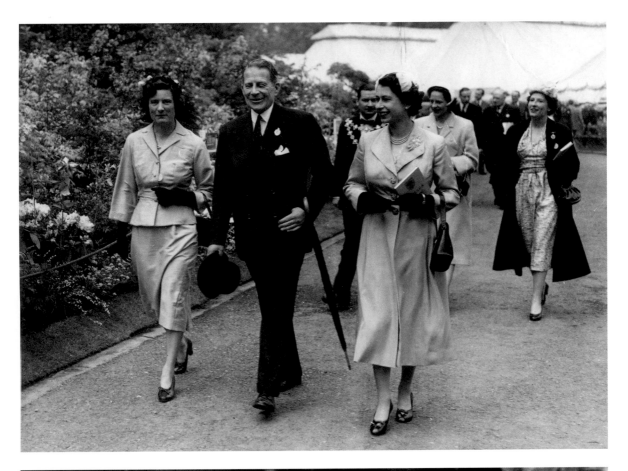

LEFT, ABOVE The Queen with her uncle Sir David Bowes-Lyon in 1955, her first visit to Chelsea since becoming Queen.
LEFT, BELOW The Queen admiring flowers in the pavilion during a tour of the RHS Chelsea Flower Show in 1984.

THE QUEEN AT CHELSEA

Princess Elizabeth grew up at Royal Lodge, in Windsor Great Park, the official residence of her parents, the Duke and Duchess of York. Her mother, who had been born Elizabeth Bowes-Lyon, was an enthusiastic gardener. While she and her husband were still the Duke and Duchess of York, they had commissioned Eric Savill to create a garden in Windsor Great Park, near their official residence of Royal Lodge, and which they named the Savill Garden in his honour. She was to be involved all her life in the creation of gardens. Her younger brother, Sir David Bowes-Lyon, had joined the RHS Council in 1934, and become treasurer in 1948; in her daughter's coronation year, on the death of Lord Aberconway, he became President, and served in that capacity until his death in 1961. So there was a well-defined royal linkage with the Chelsea Show, and each year Sir David could be seen escorting his sister and/or his niece around the show.

Princess Elizabeth's involvement with the Chelsea show began early. When she was ten, it was reported in the press that, as Lord Aberconway said at the Society's AGM, 'little Princess Elizabeth, following the family tradition, was starting to plant a little garden of her own at Royal Lodge.' The RHS Council sent her tickets to Chelsea, as a way of encouraging their future patron.

In 1952, she ascended the throne as Queen Elizabeth II, and her mother became Queen Elizabeth the Queen Mother. The new Queen became a royal patron of the RHS that June. The following year saw her coronation, and Chelsea staged a special Commonwealth Exhibit to match the Empire Exhibit a decade and a half earlier. A special tent at the south-east corner of the Great Marquee housed exhibits from South Africa, West and East Africa, Australia, New Zealand, Canada, the West Indies, India and Pakistan, Ceylon, Malaya, Mauritius, St Helena, Bermuda, Malta, Cyprus and Britain (Professor Salisbury,

the Director of Kew, described the British flora as 'an impoverished European flora', and staged a reproduction of an oak wood).

However, the Queen did not attend Chelsea that year. 'At the RHS Chelsea Flower Show', remarked the *Gardeners' Chronicle*, 'we missed the Queen, but everybody understands just how many demands there must be upon her time in these weeks before and after the Coronation.' (Not to mention mourning for her grandmother, Queen Mary, who had died in March.) 1955 was the first year since her accession to the throne that she visited Chelsea. Thereafter she would attend every Chelsea except ten, with either the Queen Mother or Princess Margaret generally attending in her place. In one of these fallow years, 1978, the Queen paid her first visit to Wisley, so perhaps that was a sufficient indulgence in the RHS for one year.

In 1977, the Queen's Silver Jubilee was celebrated by the Royal Parks in an exhibit within the marquee, with a royal crown carried out in carpet bedding. The Golden Jubilee in 2002 saw no specific celebrations. In 2012, the Diamond Jubilee year, the RHS Lindley Library staged a special exhibit of photographs of royal visits to Chelsea, and another of Royal Autographs (botanical designs on vellum, signed by royal patrons). The Queen had signed an Autograph on succeeding to the throne; she and the Duke of Edinburgh now signed a new Autograph prepared by the botanical artist Gillian Barlow.

Of all the younger members of the royal family, it has been Prince Charles who has shown the greatest enthusiasm for gardening, commissioning Rosemary Verey and others to create his garden at Highgrove, commissioning the *Highgrove Florilegium* from a team of botanical artists, and doing much to promote green issues. In 2012 he also became a royal patron of the RHS, and signed an Autograph by Gillian Barlow.

SETTING UP AND PLANTING

The basic requirements of planting a Chelsea garden have changed little over the past century. The locations of major structural planting, large trees and the like, must be determined first, before building works can take place, since foundations cannot be dug deep and the levels must be built up around the rootballs. Only in the case of water gardens does the built structure precede the plants.

Once the structure of the garden has been completed, it is time for smaller plants to be added. In order to cope with the unpredictable British climate, and even to show plants that do not normally flower at Chelsea time, special programmes of forcing and cold storage are needed to speed up or retard flowering. Once this was accomplished by packing in ice, and in 1937 the Empire Exhibit had a section devoted to Australian plants actually preserved in ice. Michael Jefferson-Brown was the first to exhibit daffodils at Chelsea: in 1982 a power surge destroyed the motor and thermostat for his cold store, and forced a heroic exercise in driving 10,000 flowers 25 miles to another store to keep them from opening too early. Today's environmental control technology allows greater precision in timing than previous generations could achieve.

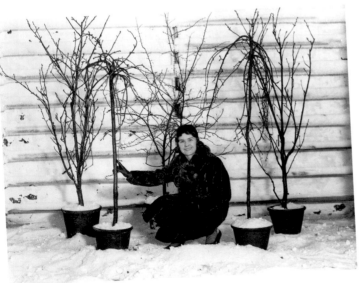

OPPOSITE Arranging a Chelsea exhibit, c.1930. Is this a genuine image of the relationship between employer and gardener, or are we witnessing a visitor posing for effect?

THIS PAGE Clockwise from top left: workmen preparing a rock garden, 1963; planting Robert Wallace & Company's garden, 1930; preparing exhibits in the marquee, 1935; exhibits in cold storage, 1934; Sarah Raven arranging *Camassia leichtlinii* for planting, 1998.

BELOW Edwin Beckett's last display of vegetables at Chelsea, 1930, showing the produce of the Hon. Vicary Gibbs's garden at Aldenham House, Hertfordshire.
OPPOSITE, ABOVE Two photographs by Tessa Traeger, taken in the greenhouses of Medwyn Williams (see page 134), showing vegetable groups being prepared for his 2005 display at Chelsea.
OPPOSITE, BELOW Medwyn Williams's finished display, which received a Gold Medal at Chelsea, 2005.

VEGETABLE EXHIBITS

In the early years of Chelsea, while Sutton's and other seedsmen arranged displays of vegetables from time to time, no one was more associated with vegetable stands in the public eye than Edwin Beckett, the head gardener of Aldenham House. (His exhibits were recorded under the name of his employer, Vicary Gibbs, but everyone knew where the credit lay.) Beckett was the author of *Vegetables for Home and Exhibition*, a work that went through three editions between 1899 and 1927. His advice was mainly directed at those exhibiting at local flower shows: always have cauliflower and broccoli, for example, in the centre of the back row. In his mammoth displays for Chelsea, Beckett would sometimes fill the stand with conical and pyramidal groups; on one occasion he displayed the vegetables in wooden-edged beds, as they would be seen growing in the garden.

There was a very simple reason for the importance attached to these vegetable displays. People who lived in towns relied for their food crops on market gardens, which tended to flourish in a ring around the urban area. The country house estate, however, needed to be self-sufficient in food, so the kitchen garden remained the principal part of the garden, the best staffed and the best funded. However delightful the stands of flowers and ornamental plants might be, it was the displays of vegetables that represented the professional gardener in his most essential function.

All that was to change with the Second World War. There was to be no return to normality after the war as there had been after the First. Even estates that had shed their flower gardens had kept their kitchen gardens going, but the war years taught lessons about the ease of transporting food from markets by motorcar and lorry, and the rise of the supermarket put the final nail in the coffin of the kitchen garden. The demolition of glasshouses and the conversion of old walled gardens to new purposes characterized the third quarter of the century; but the most immediate result was the effect on employment. The horticulturist and broadcaster Percy Thrower used to say that his generation was trained on country house estates, but on demobilization found there were no more jobs there, and went into the public parks instead.

Vegetable displays in the postwar years were no longer the work of private gardens; instead they were the work of nurseries, or of the National Farmers' Union.

The range of vegetables exhibited at Chelsea tended to be wide in terms of cultivars, but limited in its general categories to the familiar staple crops of Europe: peas and beans, carrots and parsnips, brassicas, allium crops, cucurbits, potatoes, tomatoes, asparagus, rhubarb. In 1950, Toogood & Sons showed celtuce, or Chinese lettuce, the first of the oriental vegetables to be introduced in the twentieth century; but it would be thirty years before the vogue for pak choi and other oriental vegetables began.

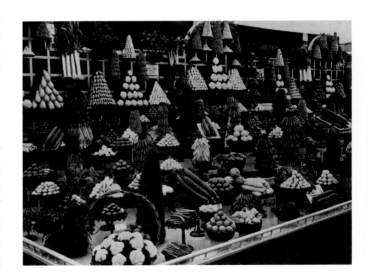

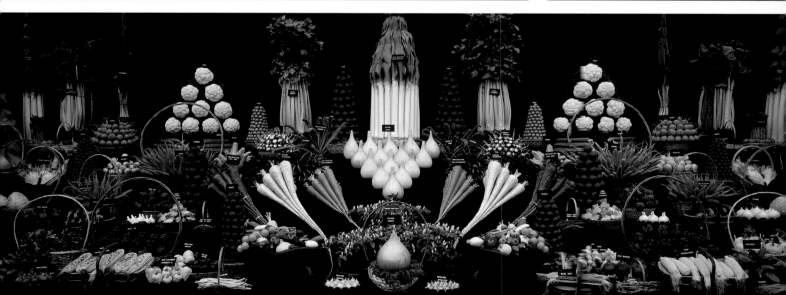

WATERPERRY STRAWBERRIES

One of the most distinctive stands in the Chelsea marquee in the postwar decades was that of Waterperry Horticultural School, based at Wheatley near Oxford. Waterperry was the last to be founded of that under-researched phenomenon, the gardening school for women – preceded by Swanley and Studley Colleges, the Glynde School for Lady Gardeners, the Thatcham Fruit and Flower Farm School and others. Waterperry was founded by Beatrix Havergal in 1932, and first exhibited at Chelsea in 1938. The Waterperry students, in their characteristic green uniforms, would become familiar figures in the postwar years, as they assembled their stand under the direction of Joan Stokes. The subject of the stand was always the same: the 'Royal Sovereign' strawberry, a variety bred in the late nineteenth century by Thomas Laxton and regarded at the time as the best variety on

the market. The exhibit of some 300 plants arranged in tiers to form a pyramid was awarded a Gold Medal in 1955, and for fourteen years in succession thereafter; a consignment of the strawberries was usually sent to Buckingham Palace after the show. The last exhibit was in 1970; the next year the school was closed, a victim of the Pilkington Committee on Education, which sought to end sex-segregated education. The photographs shown here were taken by Valerie Finnis, a former student and later instructor at Waterperry, who was later to have an exhibition of her photographs held to coincide with the Chelsea Show.

ABOVE, LEFT AND RIGHT Undated photographs by Valerie Finnis of the Waterperry stand. Beatrix Havergal is seen in the right-hand image, handing a pot to one of her students.

THE NATIONAL FARMERS' UNION
AND THE MINISTRY OF AGRICULTURE

The National Farmers' Union had begun life as the Lincolnshire Farmers' Union in 1904, and had become National in 1908. During the war it was heavily involved with the government's drive to increase domestic food production, and after the war it lobbied successfully for the Agriculture Act 1947, which increased subsidies to farmers, promoted mechanization, and attempted to ensure that Britain would remain agriculturally self-sufficient, its food supply never again endangered by war or foreign politics. Under the terms of the Act, the Ministry of Agriculture was committed to an annual review of the nation's farming in consultation with the NFU.

In 1947 the NFU staged its first display at Chelsea: a modest affair by comparison with that of the following year,

when Violet Stevenson, together with E.R. Janes of Sutton's Seeds, designed a striking arrangement of vegetables in decorative patterns. Thereafter the NFU stands became a regular feature of Chelsea until 1992. In 2001 the Ministry of Agriculture was amalgamated into the Department for Environment, Food, and Rural Affairs (DEFRA), and the NFU to a great extent lost the influence it had had.

The postwar political climate, which favoured centralization, nationalization and government investment in research, had a great effect on horticulture. By the Second World War there were already a few experiment stations: Rothamsted (founded privately in the nineteenth century for research into soils and fertilizers, taken over by the government in 1934); Long

LEFT The National Farmers' Union stand in an undated photograph, possibly part of the celebration of the RHS sesquicentennial in 1954.

Ashton (founded 1903 for the cider industry); the John Innes Horticultural Institution (founded privately 1909, and not incorporated into the government scheme until the 1980s); East Malling (founded by Wye College 1913, becoming independent with Ministry of Agriculture funding in 1920); and Cheshunt (founded 1913 by the Nursery and Market Garden Industries Development Society). In the postwar years those not already taken over by the government were annexed; Cheshunt closed and reopened in Sussex as the Glasshouse Crops Research Institute (GCRI). The National Vegetable Research Institute was founded at Wellesbourne in 1949, and the government began setting up agricultural experiment stations in different regions, among them a very horticultural one at Lea Valley. All these organizations staged educational displays at Chelsea in the scientific section, presenting information about crop breeding, pests and diseases, and horticultural science.

In the 1980s, the Thatcher government began a programme of cuts in expenditure on research. Most of the Ministry of Agriculture's regional experiment stations were closed, beginning with Lea Valley in 1989. The national stations were amalgamated into the Institutes of Arable Crops Research and Horticultural Research; but these in their turn proved unstable. GCRI and Long Ashton were eventually closed; East Malling, Wellesbourne and Rothamsted continue as charitable trusts, but their educational displays at Chelsea came to an end in the 1980s.

The RHS had begun to collaborate with the Ministry of Agriculture in 1922, on fruit trials designed to identify the varieties best suited for commercial cultivation: flavour, disease resistance, length of season, multiple cropping, post-harvest longevity were all criteria to be tested. Wisley was never a good place for the trials: frost damage occurred in most years. After the war, Brogdale Farm in Kent was acquired by the ministry in 1952 as a new site for what became the National Fruit Trials, and the collections transferred. The closure of Brogdale was debated, but a private trust was set up to save it and administer the collections; from 1992 the Brogdale Horticultural Trust began to stage exhibits at Chelsea in the manner of its former colleagues.

TRADE UNIONS THREATEN THE SHOW

The rise of militant trade unionism after the Second World War affected the world of exhibitions generally: at both Earls Court and Olympia a closed shop was enforced. In 1949 union representatives made a similar demand for Chelsea. The shows committee met the unions and reached a compromise: all building activity required for assembling the show would come under the authority of the builders' unions, but horticultural activity would be exempted. (The Horticultural Trades Association had been told of the meeting and decided not to get involved.) In 1952, however, militant organizers launched a new effort. A rogue steward from the Amalgamated Union of Building Trade Workers visited Chelsea after the show had closed and workers were repairing and returfing the grounds; he began enrolling all the site workers into a union, threatening a general stoppage if the horticulturists who were dealing with the trees did not join also. The 1949 agreement was eventually restored as the norm, and there were no further threats of stoppages, but agitation over various demands continued to the point where in 1962 the Society appointed an industrial liaison officer specifically to deal with problems at Chelsea.

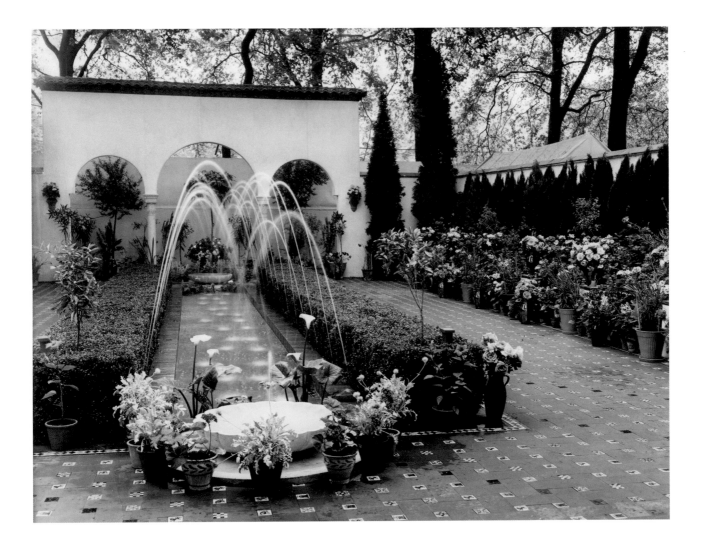

POSTWAR GARDEN DESIGNS

In 1952 the major Spanish horticultural society, the Sociedad de Amigos del Paisaje y Jardines, staged the first postwar garden at Chelsea to be put on by a foreign exhibitor. This recreation of a Spanish courtyard with tiled paving and fountains heralded what was to become a major trend of the second half of the century: a new, eclectic historical revivalism, no longer directed at the 'English Renaissance' but willing to incorporate a wide range of styles from across Europe.

In 1958 another foreign garden attracted great attention. The great French seed house of Vilmorin-Andrieux (the French counterpart to Sutton's) had wanted to put up an exhibit at Chelsea, and asked Roy Hay, then the editor of the *Gardeners' Chronicle*, what it should be. He suggested a *potager*: a French-style kitchen garden with fruit trees trained as espaliers around formal beds of vegetables and

flowers. 'You want to ruin the firm' was the reaction, but with the help of Russell Page as designer, the project went ahead, and was greeted enthusiastically. 'Never', wrote the *Chronicle*, 'have we seen such superb specimens of trained fruit trees, real works of art, the result of years of care and attention.' Over a decade was to pass before John Brookes would show the next French-style potager at Chelsea, but by 1990 such potagers had become a major fashion.

Such revivalism would grow steadily through the decades, but in the 1950s it was still very much a minority interest. More representative of the accustomed spirit of the age was the garden that William Wood and Son created for the coronation year, 1953. Called the Cutty Sark Garden, it commemorated the role of commercial shipping in the Empire, and featured a garden seat suggesting an upended boat's bow, with a ring of lawn

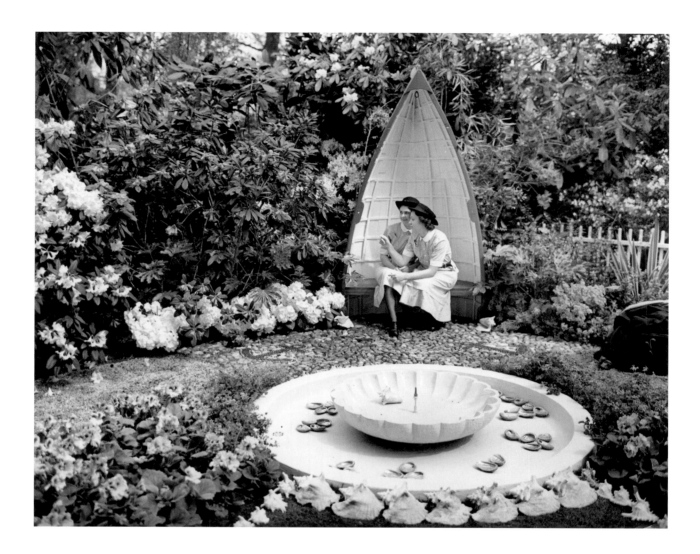

around a flower garden. Display bedding still continued, not only in parks but in many small domestic gardens.

But there was a third movement beginning to grow: modernism. In 1937 and 1938 a young landscape architect named Christopher Tunnard exhibited at Chelsea plans and photographs of gardens, among them Bentley Wood, which he designed with Serge Chermayeff and illustrated in his 1938 manifesto *Gardens in the Modern Landscape*. It featured unplanted paving in front of the windows, and beyond that a lawn punctuated by silver birches.

There was certainly one respect in which Tunnard's garden would appeal to a postwar audience: its ease of maintenance. Both aesthetic and functional interests converged on finding systems of planting that would essentially maintain themselves once established, in an age of rising labour costs. The answer lay in ground cover:

plants that could offer a uniform surface. The phrase emerged in America in the early 1950s, and was promoted in Britain in books by Margery Fish (1964) and Graham Thomas (1967).

In 1959 *The Times*'s Garden of To-morrow attracted attention at Chelsea, largely for its mechanization, but Harold Whitelegg, writing in the *Chronicle*'s special supplement, saw the main trends as the abandonment of bedding out; the use of flowering shrubs, permanent planting in borders; lawns and borders planned with curved edges, no angled corners to perplex the lawnmower; and in general a delight in open, uncluttered space.

OPPOSITE The 1952 Spanish garden by the Sociedad de Amigos del Paisaje y Jardines.
ABOVE William Wood's Cutty Sark Garden, 1953.

THE GARDEN OF TO-MORROW

The most striking exhibit at Chelsea 1959 was the Garden of To-morrow, sponsored by *The Times*. Never before or since has a Chelsea garden received so much attention in the press, for the *Gardeners' Chronicle* seized the moment and produced a special issue, with twenty pages of reflection on the state of gardening and what the future held. All the contributors agreed that adaptation to the demands of modern life meant an end to ornamental bedding and its replacement by permanent planting. All agreed that mechanization was transforming the garden: the difficulty of making a lawnmower turn at right angles meant that in the future, edges in the garden should be gracefully curved. And all agreed that automation was inevitable: 'If we had been shown the kitchen of to-day a mere 20 years ago we would have probably roared with laughter, yet the garden of to-morrow will certainly come just as surely as the kitchen of to-day has come and for very much the same reasons.'

The single most riveting item in the Garden of To-morrow was the radio-controlled lawnmower, developed by H.C. Webb and Co. of Birmingham, and demonstrated to the Chelsea audience by a variety of models (human, that is). This was automation as the enabler of leisure. But automation for the management of the greenhouse was more eagerly looked forward to: mist propagation, automatic blinds, and thermostatic controls for green-house heating and ventilation were being experimented with, and confidently expected within a few years. So too were fine water sprays to reduce frost in orchards and ever more precisely controlled plant breeding. Plastics were perhaps the most exciting new development. Plastic cord and labels that would never rot! Buckle-type tree ties! Polythene containers that allowed you to see the level of the contents without opening them! Plastic water piping that let the gardener install his own irrigation system without engineers! Plastic trugs in any colour you wanted! Already stainless steel and plastics were reducing the weight of some garden equipment; why, wondered the press, had no one yet made a stainless-steel rake or a plastic seed tray? (They were soon to arrive, and plastic containers would make possible the garden centre revolution of the 1960s.)

The *Gardeners' Chronicle* announced that the Garden of To-morrow was 'an assurance that horticulture can adapt itself to the age and at the same time maintain the high standards of garden craftsmanship and beauty that we are used to in this country'. One development that was curiously omitted was 'atomic gardening', that occasional enthusiasm of the 1950s; a few months after Chelsea, the *Chronicle* would carry an article on 'radioactive gardening', the use of radiation to induce mutations. And the hopes for such scientific progress continued for years: in 1966, the former director of Wisley Harold Fletcher asked: 'Who doubts for a moment . . . that there will be further additions to the bewildering array of new weed killers, fungicides and insecticides, systemic and otherwise . . . that disease-resistant cultivars of fruits, vegetables, and ornamentals, with other desirable qualities, will be bred . . . that growth regulators will be increasingly used to hybridize plants which previously have refused to cross; that fertile hybrids will be induced from chemically produced polyploids? Such advances in our knowledge are absolutely inevitable.'

RIGHT A demonstration of Webb's radio-controlled lawnmower, 1959.

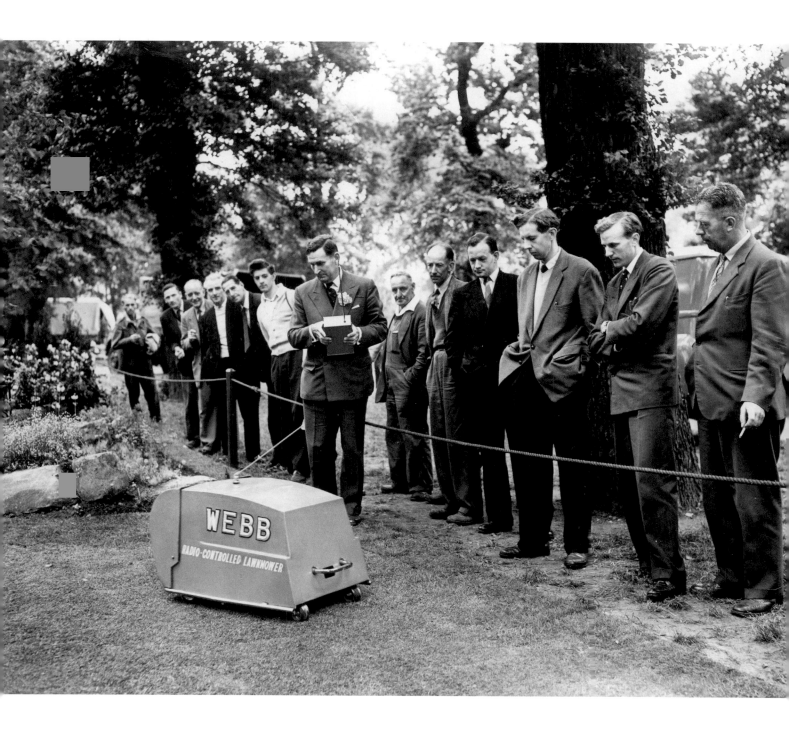

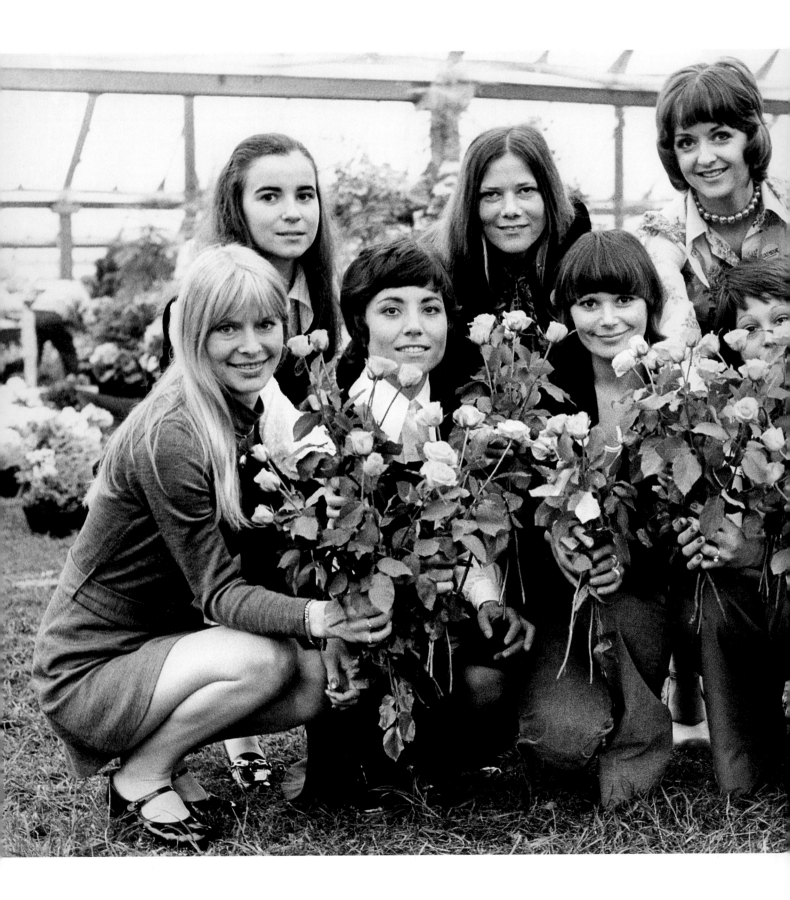

5
THE TREND TOWARDS POPULISM THE 1960S & 1970S

The beginning of the 1960s was marked at Chelsea by the largest display of orchids ever staged there: accompanying the Third World Orchid Conference, which the RHS hosted, 5,000 square feet of orchid stands and displays, from Malaya, Hawaii, Kenya, France and Germany as well as Britain. The exhibits ranged from cut spikes (the Malayan Orchid Society) to specialized stands devoted to cymbidiums (McBean's) and odontoglossum hybrids (Charlesworth, destined to be absorbed by McBean's a decade later), and even, in a virtuoso display of what could be accomplished by modern orchid breeding, the Armstrong & Brown stand featuring nearly 100 cultivars of the white *Cattleya* 'Bob Betts'.

A few months after Chelsea 1961, the Society's President, Sir David Bowes-Lyon, died, and was succeeded as President by Lord Aberconway, who was to fill that role for a year longer than his father had. The first Chelsea he presided over was in 1962, and at the reception he said: 'Chelsea 1962 is its usual and unique self. Chelsea is always different from year to year but each year is slightly better than the previous years.' Over the next twenty years, this statement was whittled down into the simple if repetitive: 'This is the best Chelsea yet.'

But the expectations of the Chelsea audience were changing. The 1960s saw the emergence of the garden centre to challenge the traditional nursery. By 1971, the

LEFT A media event at Chelsea in 1973: nine women, one for each country in the recently enlarged European Community, each holding a new rose cultivar.

LEFT Visitors leaving the Chelsea Flower Show with their purchases after closing on the last day, 1961.

Gardeners' Chronicle could say that 'people are becoming accustomed to impulse buying of container-grown plants. The amateur gardener at Chelsea is essentially buying a promise. And when the promise arrives through the post a few months later it bears little resemblance to what he originally saw.' The demand to allow plant sales at Chelsea began to be regularly aired, and regularly defeated at exhibitors' meetings. In 1961 Russell Page attacked the arrangement of stands in the marquee for its lack of grouping by subject: 'Can it help sales to display goods in a way that even the village general shop has long since abandoned? Any department store arranged on this principle would go bankrupt rapidly.' Attendance declined sharply, by 27,000, in 1966. And in 1974 the journalist Roger Newman reflected on the perceived downturn in orders taken: 'The wealthy customer still comes to Chelsea, but rarely today from a country estate; more usually from a converted cottage on that estate, with a labour-saving garden and an odd man two mornings a week. Nostalgia reigns in the place of the cheque book.' 'The great God Garden Centre', he concluded, 'furnishes all that is needed for the back yard.'

The traditional world of horticulture was indeed passing away, as reflected at Chelsea. The number of amateur stands fell sharply in the 1970s, with Maurice Mason of Talbot Manor, Norfolk, the last of the country house exhibitors to feature the produce of his estate; in 1980, other applicants having fallen through, he took the monument stand and received the Lawrence Medal (for best exhibit of the year) for his enormous display of greenhouse plants. Rock gardens, having declined in popularity since the war, dwindled until in 1965 there was only one (Whitelegg). For the next few years the alpine nurseries took that solitary role in turn. In 1968, with no applications for a rock garden at all, Wisley stepped in and staged one, under the direction of Ken Aslet, the superintendent of the Wisley rock garden. After that nature took its course, and years would pass with no rock gardens at all.

The 1960s saw the first garden for the disabled at Chelsea, the 1970s a controversy over the admission of guide dogs. What might be termed the first celebrity garden designers – the first to have their names shown in the catalogue along with the garden's sponsor – appeared in the later 1970s: David Stevens and the Whitens. Carpet bedding, long rejected by the horticultural establishment, made its first appearance at Chelsea in the 1960s, as did bonsai, and ecological gardening a decade later.

By the end of the 1970s, the old order was changing. Head of shows Ron Sargent retired in February 1978, to be commemorated by the Royal Parks in their exhibit that year with a water feature called Sargent's Lock. He was succeeded by Allan Sawyer, who became a well-known figure cycling around the Chelsea grounds. The year before, a young woman named Mavis Sweetingham had joined the shows department; she would go on to become the exhibitor manager for the Chelsea Show. And a momentous decision had been made in 1976: to allow sundriesmen to sell their wares during the show.

But in 1979, the changes that were to shake the next decade were still barely visible. In that year Richard Bisgrove, a horticultural instructor at Reading University, reviewing the show for the *The Garden* (the recently renamed *RHS Journal*) said: 'Chelsea is like an ocean liner cut off from the real world outside for an extravagant four-day cruise, a separate world of plants and people. The impression was heightened by the sight, across the water from Battersea, of the great white hull of the marquee, bedecked by flags.'

LINKS WITH THE WORLD OF FASHION

The second half of the twentieth century saw a progressive tendency for formal dress to disappear from daily life. The ceremonial presentation of debutantes at court was discontinued after 1958; hatlessness became general for men, and gradually for women also, with a corresponding increase in the importance ascribed to hairstyles; casual wear became the norm. The only interruptions in this general trend were the much-vaunted youth movement of the 1960s (a peacock range of fancy and revivalist men's clothing, and for women a sequence of mini, midi and maxi dresses, all displayed in the photograph on page 90, along with blue jeans), and punk in the 1970s. By the end of the century, clothing had largely ceased to indicate social hierarchy, and served instead as the trademark of a number of self-defined social groups.

But as television coverage of the show increased, so did the tendency for the press day to become a fashion opportunity. Yves Saint Laurent commissioned a garden in 1997 entitled Yvresse – the name of a perfume his house had launched four years earlier, and was complementing with a new lighter brand called Yvresse Legère. The following year Chanel followed suit, with a garden designed by Tom Stuart-Smith.

The year 2008 was the one in which fashion made its greatest impact at Chelsea, with three designers creating special Chelsea ranges to be launched at the show: Manolo Blahnik with rose-printed shoes, Liberty with a garden-decorated Chelsea scarf and Susannah Hunter with a peony handbag. In the same year, Andy Sturgeon used a Mary Quant dress pattern as his model for a wall design (illustrated on page 132), and the firm of L.K. Bennett staged a garden designed by the gardening broadcaster Rachel de Thame, which took as its inspiration 'the femininity and style of the 1950s, including Cecil Beaton's designs for *My Fair Lady*'.

ABOVE, LEFT A model examining Samuel McGredy's new rose 'Ginger Rogers', 1969.
ABOVE, RIGHT Manolo Blahnik's Rose Print shoe from 2008.
RIGHT, ABOVE Rachel de Thame's 2008 garden for L.K. Bennett.
RIGHT, BELOW LEFT The sun hats of 1963 collide.
RIGHT, BELOW RIGHT Front cover of *The Sketch* for 18 May 1955, using the Chelsea Flower Show as a backdrop for fashionable dress, including versions of pillbox and trilby hats.

SHOW GARDEN STRUCTURES

The smaller show gardens – Courtyard, Chic, Urban and Artisan Gardens – generally incorporate some form of building, if only a wall to indicate the relationship of the garden to the house. Designs for modernistic buildings have tended to accompany the larger display gardens, ousting the arts-and-crafts styles that characterized these sites before the war. But the Arts and Crafts style, with its emphasis on local materials and traditions, and its opposition to the machine aesthetic, has not gone away; indeed, it has resurfaced in recent years with the arrival of Artisan Gardens. These offer a profusion of rustic and sometimes ruinous buildings: cottages in regional vernacular styles, fishermen's and quarrymen's houses, caravans, thatch and rough-dressed stone. The battle of the styles has settled into an equilibrium, with the handmade aesthetic spread along the informal paths of the Ranelagh Gardens, and the machine aesthetic of the Fresh and Generation Gardens clustering along the straight roads and right-angled corners of the Pavilion Way.

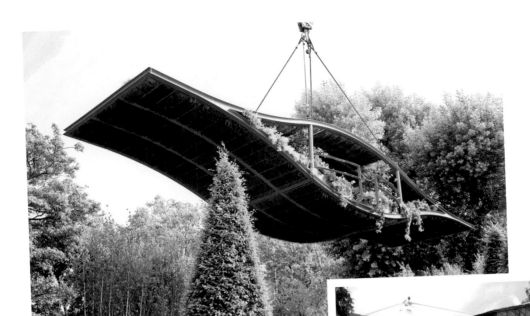

OPPOSITE The Plankbridge Shepherd's Hut
Garden designed by Adam Woolcott and
Jonathan Smith, 2012.
THIS PAGE Clockwise from top left: the Irish Sky
Garden, 2011, designed by Diarmuid Gavin;
Hesco Garden, 2011, by Leeds City Council;
Trailfinders Australian Garden, 2011;
Pepa's Story garden, designed by Borut
Benedejčič in 2012.

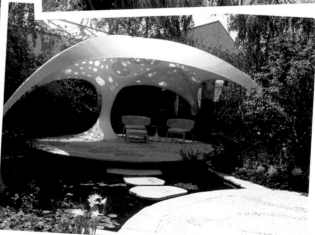

RIGHT, ABOVE Dusting the cacti on the Worfield
Gardens stand, 1966.
RIGHT, BELOW BOAC advertisement from the
Chelsea catalogue, 1960.
OPPOSITE The Federation of British Bonsai
Societies stand, 2009.

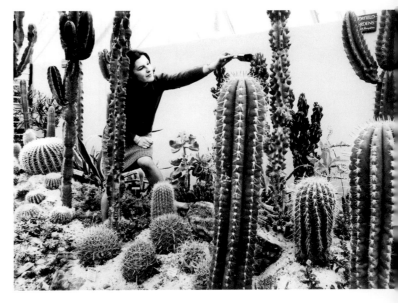

PLANT TRANSPORT AND BOAC

Transporting plants has had a long and difficult history;
as early as 1923 the carnation specialists Allwoods had a
display in the scientific section on packing plants for export.
The use of aircraft to transport plants was pioneered by
two collectors, Frank Ludlow and George Sherriff, on an
expedition to the Himalayas in 1947, for which they were
partly funded by the RHS. Previous plant hunters had had
to despatch plants by ship, whether as living specimens in
Wardian cases or, more generally in the twentieth century,
as seeds in packing cases. Ludlow and Sherriff showed that
air travel could serve as efficiently as the Wardian case to
bring living specimens to England, and with far greater
speed. Within a decade, an airline realized that here was a
new market for their services.

For ten years, from 1955 to 1964, the British Overseas
Airways Corporation (BOAC) had a stand at Chelsea. For
most of those years it had a full-page advertisement in
the Chelsea catalogue, and from 1956 it began tailoring
the ads to horticultural purposes, first with the heading
'Do you fly flowers?' and then in 1959 waxing poetic, with
the heading 'and 'tis my faith that every flower enjoys the
air', specifying that BOAC could transport flowers to any
part of the world in a matter of hours. The climax of the
advertising campaign was reached in 1960–61, with the
promotional statement 'I always fly BOAC' uttered by
cartoons of humanized plants, 'Miss Camellia Japonica of
Tokyo' and 'Mr Echinocactus Grusonii of Mexico'. Of all
images associated with Chelsea in its history, the latter is
the one most likely to provoke a twinge of embarrassment
today, not only because of the current agitation about air
miles and carbon footprints but because of the notoriety of
cactus smuggling, exemplified in 2011 when two German
collectors were arrested at an airport in Mexico with over
500 specimens, some of endangered species.

BONSAI EXHIBITS

Bonsai, the art of dwarfing trees for aesthetic effect, was slow to become popular in Britain. Most nineteenth-century gardeners regarded it as cruelty to trees, though the root pruning of fruit trees was accepted without cavil in the fruit garden. But hidden shoots of enthusiasm could be detected: the first exhibition of British-grown bonsai was held in Liverpool in 1872, to honour the Japanese ambassador, and the firms of James Carter and Peter Barr sold imported bonsai specimens, and included them in their Japanese gardens at the Temple shows.

The first exhibit of bonsai at Chelsea was staged by the Japan Society of London in 1961; in 1970 two nurseries, Bromage & Young and Tokonoma Bonsai, had stands; between 1976 and 1979 six more bonsai nurseries arrived, among them Peter Chan, who would exhibit for nearly thirty years. The Bonsai Kai of London began to show in 1987, and has continued for a quarter of a century so far. Bonsai stands distinctively present individual specimens widely spaced – an aesthetic of 'less is more'.

FOREIGN EXHIBITORS

From the very first Chelsea, when the French rose firm Robichon exhibited, nearly every year has seen foreign exhibitors – nurseries, occasional display gardens and more recently foreign horticultural societies creating displays of the local vegetation in concert with tourism agencies. Over the century there have been over 200 foreign exhibitors. The Netherlands has furnished more than any other country (34), followed by the United States with 22; yet the first American exhibit (after Mrs Hoyt), celebrating the tercentenary of the founding of Philadelphia, was only staged in 1982. There have been exhibitors from every continent: 14 from South Africa, 10 from Kenya and Zimbabwe; 14 from Japan, 1 each from Thailand, China, Taiwan and the Philippines; 15 from Australia, 2 from New Zealand; 6 from South America, 12 from the West Indies, 1 from Canada.

GARDEN AND PLANTING DESIGN

In 1961 *Popular Gardening* became the first magazine to sponsor a show garden. By contrast with *The Times's* extravaganza two years earlier, it was called the Garden of Today, and was intended to show a domestic garden 'as viewed from *your* house': 'a horseshoe-shaped lawn . . . flanked on one side by a brilliant border of annual flowers grown from seed' – striped petunias, antirrhinums, salpiglossis, against a background of Exbury rhododendrons, with children's pools. Designed by William Brett, it was awarded a Gold Medal.

The next year, the Institute of Landscape Architects showed a modernist garden designed by John Brookes, with architectural planting and concrete detailing: 'Planting has been considered as an integral part of the design, though not an end in itself; thus plant masses are important while individual plants making up the masses are not.' This garden received only a Silver Flora Medal. A year later, and *Popular Gardening* produced another Garden of Today, on similar lines to its predecessor. Two armies had sounded their battle cries: in the 1960s the modernists were a small minority, and the garden of annual bedding and block-based colour schemes seemed still in the ascendant.

There were signs, however, that it was in retreat. Increasingly the demands for ground cover and ease of maintenance were being heard, not only from country estates and the business corporations that were taking them over but in the world of the small domestic garden. During the 1960s the great mountainous displays of flowers constructed on the stands of Sutton's and Carter's, the style associated with E.R. Janes, disappeared from the marquee, just as rock gardens dwindled outdoors on the Rock Garden Bank.

The tree and shrub garden had replaced the rock garden in the public's affections. Within the marquee, the stands of Hillier, Notcutts, Sunningdale, Slocock, Reuthe and L.R. Russell increasingly came to be virtually gardens on their own, landscaped around public-access corridors or backdrops. (Hillier began the 1960s with a stand in which their trees were grouped in beds according to different soil types, as a contribution to education; a decade later they launched *Hilliers' Manual of Trees and Shrubs* from their Chelsea stand. They would eventually enter the *Guinness Book of Records* for the greatest number of consecutive Gold Medals – more than sixty to date.) New garden designers like Paul Temple emerged into view, first with shrub gardens and later with a greater variety of subjects.

LEFT Roses at Chelsea, 1965: this cultivar, 'Pink Sensation', has now vanished, and is not to be confused with the 'Pink Sensation' currently available, which was introduced in 1992.
RIGHT Three Chelsea views from 1964.
Top: cacti on display at the Worfield Gardens stand. Middle: rock garden by Whitelegg, 1964, one of only two rock gardens to be exhibited that year. Bottom: tree and shrub garden by Paul Temple.

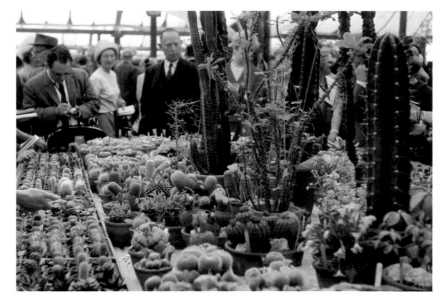

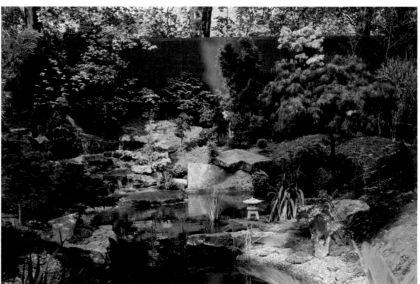

MY CHELSEA

I have a love–hate relationship with RHS Chelsea Flower Show. In the weeks before the show I hate it; it dominates my subconscious, wakes me in the night and hangs like a cloud on the horizon. But when that first Friday on site arrives, when there is no going back, the relationship changes and my love is rekindled. The excitement begins as I walk in through the Royal Hospital entrance. As I enter the Great Pavilion I find an empty shell surrounding a granite obelisk, some dusty turf and piles of wooden boxes that will support horticultural treasures: auriculas, sweet peas, ferns, pinks, narcissi hanging on to spring and chrysanthemums heralding autumn. In the centre of it, a 20-metre-square plot that I will call home for the next two weeks.

The Hillier Chelsea team create a garden out of 3,000 plants, 20 tons of sand, 15 tons of paving, pallets of timber sleepers, 10 tons of chipped bark, crates of straw-filled bags, cut conifer foliage, and numerous buildings, statues, pots and assorted paraphernalia. The finished result will be admired and photographed by thousands, and all involved will feel a strong emotional attachment to that creation. But it will be short lived; after all that effort it will exist for only a week before it is torn apart and returned to reality.

Creating a Chelsea exhibit is an emotional roller-coaster. During build-up the team effort and adrenalin keep me on a high. I love dropping back into the Chelsea family: the other exhibitors, the show team and all those characters I have got to know over the years. We know little about each other's lives, but for a few days each year we are bound together with the same objective. When the exhibit is complete, and the construction team depart, the magic bubble bursts temporarily. The best bit is over for another year; however, those of us who remain for the show know we have a duty to show off what we have worked together to create.

Despite the media focus on the show gardens we all know that what's inside the pavilion is the real Chelsea. This is what the gardeners come to see. The public reaction during the show makes the effort worthwhile: they are the real judges and their praise is the ultimate accolade.

The look of the show has changed over the years. The yellow light and the steamy scented air of the old marquee is a memory. I no longer feel like a new boy, but that feeling took at least ten years to put aside. Bowler hats and dark suits have made way for polo shirts. Despite the face of Chelsea changing, the underlying spirit is the same. It is the showcase of British gardening on the world stage. I am proud to be part of it, and even if it all ends tomorrow it will still be a big part of my life. Every year our Chelsea garden is the best thing we have ever done; every member of the Hillier team says the same. Chelsea Flower Show may come and go, but the unique experience of every show remains with all of us who have been lucky to be part of it.

Andy McIndoe, managing director, Hillier Nurseries

MY CHELSEA

I've been involved in the preparation of plants for Chelsea for Hillier Nurseries for forty-eight years, and every one of those years has been different. Sometimes I am coaxing plants into flower days before the show; in other years everything is in the cold store from early April. One thing is certain: I work seven days a week, eighteen hours a day, in the months before the show! Since the Great Marquee was replaced by the pavilion, the plant material we use has become bigger, which means an even greater challenge in terms of handling and transport.

When I began helping with the Chelsea exhibit the focus was on rhododendrons and azaleas. Many were lifted from the open ground, either from the nursery or from the arboretum, under the direction of Sir Harold Hillier. Chelsea was the highlight of his year, as it was and still is for all of us. Harold always wanted to show everything, so often more plants made the journey to London as part of the exhibit than stayed.

Over the years the focus of Chelsea has changed. In my early days it was all about taking orders. In the Great Marquee, Tuesday morning was an exciting time, not only because of the medal results but also because of the arrival of the gardening gentry and their gardeners. We stood in suits and bowler hats, pencils sharpened and ready to sell!

Perhaps my best moment at Chelsea was winning our first Lawrence Medal (for the best exhibit shown to the Society in any one year). But each year winning a Gold Medal is just as special. I never take it for granted, and on Tuesday morning finding that Gold Medal certificate makes the weeks of preparation and all the hard work worthwhile.

Ricky Dorlay, master plantsman, Hillier Nurseries

BELOW Setting up inside the Great Marquee: the great massed mounds of the seed houses are still in evidence in the early 1960s.

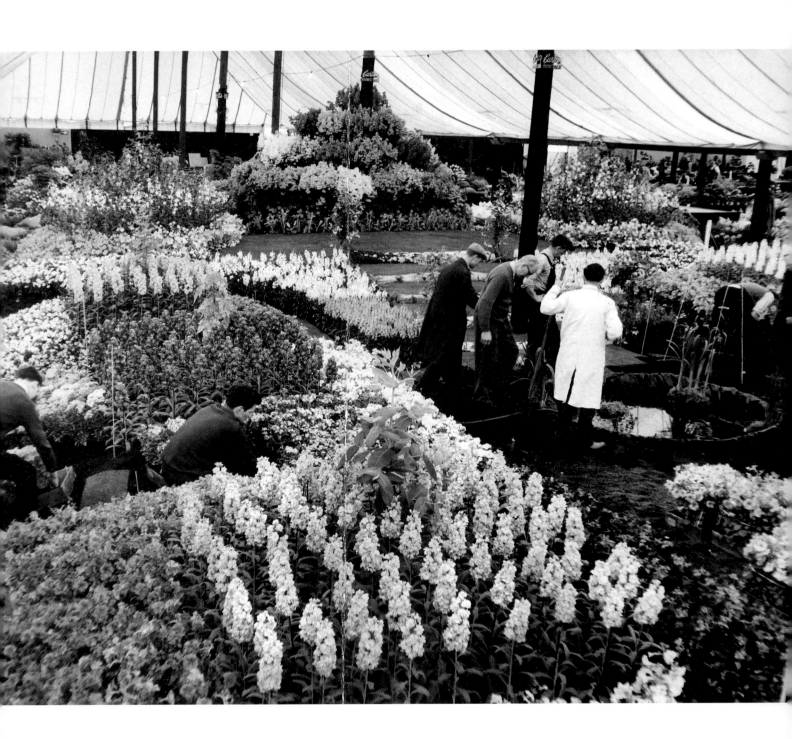

NAME Graham Stuart Thomas
PROFESSION Nurseryman and
garden designer
EXHIBITED 1956–70

GRAHAM STUART THOMAS (1909–2003), perhaps the most eminent horticulturist of his generation, attended his first Chelsea Show in 1929, while working for the alpine nurseryman Clarence Elliott. While working for Hillings, he became famous as a rosarian, but he did not exhibit at Chelsea until 1956, when he joined James Russell at Sunningdale Nurseries. By that time he had already been appointed gardens adviser to the National Trust, where he evolved a policy of providing the Trust's country houses with gardens in period style. He wrote over twenty books on roses, perennials and garden planting.

For fifteen years, Sunningdale's much-admired exhibits of trees, shrubs and roses were organized by Thomas with his assistant Granville Ellis (who in his turn trained the young Paul Temple). In 1968, Waterers acquired the nursery; it continued to exhibit at Chelsea until 1976, but Thomas had left in 1970, taking much of the old rose collection he had amassed to create a rose garden at Mottisfont Abbey. He received the RHS's Victoria Medal of Honour in 1968, and the OBE in 1975.

PLANTSMEN AND GARDEN DESIGN

Sunningdale Nurseries exhibited regularly at Chelsea from 1949 to 1976. The directors were both eminent horticulturists and garden designers: James Russell and Graham Thomas, who in the outside world was gardens adviser to the National Trust, gradually ornamenting its range of country houses with gardens designed in period styles. Within the marquee the pair effectively created tree and shrub gardens at their stands. Their rivals, in particular Hillier's and Notcutt's, also conceived of their stands as gardens, Notcutt's putting the arrangement of their stands in the hands of Mark Rumary.

Mark Rumary joined Notcutt's nursery in 1960, and three years later was made their chief garden designer, running a landscape design service alongside the nursery's retail work. From 1967 until his retirement in 1994 he organized all of Notcutts' Chelsea exhibits, winning several Gold Medals and in 1969, 1981 and 1994, the Lawrence Medal for best exhibit of the year. In 1995 he was made an Associate of Honour.

The late nineteenth-century vogue for hardy perennials, associated with the nurseries of James Kelway and Amos Perry in particular, showed no signs of abating, but the long reign of the herbaceous border as a means of their display was ending. Alan Bloom of Bressingham Gardens became famous for his concept of the island bed, promoted in books from 1957 and Chelsea stands from 1965. In 1970 his son Adrian joined him as managing director, and during the decade that followed used their exhibits to promote heathers and dwarf conifers as a combination for landscaping.

Two of the major planting fashions of the postwar years played only a minor role at Chelsea. The cult of old roses could be seen before the war in some exhibits by Bunyard, best known for fruit; while at Sunningdale Graham Thomas, the period's major rosarian, tried to build up a collection of all roses ever grown in Britain, and included these in his displays. Peter Beales followed in 1971. The fashion for single-colour gardens, commonly associated with Sissinghurst, was promoted by Mrs Desmond Underwood, who exhibited grey and silver-leaved plants from 1957 to 1977.

Traditional rock gardens may have faded from Chelsea during the 1960s, but alpine gardening did not disappear: it merely shrank. Clarence Elliott had started exhibiting

RIGHT John Brookes's plan for his Chelsea garden in 1962.

alpines in sinks and troughs in 1923, and his model was increasingly followed. By the 1970s Ingwersens had survived their competitors to be the principal alpine firm at Chelsea, no longer constructing rock gardens but exhibiting alpines for the smaller garden, following the tradition of table rock gardens. Table gardens of a different sort were presented by other nurseries, including a newcomer at the end of the 1960s, Broadleigh Gardens, with their landscapes of small bulbs.

Paul Temple emerged in these years as one of the most versatile designers in the show's history, the gardens he created at Chelsea between 1963 and 1990 ranging from tree and shrub gardens, to the 1981 rock garden which journalist and broadcaster Alan Titchmarsh praised for 'recaptur[ing] the golden age of the Chelsea rock garden bank', to his 1967 garden in association with the Electrical Development Association, in which electricity played a role in everything, including a fully automatic greenhouse.

Modernist garden design in these decades was not generally associated with an interest in horticulture. Geoffrey Jellicoe once suggested that the Institute of Landscape Architects should take over the judging of show gardens, but the RHS paid no attention. Ironically, just as the modernists seemed to be succeeding in finally shedding the legacy of the Victorian period, it began to be revived. In the 1950s, Maurice Mason began staging displays of rex begonias, plants associated with the 'subtropical' foliage movement of the 1860s, and Brian Halliwell, who furthered the subtropical revival at Kew in the 1970s, staged an immense display of ivy varieties. In the 1970s interest in Gertrude Jekyll was revived, with John Brookes designing a Jekyll garden at Chelsea in 1976. Jekyll could at least be presented as a rebel against the High Victorians, but then in 1984 Roger Sweetinburgh replicated a Victorian villa garden for *Amateur Gardening*, to celebrate that magazine's centenary, and the Victorian revival was well under way.

THE OUTSIDE ROOM COMES TO CHELSEA

In 1962 the Institute of Landscape Architects held a competition among its members for the design of a garden for Chelsea, intended to introduce more modern styles into the show. The winner was a young designer named John Brookes, who had been exhibiting garden plans since 1959. His garden featured a layout of interlocking squares, an L-shaped pool, a concrete pergola and a pavilion with a translucent roof – not to mention what was becoming known as 'architectural planting', the use of spiky foliage plants. Although the RHS made an experimental foray into architectural modernism with its Bowes-Lyon Memorial Pavilion at Wisley (with a translucent roof), it was clearly not enthusiastic about a concept of gardening which regarded plant masses as important but not the plants themselves.

In 1969, Brookes began a successful writing career with *Room Outside*, following it the next year with *Gardens for Small Spaces*, *Garden Design and Layout*, and in 1977 *The Small Garden*. During those same years he designed six Chelsea gardens, illustrating the principles described in the books. The immediate result was an increase in his commissions – nearly 200 by the end of 1974. And thus a version of the architectural modernism embodied in 1962 began to filter into the world of the small domestic garden, carried by a new formulation of the purposes of the garden. As the title *Room Outside* suggested, the small garden was conceived not as the setting of a house but as one element of the house, with particular domestic functions: outdoor eating and partying, children's play and other leisure activities were the elements around which the garden should be designed. And that entailed not only saving labour but planning levels for ease of access.

In the years 1971–3, Brookes designed three gardens for the *Financial Times*: a town garden in 1971 (Gold Medal), a suburban garden in 1972 and a country garden

EXHIBITION GARDEN PLAN

scale ¼" to 1'0"

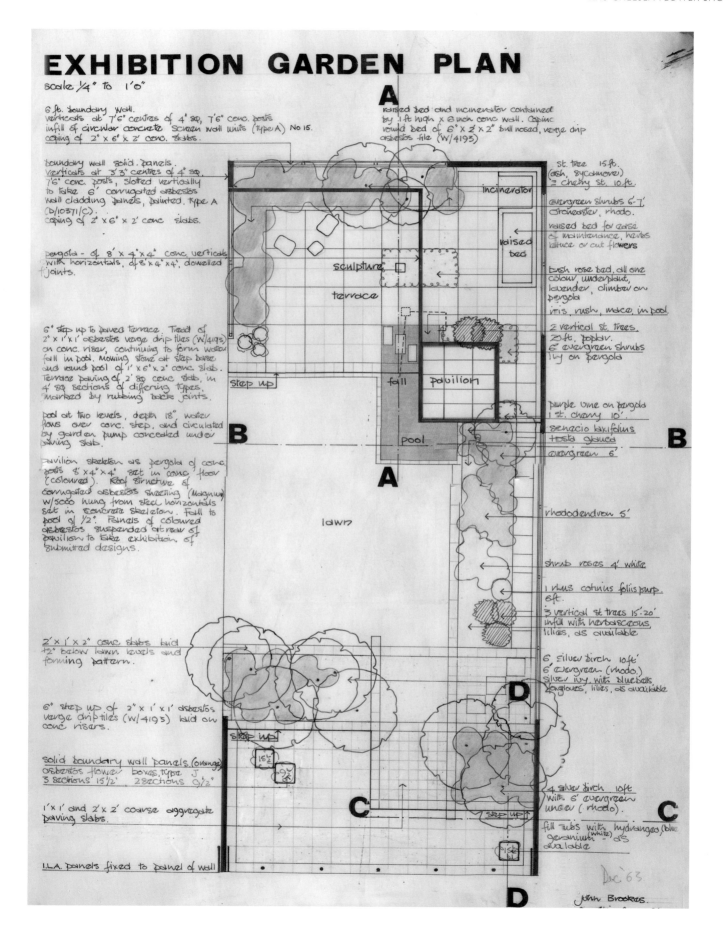

6 ft. boundary wall.
verticals at 7'6" centres of 4" sq, 7'6" conc. posts
infill of circular concrete screen wall units (Type A) No 15.
coping of 2" x 6" x 2' conc. slabs.

boundary wall solid. panels.
verticals at 3'3" centres of 4" sq,
7'6" conc. posts, slotted vertically
to take 6' corrugated asbestos
wall cladding panels, painted. Type A
(D/10371/C).
coping of 2" x 6" x 2' conc. slabs.

pergola – of 8' x 4" x 4" conc. verticals
with horizontals, of 8' x 4" x 4", dowelled
t joints.

6" step up to paved terrace. Tread of
2" x 1' x 1' asbestos verge drip tiles (W/4193)
on conc. riser, continuing to form
fall in pool. Mowing stone at step base
and round pool of 1' x 6" x 2' conc. slab.
Terrace paving of 2' sq conc. slab, in
4' sq sections of differing types,
marked by rubbing back joints.

Pool at two levels, depth 18" water
flows over conc. step, and circulated
by garden pump concealed under
paving slab.

Pavilion skeleton as pergola of conc.
posts 8' x 4" x 4" set in conc. floor
(coloured). Roof structure of
corrugated asbestos sheeting (Magnum
W/5000 hung from steel horizontals
set in concrete skeleton. Fall to
pool of ½". Panels of coloured
asbestos suspended at rear of
pavilion to take exhibition of
submitted designs.

2' x 1' x 2" conc. slabs laid
½" below lawn levels and
forming pattern.

6" step up of 2" x 1' x 1' asbestos
verge drip tiles (W/4193) laid on
conc. risers.

solid boundary wall panels (orange)
asbestos flower boxes, type J
3 sections 15½'. 2 sections 9½".

1' x 1' and 2' x 2' coarse aggregate
paving slabs.

I.L.A. panels fixed to panel of wall

raised bed and incinerator contained
by 1 ft high x 8 inch conc. wall. coping
round bed of 6" x 2 x 2" bull nosed, verge drip
asbestos tile (W/4193)

st. tree 15 ft.
(ash, sycamore)
2 cherry st. 10 ft.

evergreen shrubs 6'-7'
cotoneaster, rhodo.

raised bed for ease
of maintenance, herbs
lettuce or cut flowers

bush rose bed, all one
colour, underplant,
lavender, climber on
pergola

iris, rush, mace, in pool

2 vertical st. trees,
20 ft. poplar.
6' evergreen shrubs
ivy on pergola

purple vine on pergola
1 st. cherry 10'.

senecio laxifolius
hosta glauca
evergreen 6'

rhododendron 5'

shrub roses 4' white

1 rhus cotinus foliis purp.
6ft.

3 vertical st trees 15'-20'
infill with herbaceous,
lilies, as available

6. silver birch 10ft'
6' evergreen (rhodo.)
silver ivy, with bluebells
foxgloves, lilies, as available

4 silver birch 10ft
with 6' evergreen
under (rhodo).

fill tubs with hydrangea (blue
geranium (white) as
available

incinerator

raised
bed

sculpture

terrace

step up

fall

pavilion

pool

lawn

step up

step up

step up

Dec '63.

John Brookes

in 1973. In these he worked in collaboration with Arthur Hellyer and Robin Lane Fox, the newspaper's gardening correspondents, and produced gardens that combined modernism and family-oriented planning with a palatable degree of horticulture, sufficient to win the approval of Percy Thrower, who reviewed Chelsea for *Amateur Gardening*. The 1971 town garden, which had no lawn but rather gravel and paving surrounding a water canal, included a small vegetable garden, cordon fruit trees and a sink garden; Thrower said that 'it was something I should have been proud to own'.

In 1975–7 Brookes designed three gardens for the Inchbald School of Design, and became stylistically more adventurous, or at least more various. In 1975 he designed a potager (illustrated in his 1977 book *Improve your Lot*). Following the publication of Betty Massingham's biography of Gertrude Jekyll in 1975, Brookes created in 1976 the 'Jekyllian' garden that was the first public sign of the Jekyll revival. How far in advance his attempt to produce a version of Jekyll's style was may be seen from Anne Scott-James's review: 'But how Jekyll-ish was it really? . . . Would she, for instance, have allowed a painted wood seat, albeit a Lutyens seat, in her garden, being always such a champion of the natural material? I just don't know. However that may be, the garden was elegantly planted with green and white flowers and foliage plants, and had classical statues and a small round pool. Such a garden would be a joy in London.' The garden received a Gold Medal – the RHS no doubt welcomed the greater attention paid to plants. Finally, in 1977 he produced a Moorish garden (Silver-Gilt Flora Medal), signalling the interest that would lead him to write an historical study of Islamic gardens a decade later.

THE FIRST CELEBRITY GARDEN DESIGNERS

The last quarter-century has seen the rise at Chelsea of the celebrity garden designer, whose face appears and whose designs are discussed on television. But the first symptoms of this syndrome can be seen as far back as 1976.

Famous designers had created gardens at Chelsea for decades, but as we have seen in many cases their names did not appear in the catalogue. If the designers represented no one but their own practice, financed their garden themselves and used the garden as publicity for their firms, then they were named in the catalogue as the designer; examples include Percy Cane and Ralph Hancock, Eleanour Sinclair Rohde, the garden historian and herb farmer who exhibited a single garden, in 1921, and the Misses Hopkins, who showed gardens in the first years of Chelsea. If the garden was the work of a nursery with a landscaping division, the nursery was named in the catalogue, but not the employee who made the design. If the garden was sponsored by a company, a publication or a society, the organization was named, but not the designer contracted to make it. You might learn the identity of a designer from reviews in the magazines, but the role of people like Sylvia Crowe, Russell Page and John Brookes in making important and influential gardens at Chelsea cannot be deduced from anything the RHS produced at the time.

The first breach in this wall of silence was made in 1976. For the first time, both the sponsor and the designer of one garden were credited for a garden sponsored by *Homes and Gardens* and designed by David Stevens. In 1977, Stevens designed a further garden for the same sponsor, a courtyard or terrace garden intended to be equally applicable as a roof garden. *The Garden*'s reviewer praised the general planting – 'carefully chosen for their soft association of greens, whites, blues and greys' – but queried 'why include a pot of cotton grass (*Eriophorum*) in water in the small pond? So pretty in the wild, these have

never been used as water plants and still less should they be grown in town.'

Then in 1978 the husband-and-wife team of Faith and Geoff Whiten were credited with designing a garden for *Practical Householder Magazine* (for whom they made two more gardens over the next few years). In 1980 their garden, praised in *Amateur Gardening* as 'highly original', featured large rectangles of paving surrounding a formal waterfall, but with heavily planted beds and tracts of trelliswork. The balance of paving and planting was a characteristic of both design teams.

For a decade, Stevens and the Whitens were the only garden designers singled out in this way. The names of other designers finally began to appear alongside the sponsors in 1987, and from 1988 on virtually every garden was jointly credited.

BELOW, LEFT David Stevens's garden for *Homes and Gardens* magazine, 1976.
BELOW, RIGHT David Stevens's plan for his 1976 garden.

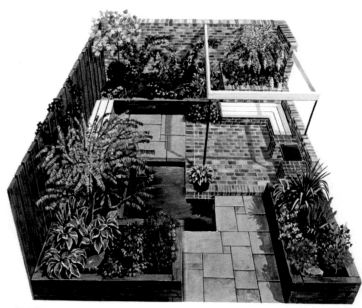

BELOW The President's Award, presented each year for the President's favourite exhibit.
RIGHT The fruit and vegetable committee judging in 2000, with Jim Arbury, the committee secretary, in the background. At the left is Medwyn Williams, the greatest vegetable exhibitor of recent times.

JUDGING

In 1929 Ellen Willmott of Warley Place in Essex served as a Chelsea judge, and remarked that she wanted to give everyone a prize. Exhibits and gardens are awarded medals on a scale from Bronze, through Silver and Silver-Gilt, to Gold; there have been various other medals at different points in Chelsea's history, as described on page 131, as well as two awards that bypass the normal apparatus of judges and assessors: the President's Award, sometimes described in the press as the highest award on offer, and the People's Choice Award for best garden, the result of a poll of the visitors.

Judging takes place the day before the show opens to the public, after the press have departed. The judges submit their reports to Council, who sit through the night debating and making the eventual decisions about awards. The following morning, award cards are distributed to the stands and gardens, in a ritual now familiar to all from the BBC coverage.

The judging of gardens is more complex than that of stands, as purely aesthetic criteria come into play. Exhibitors are asked to submit statements of intent, so that the gardens are judged not abstractly but against an agreed criterion. The gardens are first examined by a team of assessors, whose reports on the degree to which the intention has been met are given to the judges to prepare them for the final judgment.

Judges are chosen for expertise in their particular exhibition categories, but they cannot be expected to know everything. Graham Thomas once recalled: 'We habitual visitors can usually put a name to all the major exhibits before the firms' name cards are displayed, and, on one occasion, confronted by a superb mountain of annuals and popular flowers I murmured out loud to myself "Sutton's, I expect," whereupon a little man I had not seen behind the tower of *Salpiglossis* popped out and put me thoroughly in my place by exclaiming "'T'aint, it's Carter's."'

MY CHELSEA

Bowler hat and furled umbrella were the traditional uniform for RHS Council members at Chelsea Flower Show (yes, they were almost all male). Until the 1980s the show garden judging was completed in an hour or so on the Monday by all members of the Council. Guided only by the catalogue entry and the President's comments, they awarded Gold, Silver-Gilt, Silver and Bronze Medals peremptorily, according to the number of raised umbrellas. My introduction to this effective, if a trifle arbitrary, procedure was in response to a rising tide of polite protest among professional exhibitors. In 1985 I was the junior member of a panel of three assessors, including Arthur Hellyer, charged with looking in advance at every garden in detail and reporting directly to the assembled Council members before each garden was judged. We did our best, but Lord Aberconway, the President, was not a patient listener. I remember wondering why we had been asked! But the idea caught on and the procedure was steadily developed into what is now a model of fairness and thoroughness with a complicated set of checks and balances inconceivable thirty years ago.

John Sales, RHS judge of show gardens since 1985

FINISHING TOUCHES

Gardens and exhibits must be put together in ten days on site, but before the hectic activity of building and tweaking there are months of planning and preparation. Nurseries and construction companies – like Mark Fane's celebrated company Crocus, which since its founding in 2000 has been involved in twenty Gold-Medal-winning gardens – have to start growing their intended plants a year in advance. But even before that, the planning process begins fifteen months in advance within the RHS shows department. The complexity of shows management increased steadily after Mavis Sweetingham became the first Chelsea show

manager in 1987. She retired in 2003, to be awarded an MBE the next year; she was succeeded first by Anita Foy, and then in 2007 by Alex Baulkwill (later Alex Denman), who put together a team of five, all female, to look after all aspects of Chelsea administration.

Shows staff, exhibitors and press have developed rituals of gregariousness over the years. The BBC now stages an annual competition in the hospitality village for the best miniature garden created by one of its teams; the shows department takes part. Competitors must submit briefing notes, and prizes are awarded – in the form of photocopies of award cards.

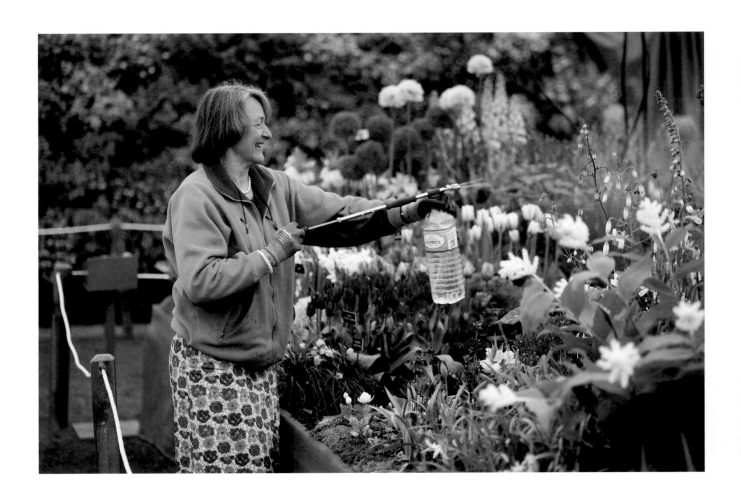

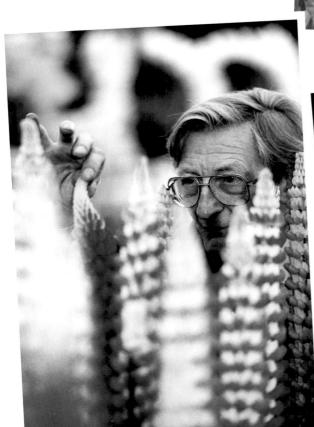

OPPOSITE Lady Skelmersdale watering her Broadleigh Gardens stand in the pavilion, 2012.
THIS PAGE Clockwise from top left: plants wrapped in newspaper for protection during transit, being placed on a stand in 1961; an exhibitor uses hairdryers to blow warm air onto her irises, 2008; flowers covered with paper bags for protection in transit, 1937; Maurice Woodfield checking the lupins on the Woodfield Brothers stand, 1991.

LEFT Catching them young: a two-year-old child gets an overwhelming impression of Blackmore & Langdon's delphinium collection in 1971.

CHELSEA AND THE MEDIA

Press day – or actually press morning, since the grounds have to be cleared for the royal family by mid-afternoon – is the moment when the exhibits and gardens have become mature enough to be judged, but are not concealed by crowds. Over the century gardening journalists have wandered through, noting what to report to their readers, from A.J. Macself and H.H. Thomas in the early years, through Roy Hay and Percy Thrower fifty years ago, to Fred Whitsey and Jack Wood in more recent times. Today magazine journalists tend to be overshadowed by concentrations of cameramen and interviewers.

The RHS quickly became involved in the new medium of radio: even before agricultural broadcasting began, the Society was contributing bulletins on gardening to the BBC from 1924. In 1931 the BBC decided to use professional announcers, and the RHS put them on to C.H. Middleton, who became the radio voice of the 'Dig for Victory' programme. But radio had little impact on Chelsea, and vice versa.

Television was another matter. Percy Thrower began to present gardening programmes on television from 1952, but the RHS was this time slow to adapt, and in particular kept commercial television at a distance. In 1958 the BBC began to give Chelsea what was then described as full-time coverage (though small by comparison with today). In 1988 the BBC planned a seventy-fifth-anniversary celebration of Chelsea, and proposed the production of a videotape that would be offered for sale; thus began the RHS's involvement with video and, eventually, DVD. In the 1990s the amount of screen time devoted to Chelsea was increased, with Alan Titchmarsh as the lead presenter, but the RHS became concerned that the horticultural content was being diluted, with too much emphasis being placed on the celebrities who gathered on press day. In 1998 the Society's Director-General, Gordon Rae, negotiated a new contract which gave Channel 4 the rights to Chelsea coverage for a four-year period. The BBC resumed normal service in 2002, but on the understanding that they needed to give more attention to the aspects of Chelsea that the RHS wanted to promote.

Chelsea coverage soon spread to cover the entire week, with lead-in programmes on the weekend before opening, small items each weekday morning during the show and one or more early evening slots – extended into the weekend once Chelsea itself was extended to the Saturday. Alan Titchmarsh continued in his role as lead presenter, assisted by Joe Swift and Carol Klein of Glebe Cottage Plants, who led the cameras away from the display gardens and into the marquee to look at actual plants.

There have been many mixed reviews of the coverage of Chelsea: too much emphasis on gardens and not enough on plants; too much banter among celebrity presenters; too many gimmicks; too much music . . . But from the RHS's point of view, every May, horticulture gets eleven hours of prime-time television, and is featured for a week on the front pages of the major newspapers. And not only in Britain. Nearly every year since 2004, the travel company Trailfinders has sponsored a garden, put together by the Australian nursery Fleming's; every year, as a result, Chelsea features on Australian television, and Fleming's has been able to argue for the importance of horticulture at a time of financial cutbacks.

Legend had it in the shows department that in the 1950s Winkfield Manor Nurseries had girls in swimsuits posing in one of its gardens on press day, and that Arthur Simmonds, the RHS's assistant secretary, invoked the 'no livestock' rule to have them removed. Ambrose Congreve, the nursery's proprietor, indignantly denied the story when it was published in the 1980s. Today it is not unusual for this sort of livestock to appear in gardens on press day.

MY CHELSEA

Garden photography can be a lonely business. Our working day normally involves traipsing across the countryside at unearthly hours in the morning, and engaging with a garden entirely on our own. Chelsea is a highlight in our working year because we get to meet up with each other and to share our slightly insane timetables. The 5.00 a.m. start on press day is an essential requirement for the best pictures, but for us there is a social buzz about it as well. Although we are competitors, we are friends too. There's an unspoken etiquette about photographing Chelsea, and we tiptoe around each other, trying not to block another's view, or to shake the boards on which the tripods stand.

Photographers at Chelsea look hard and long at the gardens, and develop a very good judgement of which are best. Early on press day the biggest gaggle of photographers around a garden is a pretty sure predictor of Best in Show.

The early morning advantage is over by 8.00 when the grounds fill up, and then comes our social highlight, which is breakfast together in the exhibitors' restaurant. Some years we adjourn to make a team photo of the whole group. This tradition began around 1990 when there were maybe a dozen of us in the picture. Nowadays it can be nearer sixty.

With this number of photographers at Chelsea, it is a mystery to me what happens to all the pictures we take. We are all frantically photographing the same things and there is a limited market for the pictures. Yet we flog ourselves to exhaustion. I think that this is partly through a competitive urge to make a better picture than our colleagues. But it is also because taking pictures is our response to beautiful gardens and, surrounded by the stimulation of Chelsea, we cannot stop ourselves.

Andrew Lawson, photographer

MY CHELSEA

The Bull Ring Gate, RHS Chelsea, May 1980. 'No, you can't come in yet: it's only quarter past five,' said the man at the gate.

This was to be my first morning as a garden photographer at the RHS Chelsea Flower Show. The light was already, well, lovely, but, thanks to this rather serious gent, moustached and in uniform, I was unable to get in. He had probably never enjoyed the delights of Claude Monet's misty paintings at Giverny. I waited. Meanwhile, the sun was rising and the softness was evaporating . . .

Fortunately, the RHS shows director, Allan Sawyer, passed by and had a quiet word. Inside, I found that the only other beings inside the multi-tented showgrounds were a dog-handler and his Alsatian. Otherwise I had the place to myself. Nowadays, there are many more early morning photographers, from around the world.

I trundled along the show's Embankment gardens and then sharp left along the wide Main Avenue. On either side were gardens which had been built and created over three weeks. They were backed on the right by a vast avenue of London plane trees, through which the sun sparkled on to the gardens below.

That year, 1980, was also the fifth of the legendary plantswoman Beth Chatto's eleven years at Chelsea, inside what is now the Great Pavilion. Except for the first year (when she won a Silver-Gilt) Beth habitually won Gold Medals for her displays of species plants. Some of these she had found while she and her husband, Andrew, were climbing in the Dolomites: among them *Polygonum bistorta* and several hostas. At Chelsea Beth planted her discoveries geometrically on pyramid structures, at differing heights, on a square of tables. In the middle, she and her staff were inundated by admiring crowds all day long, seduced by the enviable Chatto style.

In later years on the avenues, great Chelsea stars of landscape architecture emerged: Christopher Bradley-Hole, Tom Stuart-Smith, Arabella Lennox-Boyd, Andy Sturgeon, and then, from abroad, Piet Oudolf (Holland) and Ulf Nordfjell (Sweden), all of them Best in Show

winners. In 2007, Nordfjell, like all Chelsea Show garden-makers, had spent months ensuring that his plants would flower on cue for the Monday morning judging committee in his first Chelsea year. He was awarded a Gold Medal but had to wait until 2008 to be awarded Best in Show, with a new design. Why? In 2007 the carefully sculpted white blossoms of Siberian crab apple trees failed to flower until four days later, too late for the judging. Such is the precision of Chelsea.

Three years ago, my annual photoshoots at RHS Chelsea Flower Show had to stop. I expected to miss being there – and I do.

Jerry Harpur, photographer

MY CHELSEA

Watching the show develop over the last forty-odd years has been a fascinating experience. While the high standard of exhibits might have been constant, the style and content of the show have changed out of all recognition. The show is far more varied than it used to be – something that keeps gardening fresh and gardeners on their toes. The show gardens in particular really do reflect and even kick-start trends, and I enjoy the controversy they engender. My first walk-round on the Sunday before the show opens always gets the adrenalin flowing: seeing how one's friends have done with their designs; choosing which gardens one could live with and which would drive one nuts; meeting growers and looking at their new plants; deciding which things are 'must haves' and those that are, just occasionally, hideous.

The show has been a fixture in my diary every year since the late 1960s, and being a part of the broadcasting team for thirty years now (my first broadcast from Chelsea was in 1983) has been a tremendous privilege. The only trouble is that, as one gets older, it seems to come round faster each year! My best moment was winning a Gold Medal in 1985 for a garden I designed and built for *Woman's Own* magazine.

Alan Titchmarsh,
gardener, writer and broadcaster

ALAN TITCHMARSH

Alan Titchmarsh is the best-known television commentator on gardening. Trained in Ilkley Parks Department and Kew, he became assistant editor at *Amateur Gardening* before embarking on a freelance writing career in 1979. He has written several gardening books (not to mention novels and memoirs) as well as gardening columns in various newspapers. Having had experience as a radio broadcaster, he moved into television, and in 1983 joined a new programme called *Breakfast Time*, which involved him presenting Chelsea.

He has since been a regular presenter of the BBC's Chelsea coverage, interrupted only in the years 1999–2003, when Channel 4 held the contract. From 1996 to 2002 he was the main presenter of *Gardeners' World*, and from 1997 to 2003 he was part of the team presenting *Ground Force*. He was awarded the RHS's Victoria Medal of Honour in 2003, and the MBE in 2000; he became a vice-president of the RHS in 2009. He has been named Gardening Broadcaster of the Year four times by the Garden Media Guild.

BELOW A poster for the 1973 Chelsea Flower Show, designed by Tim Demuth and published by London Transport.

ACCESSIBILITY AND DISABILITY

The first garden for the disabled at Chelsea, staged in 1967, had been proposed by the Central Council for the Disabled, and was designed by their Disabled Living Activities Group, the result of three years' experiments and deliberations. It contained raised flower beds, a raised pool 2–3 feet off the ground, together with a lawn, terrace, non-skid paths, herbaceous border and greenhouse. There was also a tool shed, with tools selected for their utility for the disabled. An occupational therapist was in attendance to deal with enquiries through the week. There was only one problem: 'The R.H.S. had regrettably to discourage organized parties of disabled visiting Chelsea on account of the very real danger from crowds.' But arrangements had been made to reassemble the disabled garden at Syon Park, which had recently opened a garden centre and was capable of dealing with access. The cost of recreating the garden there was estimated at £1,000 (equivalent to £14,000 today). It was not until 1974 that a model garden for the disabled was planned at Wisley, with grant aid from the Reader's Digest: the first model garden there not devoted to food production on a small site, it was opened in 1977.

The problem of disabled access to the show did not go away. In the mid-1970s the question of guide dogs for the blind was raised insistently, and in 1975 Council decided to provide human guides for any blind people who arrived, but not to allow dogs. For one thing, it was pointed out that the dogs stood a high chance of being injured in the crowds. In January 1976, *The Times* published a letter from Lord Snowdon attacking the RHS, and the correspondence boiled to the point where the President began a letter of reply by saying, 'I do not care what people think of me: I can however no longer refrain from saying that my colleagues on the RHS Council and our officers are not patronizing or insensitive people: still less are they imbued with fascist arrogance.' The Minister for the Disabled, Alfred Morris, intervened and arranged meetings, eventually announcing that blind visitors would be provided with human guides, and guide dogs kennelled while their masters were in the show. Despite the fact that this was simply a restatement of Council's existing policy, the Minister presented it as a climbdown on the part of the RHS.

CHELSEA WEATHER

Chiswick weather, which had had such a devastating impact on the 1829 show, did not take long to move to Chelsea. The first shows were bright and sunny; those of 1915–16 suffered from heavy rain. In 1932 the rain was so severe that an exhibited summerhouse fell to pieces. Localized flooding occurred also in 1971, and in 1995 the roof of the RHS Enterprises kiosk collapsed under the rain, with much damage to the book stock available for sale. The alpine nurseryman Clarence Elliott, having once been suddenly drenched by an overflowing gutter, quipped, 'Now I know why it is called the Chelsea Shower Flow.'

On the other hand, in 1922, 'The heat was so great on the day before the show opened that, no matter how willing the workers were, they could not do the results justice. Consequently the exhibits were not so complete as usual early on the opening day.'

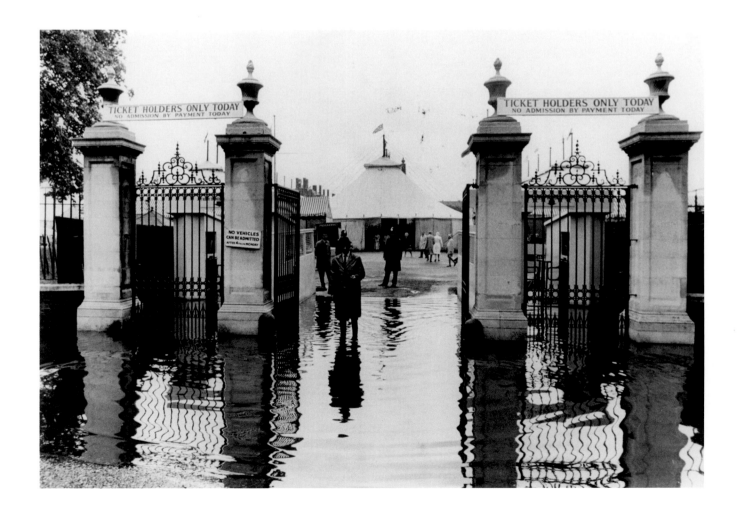

OPPOSITE 1971 was a bad year for flooding at Chelsea. **THIS PAGE** Clockwise from top left: the homemade approach to protection from the rain; the royal visit to Chelsea, 1999, being rained on; yet more rain in 2000. By contrast, the overheated show of 2010, when the provision of Pimms proved a blessing.

CHELSEA ECCENTRICITIES

English life being what it is, Chelsea has had its fair share of eccentrics exhibiting over the years. Even before the First World War there were that exuberant flat-earther Walburga, Lady Paget and the entomologist Montagu Summers, who showed paintings of insects incorporating real insects. But horticultural eccentricity played no significant part at Chelsea until 1981, when an exhibit from the Belgian Ministry of Agriculture nonplussed the critics. John Street described it as 'bizarre to the point of being outrageous'. Alan Titchmarsh described it as 'a cross between something out of Disneyland and an Arcadian landscape. Six-foot high cedars grew out of gigantic bowls [Street said 'flying saucers'] supported on thick wooden legs, and the entire construction was underplanted with a sea of conifers and rhododendrons' – 'after the manner of Victorian summer bedding', added Street.

The age of the conceptual garden brought a rich harvest of quirks and eccentricities. A decade after the Belgian exhibit, the *Daily Telegraph* garden sported a topiary figure at one corner of its formal herb garden, of which Jane Taylor said: 'I was doubtful about the topiary lady, who appeared to have tipped on to her backside in the charming parterre of neatly clipped box.' In 2001 there was the Merrill Lynch Garden for Learning with its charcoal globe and worm-like hoops; in 2006, the turf sculpture of a sleeping woman in Marney Hall's Garden of Dreams; and most eccentric of all, in 2008, James May's Paradise in Plasticine garden.

OPPOSITE James May's Paradise in Plasticine, 2009.
THIS PAGE Clockwise from top left: a tree adorned with teabags instead of flowers, 1994; a living statue at the Bradstone Fusion Garden, 2011; land sculpture of a reclining female, in Marney Hall's 4Head Garden of Dreams, 2006; 'Planting the Idea', an educational exhibit by Knightsbridge School, in the pavilion, 2012.

6

IN THE GLARE
OF THE MEDIA
THE 1980S & 1990S

Back in 1950, Lord Aberconway, the President of the RHS, had said that 'no one could have the Derby or a Test Match to one's self, and no one could expect to have Chelsea Flower Show to himself'. Even then it was an unrealistic comparison. In 1979, for the first time, the show became so crowded that the entry turnstiles had to be closed, and further admissions prevented until the grounds had cleared. The following year, in the hope of avoiding a similar problem, the show was opened earlier (8.00 a.m.) and closed later (8.30 p.m.), and a one-way system was put into effect in the marquee.

All this reduced the pressure somewhat, but only for a while. In 1987, once again, the turnstiles were closed, and Council determined to be more radical. It was announced that in 1988 a ceiling would be imposed on the number of tickets sold; the figure of 40,000 visitors per day was agreed to be the maximum acceptable, and all tickets were to be booked in advance. By April everything seemed to be going wrong. So few tickets were being sold that an advertising campaign was hastily initiated to encourage visitors, and the ban on tickets sales at the gate was removed. Ticket sales mounted gratifyingly, but a new phenomenon made itself felt, and has never since gone away: ticket touts, selling unused tickets at inflated prices.

The later 1980s saw a cloud hanging over the future of Chelsea. Should the Royal Hospital site be abandoned, and the show moved to a larger venue? Battersea Park was an obvious choice, just across the river; Osterley Park was seriously proposed, and Regent's Park; Wisley loomed hopefully in the distance. Land Use Consultants was commissioned to investigate these options, and ended by deciding that no other option would be as successful as Chelsea.

Help arrived from an unexpected quarter. In 1990 a new flower show was established at Hampton Court Palace, in a joint venture between Historic Royal Palaces and Network Southeast. The show, held in July, achieved 300,000 visitors, and continued until Network Southeast announced that it would no longer

LEFT Robin Williams's Across the Generations garden for Help the Aged, 1993.

MY CHELSEA

My love affair with Chelsea started when I visited the show for the first time in 1952.

In 1977 I joined the shows department as secretary/assistant to the show manager and over time my role as assistant increased. Finally in 1987 I became Chelsea show manager – the first woman to hold the post. The show had become my passion and all my energies were devoted to ensuring a smooth, well-run show for exhibitors, contractors, the Royal Hospital, the members and the public.

My tenure saw the show expand to include the Ranelagh Gardens and the replacement of the canvas Great Marquee with the taller modern pavilion. I retired in 2003.

Over the years the weather provided excess rain, drought, snow and high winds, with which the RHS team and the exhibitors had to cope to produce shows of which I have been inordinately proud.

Very late on Monday night when we used to deliver the award cards in the Great Marquee, the calm and the perfume of the plants gave me a marvellous sense of inner peace, as I knew that the show was ready for the members and our high standards had been maintained.

Of very many great memories, my best was the realization that the steps into the Ranelagh Gardens had been named the Sweetingham Steps.

Mavis Sweetingham, RHS show manager 1987–2003

continue to subsidize it. The future of the show was open for bidding; the RHS, which already had the necessary infrastructure for running large shows, was successful, and from 1993 Hampton Court became an RHS show. Within a couple of years a new hierarchy of shows had been worked out: exhibitors were encouraged to start in Westminster, move on to Hampton Court and, having proved themselves there, make the final push to Chelsea. Hampton Court was much more spacious; nurseries as well as sundriesmen were allowed to sell their stock during the show; it could satisfy the demands of a large portion of the shows audience, and leave Chelsea to continue its accustomed practices without the traditional grumbles. Chelsea could now be positioned as the horticultural peak among flower shows.

To be the peak among flower shows required efficient organization. Allan Sawyer, Ron Sargent's successor in the 1970s, was succeeded as head of shows by Geoff Harvey, and Geoff by his assistant Stephen Bennett, who reorganized the shows department in the later 1980s, putting Mavis Sweetingham in charge of Chelsea. One of her major tasks was to select potential new exhibitors who showed promise at

the Westminster shows, and groom them for the next stage; Jekka McVicar recalled that after winning a Silver Medal at an October show, '[we] were then "persuaded" by Mavis Sweetingham, in her usual forceful manner, to do Chelsea'.

But efficiency of organization brought its own problems. In the early 1990s Joni Nelson, an American attorney, determined to create a major flower show in California, and set up the Chelsea America Foundation. The shows department was generous with advice, and then found that American horticulturists were under the impression that the California show was being staged with the RHS's assistance. A flurry of correspondence followed as the RHS tried to disengage itself from the venture. Worse still, the 'Chelsea America' logo had been registered as an American trademark, with the result that the RHS could not sell any merchandise in America that bore the word 'Chelsea'; an attempt to stop the use of the word 'Chelsea' by the Foundation was defeated in the American courts. (In Japan there is a brand of butterscotch that bears the logo 'Chelsea – the taste of old Scotland'. One wonders what would happen if that were to be marketed in the States.)

Back at home, the rituals of Chelsea had developed into a settled form. On the Monday morning the press arrived, increasingly accompanied by television crews, to record their impressions of the show. A Chelsea lunch was held for Council, relevant committees and dignitaries, with a guest speaker (frequently the current Minister for Agriculture). Then the showground was cleared of most of its occupants, and the royal family arrived in the late afternoon for their private view. Finally, Council held an evening meeting to assess the judges' recommendations and make the final allocation of medals. On the Tuesday morning the award cards were distributed. A major addition to this process came in 1989, when the first Chelsea gala was held on the Monday evening after the royal family's departure, to raise money for both the RHS and another nominated charity, which in 1989 was Help the Aged. The gala proved a success, and has continued to the present day, bringing in some 5,000 people each year at a cost of £350 per ticket. In due course galas began to be held at the Hampton Court show, and a special events department was set up – within the framework of the shows department – to administer them all.

The prohibition of selling plants at Chelsea continued, but sundriesmen enjoyed their new-found freedom to sell goods at their stands. In 2001 *Country Life* complained that the show was becoming 'a horticultural shopping mall'. At the end of the show, 5.00 p.m. on the Friday (until 1999, when the time was moved back to 4.30), it was possible for nurseries to sell off their exhibited stock, and public and photographers alike relished the scene of impossibly heavy and cumbersome plants dwarfing the people who were carrying them away. The nearest Underground station, Sloane Square, not only put special traffic arrangements into effect for the duration of the show but had to suffer the build-up of horticultural litter on the platforms, as train doors closed unforgivingly on delphinium stems and collisions shed leaves over the floors. (From 2005 the show was extended for a further day, so the sale was relocated to the Saturday.)

The 1960s and 1970s had seen controversies over disabled access, the 1980s overcrowding; in the 1990s the controversies over gardens began. Fortunately, political controversy over gardens has been minimal in the show's history: in 1986 Newham Council withdrew its proposed exhibit in protest against the inclusion of a display by the government of South Africa, but that is the only such incident so far. The politics of environmentalism, however, surfaced more than once: in complaints about firms using tropical hardwoods for garden furniture, and in agitation over the stripping of stone from limestone pavements, the subject of an article in the *Daily Telegraph* in 1990. These issues, of course, extended beyond Chelsea alone, and a conservation working party was set up to decide on a Society-wide policy for the RHS. In 1994 there were calls for a limestone rock garden by Peter Tinsley to be banned, but Council ruled that it was not in breach of the rules, which were still being formulated.

Matters of style, extending to matters of definition, were another matter. For most of the postwar years, it was the modernists who complained about Chelsea gardens for being traditional, unadventurous and repetitive, as when John Brookes said of David Stevens's 1985 garden that it was 'one of the millstream syndrome', adding that 'the whole Modern Movement might never have existed within the acres of Chelsea Hospital surround during May'. That was to change. The award of Best in Show to Julie Toll's 1993 seaside garden (see page 146), which many people did not regard as a garden at all, led to calls for the exclusion, or else assignation to a separate category, of things that were not 'real gardens'.

The 1980s also saw some populist ventures on the part of the RHS. In 1987 it instituted a window box competition, and the following year a competition for hanging baskets. Never mind that the hanging basket had been invented by the Society's founder Sir Joseph Banks (as a means of growing epiphytic orchids); a prominent segment of the horticultural press looked down its collective nose at it, and regarded the competition with distaste.

Nonetheless, these competitions continued for several years, with hundreds of entrants. Even more popular, and continuing to the present day, were competitions for floristry and for the best young florist of the year.

SCULPTURAL BEDDING DISPLAYS

The use of carpet bedding (patterns created with dwarf succulents and creeping foliage plants) to make three-dimensional figures had been a mainstay of municipal parks in the first half of the twentieth century – the park superintendent's annually redesigned counterpart to topiary. Sneered at by the pundits of horticultural fashion, it was dying out in the second half of the century, when its revival was spearheaded at Chelsea. In 1966 Hove showed a copy of its floral clock; in 1977 the Royal Parks showed a floral crown for the Queen's Silver Jubilee, and two years later a carpet-bedded swan. When in 1981 they showed a simpler, flat display of the Prince of Wales's feathers, the *Gardeners' Chronicle* condemned this revival of a genre of planting that 'should long since have been forgotten'.

In 1983 Torbay Council staged an exhibit of a cottage garden, complete with a cottage in carpet bedding, and this time the *Chronicle* thought it was 'delightful'. Bob Sweet, the Parks director, went on to produce a series of Gold-Medal-winning displays with figures such as the Pied Piper of Hamelin. Torbay was followed by other local authorities, and sculptural bedding, now regarded as craftsmanship horticulture, has appeared at nearly every Chelsea in the past thirty years.

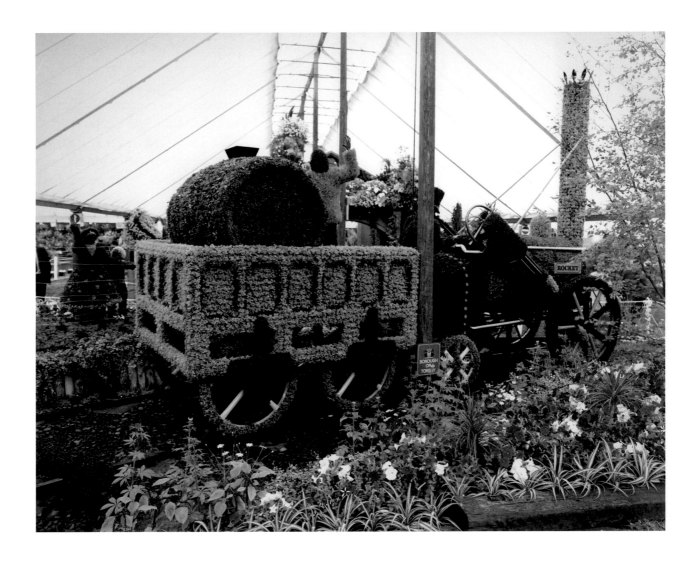

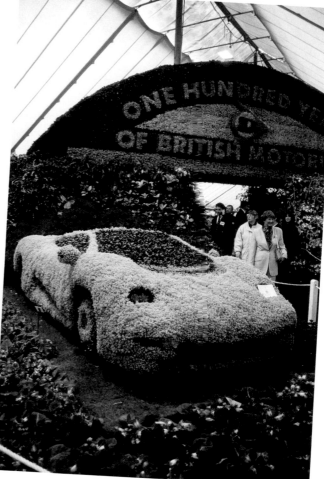

OPPOSITE One of Torbay Borough Council's displays of sculptural bedding: Stephenson's *Rocket*, created by Bob Sweet and his colleagues, 1988.

THIS PAGE Clockwise from top left: floral display for the Queen's Diamond Jubilee, 2012; Birmingham City Council's 1996 exhibit to celebrate 100 years of British motoring; the National Farmers' Union map of Britain in carpet bedding, 1981.

SPONSORSHIP

In the wake of *The Times*'s Garden of To-morrow in 1959, the RHS began to accept other newspapers and gardening magazines as sponsors of Chelsea gardens. In the 1980s the number of sponsors began to multiply: the Halifax Building Society, B&Q, McAlpine Homes, local horticultural societies and Help the Aged had all funded gardens by the end of the decade. In 1980 the BBC contributed £20,000 to the cost of a garden staged by the Beaminster and District Gardens and Allotment Society, and the press warned that 'This wants watching. If not, before very long, the tail of the media will wag the dog of the Royal Horticultural Society.' Over the years, as the costs of staging gardens grew, the number of sponsors for a single garden could rise to over a dozen. Among the institutions who funded gardens most regularly in the 1980s and 1990s were Pershore, Merrist Wood and Capel Manor Colleges, Wyevale Garden Centres, *Harpers*

& Queen and Sheikh Zayed bin al-Nahyan, the founder of the United Arab Emirates, who sponsored a garden every year from 1998 until his death in 2004. They were joined in the new century by Laurent-Perrier, Merrill Lynch and Cancer Research UK as annual presences.

By this time the RHS itself was seeking sponsorship for various aspects of Chelsea. Badly hit by the introduction of VAT in the 1970s, it had been forced into commerce and fundraising, creating a new company, RHS Enterprises, to handle its commercial activities. The Society began looking at opportunities for increasing revenue at Chelsea. In 1980, private hospitality chalets were provided in Ranelagh Gardens for the first time. In 2000 Merrill Lynch agreed to sponsor the entire RHS Chelsea Flower Show for a four-year period, extended to five. It has been followed by Saga, the Southowram paving company Marshalls, and M&G Investments, including in its centenary year.

LEFT Banners announcing the sponsorship of the 2012 show by M&G Investments.

SHOW CATALOGUES

The first Chelsea catalogue was the largest ever produced: conceived as a significant advance on the Temple show catalogues, it ran to nearly 200 pages and included an immense range of advertisements for nurseries and sundriesmen, in addition to the lists of exhibitors and publicity for the Society. This standard declined during the First World War, however, and it was not until 1921 that the catalogue crept back up to exceed 100 pages. These early catalogues were 21cm tall, and their front covers showed the Society's logo and a list of contents. In 1923 a linen wrapper was added, with the title 'Chelsea 1923' written diagonally across the front; that, with only the year and the colour changing, remained the front-cover pattern for years. In 1929 the height of the catalogue was extended to 23.5cm; after the war it shrank back to 21cm, its height to the present day. The calligraphic title was changed to Roman letters in 1951; in 1963, for the fiftieth anniversary, a shield with the Society's official apple tree featured as a cover design, and this remained constant until 1967, apart from three years in which a strelitzia appeared instead.

From 1974 the cover design changed annually, and eventually used the same design as the year's Chelsea poster. Alec Bristow, one of the great promoters of allotments, who managed the Society's first ever market research survey in the 1970s, emphasized repeatedly that a poster on the Underground must convey its message within six seconds: this rule governed the presentation of posters and catalogue covers for many years. From 1988 the catalogues regularly included a selection of photographs of the previous year's show, and over the succeeding years they have become increasingly decorative, including interviews with judges and exhibitors, and drawings of the show gardens.

AWARDS AT CHELSEA

The Horticultural Society struck its first medal in 1808, when it had been in existence a mere four years. Over two centuries a range of medals was gradually built up and periodically reformed. In each range of normal medals there is a hierarchy from Bronze to Silver to Silver-Gilt to Gold, the ranges including the Knightian for exhibits of vegetables, the Hogg for fruit, the Grenfell for pictures and flower arrangements, the Lindley for educational displays, and of course the Flora for floral stands and gardens. In addition, the Society maintains a number of cups and medals awarded annually for special purposes; among these is the Lawrence Medal, for the best exhibit at any of the Society's shows in a given year.

But there are also awards that have been created specifically to be given at Chelsea. In 1977 the firm of International Distillers and Vintners subsidized an award for the best overseas exhibitor at Chelsea; Wilkinson Sword took it on in 1981, but it was discontinued in 1984. Wilkinson Sword instead subsidized an award for the best garden at the show, until 1993. Today there are awards for the Best Show Garden, the Best Artisan Garden, the Best Fresh Garden, as well as awards for the Best Exhibit in the Pavilion, for the Florist and Young Florist of the Year, and most recently for the Best New Plant and Garden Product of the Year. And since 2004, there has also been the President's Award, for the President's personal favourite.

All these awards are the outcome of the process of judging. But since 2003, there has been a further award, instituted by the BBC: the People's Choice Award, for which show visitors and television viewers vote, and which is announced at the close of the show. The first garden to receive this accolade was Paul Martin's Chic Garden entitled Lazy Salad Days.

GARDEN ORNAMENT

For the first half-century of the Chelsea Show, garden ornament was a highly traditional enterprise. The firms offering decorations for the garden either drew on classical motifs – the Renaissance fountain, antique sculpture, decorative pots and jardinières based on seventeenth- and eighteenth-century precedents – or emerged from the Arts and Crafts tradition of vernacular styles and materials: rustic and thatched structures, rough-hewn stonework and brickwork. The extreme point of historical revivalism was hit by Ernest R. Smith, who offered '13th-century thatched bird tables', without indicating what documentary sources he had found for his designs. More authentic period pieces could be found from Crowther of Syon Lodge, who sold genuine antiques.

The 1960s saw the tentative arrival of abstract sculpture in the gardens of modernist designers, and by the 1990s it was possible to buy highly untraditional garden ornaments at Chelsea. Sculptures in rusted metal and wirework were followed in 2000 by the bronze goblins of David Goode – which escaped the ban on gnomes because they were not painted figures – and then by stained-glass panels, the glass and metal flower sculptures of Quist, and the tapered African figures of Zimsculpt and Guruve. Today the range of clashing styles of ornament constantly raises the hackles of critics, but it is hard to imagine an audience that is not catered for.

XIII CENTURY
Thatched Bird Tables

THERE is a never ending charm with a Heather Thatched Bird Table, apart from the degree of rusticity it creates, there is also its romantic association with an early English period when Falconry was the sport of Kings. The heather roof harmonises with all the hues, shades and shadows of the garden. The daily delight of watching the varied habits of bird life is interesting to all ages, and last but not least provides a secure haven from storms and wintry weather.

THE "BIRDS NEST"

Internal Nest	12ins. high, 24ins. wide with perches.
Overall Sizes	Roof 42ins. high, " 35ins. wide. Table 16ins. dia., 8ft. high fixed.

50/-

Carriage Paid and Packed English and Welsh Mainland S... Scotland **55/-** each. Ireland, English Ports only.

HAZEL WATTL...

For Plant Protection and Pr... with one stake to each. 24, 30, 36, 42, 48, 54, 60... Carriage Paid Prices qu... State Size. Quant...

ARTISTS and CRAFTSMEN in ...

Showrooms and Head Offices :

ERNEST R. SMITH & Co. ELECTR... HASL...

OLD WORLD GARDEN ORNAMENTS
IN SOLID BATH STONE

BIRD BATHS
DOVE COTES
BALUSTRADING
SEATS.
ALSO
OLD WALLING STONE & ROCKERY STONE OF ALL KINDS.

PLANT BOXES
GARDEN HOUSES
SUNDIALS
VASES.
ALSO
CRAZY PAVING
PERGOLA PILLARS
WELL HEADS & LEAD FIGURES

PHONE COMBE DOWN 8

WIRES WILKES COMBE DOWN 8

WRITE FOR ACTUAL PHOTOS & PRICE LIST TO

THE HORSECOMBE QUARRIES & STONE WORKS
(A.F. WILKES, F.R.H.S., PROPRIETOR)
COMBE DOWN, BATH.

CUSTOMERS OWN DESIGNS QUOTED FOR

ARTISTIC GATES
MADE BY THE
SOMERSET SMITHY
WILLOW VALE, FROME
GOLD AND BRONZE MEDALLISTS

The Gate above designed for J. ARTHUR RANK, D.L. J.P. and LORD WEYMOUTH, M.P.

WORK SUPPLIED DIRECT FROM THE SMITHY AND MADE BY EXPERIENCED CRAFTSMEN

DESIGNS . AND . ESTIMATES . FREE

OPPOSITE Left: the 'thought wall' sculpture, based on a Mary Quant dress design, from Andy Sturgeon's Cancer Research UK garden, 2008. Right: the pavilion in Marcus Barnett's *Times* Eureka Garden, 2011, designed to resemble a crumpled leaf skeleton.

THIS PAGE Clockwise from top left: '13th-century thatched bird tables' from Ernest R. Smith, 1931; fountains and other ornaments from Cavendish Stone, 2011; gates by the Somerset Smithy, 1936; a deer sculpted in wire, from the Land's End Garden by Adam Frost, 2012; sundials and sculpted balls of filigreed stone by David Harber, 2012; arts-and-crafts bird houses from the Horscombe Quarries, 1924.

IN THE MARQUEE

Not all plants are exhibited at Chelsea. It is, after all, the Great Spring Show, and all the wonders of technology cannot guarantee a successful exhibit of autumn-flowering plants like dahlias or chrysanthemums. Fruit has always been the poor relation of vegetables at Chelsea; Bunyard's could stage a massive exhibit of early apples in the interwar period, but in recent years the only nursery to show fruit trees regularly was Chris Bowers's Whispering Trees Nursery, in the late 1980s and early 1990s. Ken Muir has been showing strawberries and soft fruit regularly since 1970.

At the end of the century, Medwyn Williams emerged as the leading figure in the exhibition of vegetables. He had begun by helping his father exhibit at local shows, first mounting his own display at the Anglesey County Show in 1969. He developed the ambition of exhibiting at Chelsea, and worked his way up the scale, being invited after winning a Gold Medal at Hampton Court in 1995. From 1996 to 2005 he exhibited at Chelsea, achieving the unprecedented feat of winning ten consecutive Gold Medals for vegetables – a record that beat even Edwin Beckett. Medwyn's son Alwyn continued to stage displays at Chelsea after his father's retirement, but Medwyn returned in 2009, the year his grandson Owain joined the company's board, and their joint display brought them another Gold Medal, and the President's Award.

The days when displays of orchids covered an entire side of the marquee had vanished with the Second World War and the successive demise of the great firms of Sanders, Mansell & Hatcher and Armstrong & Brown. By 1980 there were two regular orchid exhibitors: McBean's, who had been at Chelsea since the beginning and had swallowed up their old rival Charlesworth, and the more recent Burnham Nurseries, which had first shown in 1958, and which continued to show until 2009; the death of its proprietor, Brian Rittershausen, the next year put an end to its displays.

Cacti, traditionally something of a minority interest, have always been represented at Chelsea, and carnivorous plants, neglected during the first half of the century, have been a constant feature of the last forty years, especially at the hands of Marston Exotics and the Carnivorous Plant Society, and more recently of Hampshire Carnivorous Plants.

Bedding plants, once the mainstay of the ornamental garden, declined steadily in their representation in the marquee during the twentieth century. Stuart Ogg, who exhibited from the 1930s to the 1960s, and served on the shows committee until 1991, complained in his later years that he was the last person in the RHS administration who was interested in bedding plants. Hardy perennials had been the progressive wave of horticulture. Two of the great herbaceous plant nurseries have exhibited regularly at Chelsea since the first show in 1913: Kelway's, which had been the leading perennial nursery of the late nineteenth century, and Blackmore & Langdon, which began showing at the Temple shows soon after it was founded in 1901, and which still creates displays of delphiniums each year.

Clematis were represented until the 1960s by George Jackman & Sons, whose founder was commemorated in the name *Clematis × jackmannii*. From 1966, Treasures of Tenbury served as the leading clematis exhibitor, but that firm never fully recovered from the frost damage to much of its stock in the winter of 1980–81. Raymond Evison, who had been staging its Chelsea exhibits, left to found the Guernsey Clematis Nursery, which grew to account for a quarter of the world's supply of young clematis plants; since founding Raymond J. Evison Ltd in 1997, he has exhibited annually at Chelsea.

Trees and shrubs continued to provide ambitious displays at the hands of Notcutts, whose exhibitions manager John Dyter went on to become the chairman of the Arboricultural Association, and Hilliers, whose

ABOVE, LEFT The Carnivorous Plant Society's exhibit, 2009.
ABOVE, RIGHT The stand of Whetman Pinks, of Dawlish, in 2012.
BELOW The 2011 stand of Blackmore & Langdon, one of the few firms still extant today who exhibited at the first Chelsea Show in 1913.

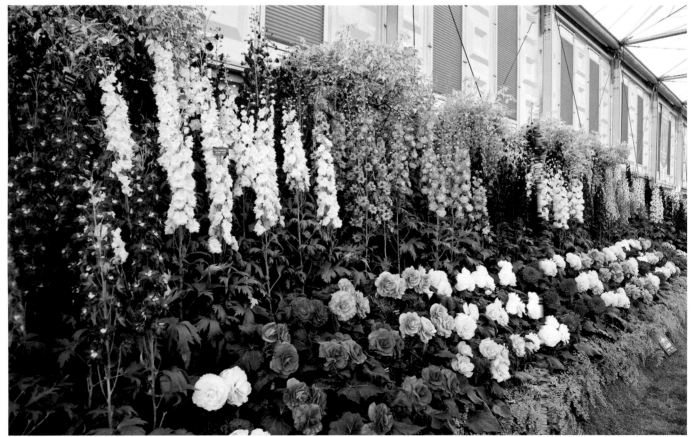

exhibits in the last years of the century were overseen by Andrew McIndoe, and the plants – sometimes numbering 3,500 – selected and groomed by Ricky Dorlay, who had undertaken the role of 'plant preparer' in the 1960s. Hilliers have become accustomed to filling the monument stand, and have won a Gold Medal every year since Chelsea resumed after the Second World War, an unmatched record.

In addition to the stands of nurseries are exhibits by local authorities, the Royal Parks and the Commissioners of Crown Lands, whose displays have ranged from simple plant collections to landscapes. Among the parks departments that created noteworthy exhibits were Hillingdon (Susan Smith, 1970s), Belfast (J. Craig Wallace and Reg Maxwell, 1980s) and Torbay (Bob Sweet, 1980s). The Royal Parks and Torbay were responsible for reviving sculptural bedding in the 1970s and 1980s, when it was on the point of disappearing from public parks.

Foreign horticultural societies have also been a regular presence under the marquee since the 1970s. The Kenya Horticultural Society staged the first of three displays in 1971, followed after a few years by Colombia. The Barbados Horticultural Society and Kirstenbosch Botanic Garden in South Africa have had exhibits nearly every year since 1988; they have been followed by the horticultural societies of Mauritius, Trinidad and Tobago, the City of Durban, and São Paulo, Brazil, as well as comparable stands created by tourist authorities from Malaysia and other countries. The displays have tended to show the native flora, but some have made elaborate gestures at exoticism, most notably the Nong Nooch Tropical Botanic Garden in Thailand, which since 2010 has based its decorations on the architecture of Buddhist temples.

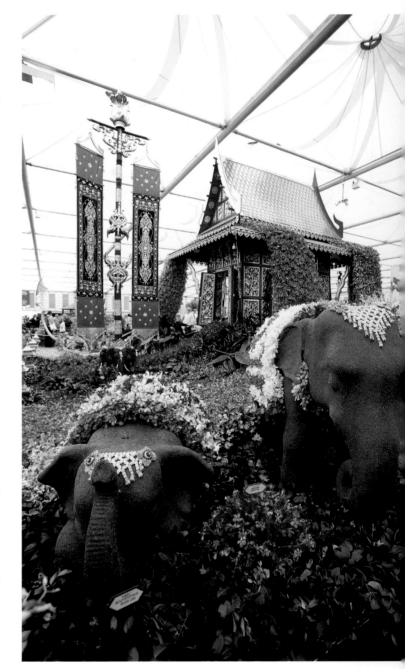

OPPOSITE The exhibit by the Nong Nooch Tropical Botanic Garden, 2012.
BELOW The Trinidad and Tobago Horticultural Society's stand, 2009.

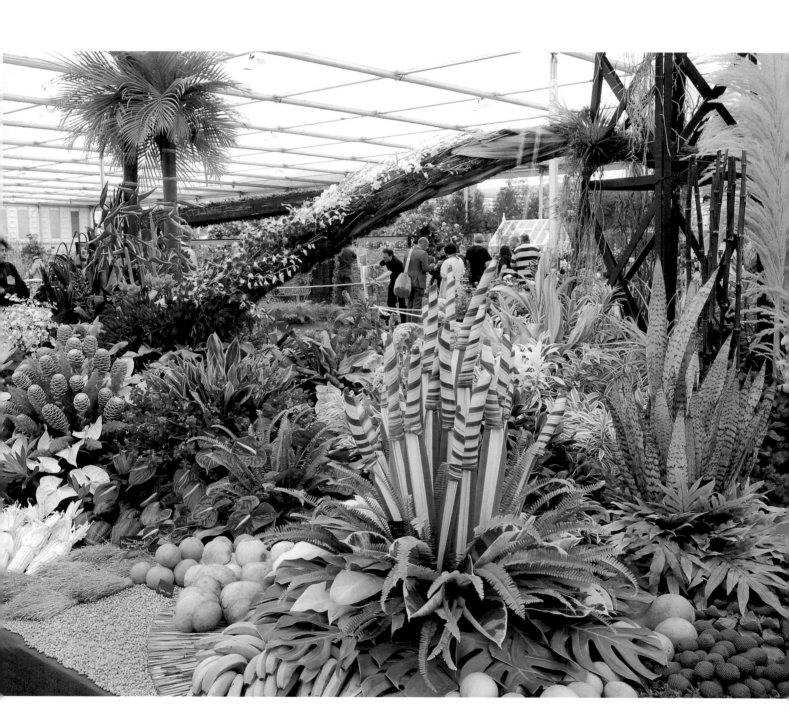

FAMOUS VISITORS

One of the features of Chelsea publicity today, in the press and even more on television, is the glimpses offered of celebrities visiting the show. Sometimes they appear for relevant reasons, such as having plants named in their honour; the news presenter Angela Rippon is shown here opening the Rainbows Hospice garden in 2012 (which was subsequently recreated at the hospice itself).

Some other famous visitors have more solidly horticultural reasons for attending. Ringo Starr, a regular visitor to Chelsea, had maintained and developed the gardens of Tittenhurst Park, Berkshire (his successor there, Sheikh Zayed bin al-Nahyan, sponsored seven gardens at Chelsea). And Kim Wilde, while not relinquishing her career as a singer, trained as a gardener in the late 1990s, and developed a practice as a garden designer, which has included creating a Gold Medal-winning garden at Chelsea, for Wyevale Garden Centres, in 2005.

CLOCKWISE FROM TOP LEFT Helen Mirren at Chelsea, 2009; Brian May (left), with Patrick Moore, 2008; Kim Wilde, 2008; Angela Rippon, 2012; Trevor McDonald, 2012; Vivienne Westwood, 2012; Ringo Starr and Barbara Bach, 2008; Jerry Hall, 2012 (centre); and Emma Thompson, 2006.

PLANTSWOMEN

Few of the nurseries that have exhibited at Chelsea have been managed by women. Such eminent figures as Gwendolyn Anley (violets) and Anne Ashberry (carpeting plants) exhibited only once.

This began to change after the Second World War. Mrs Desmond Underwood, whose Ramparts Nursery fuelled a fashion for *Grey and Silver Plants* (the title of her 1971 book), exhibited every year from 1957 to 1977. By that time three other important firms with female

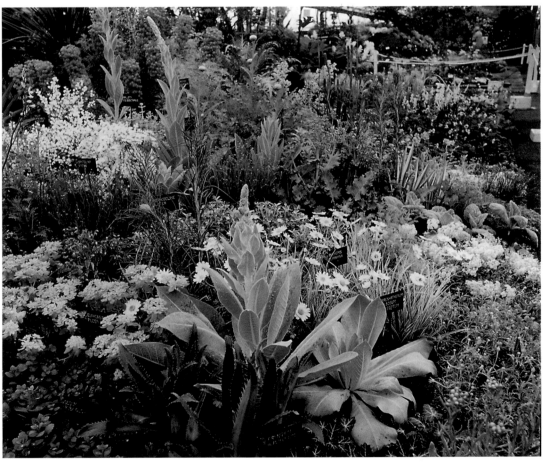

ABOVE AND OPPOSITE Beth Chatto, photographed (above) by Tim Sandall in 2009, and (opposite) thirty-three years earlier, with her first Gold Medal at Chelsea.
LEFT One of Beth Chatto's stands in the 1980s, with a range of euphorbias, leucanthemums, stachys and other 'Unusual Plants'.

MY CHELSEA

After months of daily care and attention preparing plants for my first appearance at the RHS Chelsea Flower Show, the most life-changing day of my life arrived: 13 May 1976, thirty-seven years ago. There followed ten more exhibits – very few compared with those of other nurseries who have maintained the unbeatable standard of the show over several generations.

As a newcomer I was aware of my lack of experience in the art and craft of exhibiting plants. At that time many exhibits consisted of beautifully grown cultivars presented in well-scrubbed pots staged in rows on tabletops. The plan in my head was to reassemble my plants, scattered like a broken jigsaw puzzle around my empty site, to form a miniature version of a living garden without a pot in sight.

Relieved to find that nothing important had been damaged, I retired to a modest hotel, unlocked my door, and was somewhat startled to find a dead mouse on the carpet. Taking it by its tail, I presented it to the manager and suggested a glass of wine would be fair exchange. Shortly afterwards the keys of my van were brought to my room. A fellow nurseryman, staying in the same hotel, had noticed my abandoned van and had safely locked it away.

While memories of the excitements, uniqueness and magic of Chelsea still burn bright, my most abiding memory of being at Chelsea was the lack of competition spirit. The competition was within ourselves: to learn, to improve and not to let ourselves down.

Friendships formed then among genuine plantspeople have endured.

Beth Chatto, plantswoman

proprietors had appeared under the marquee. Broadleigh Gardens, a nursery specializing in small bulbs, run by Lady Skelmersdale, first exhibited in 1969, and continued for over forty years. Hazel Key's Fibrex Nurseries, specializing in pelargoniums, exhibited regularly from 1972, and continued after her death in 2004. And in 1976 Beth Chatto, who had been encouraged by Mrs Underwood, exhibited at Chelsea for the first time, having previously shown at Westminster shows, and went on to win ten consecutive Gold Medals; her final exhibit, in 1987, received the Lawrence Medal for best exhibit of the year. Her reputation had taken successive

BELOW Sweet pea 'Carol Klein', a new variety launched by Eagle Sweet Peas in 2012.

forms: first as a source of plants for the cognoscenti (her catalogues bore the label 'Unusual Plants'), then as the doyenne of the dry garden, and finally as a source of marsh and woodland plants.

The 1990s brought two more nurserywomen into the public eye. Carol Klein's firm Glebe Cottage Plants showed regularly at Chelsea from 1990 to 2005, by which time she had also become familiar as a television presenter. In 1992 Hardy's Cottage Garden Plants began to exhibit, and is still continuing twenty years later. In 1993 Jekka McVicar staged her first Chelsea exhibit, and over two decades Jekka's Herb Farm came to be the country's leading source for culinary herbs. Like Beth Chatto, she received the Lawrence Medal in 2009 – despite the fact that her garden gnome (named Borage), which had been hidden in the foliage on previous stands in secret defiance of the Chelsea regulations, was clearly visible, a fact which caused a certain degree of controversy.

MRS UNDERWOOD

Mrs Desmond Underwood (1910–78), who exhibited at Chelsea every year from 1957 to 1977, was born Pamela Montgomery Cuninghame, the daughter of a former military attaché in Vienna. She began growing carnations commercially after the Second World War, and eventually expanded into other categories of plants with grey and silver foliage, producing the pioneering, and still standard, monograph *Grey and Silver Plants* in 1971. She became one of the promoters of the flower arrangement movement of the 1950s, and also entered politics, serving terms of office on Essex County Council and Colchester Town Council. She was awarded the Veitch Memorial Medal in 1969, and the Victoria Medal of Honour in 1977. In that year she supplied the plants for a silver foliage garden at Buckingham Palace. Her firm, Ramparts Nursery, near Colchester, had become the preferred source for many garden designers; after her death in 1978 she was succeeded by Jack Gingell, who continued the firm's Chelsea displays until the end of the 1980s.

MY CHELSEA

I have a love–hate relationship with the Chelsea Flower Show and it seems to become more difficult with every passing year, either because the weather decides to do the dirty or because I just pile the pressure upon myself.

My first Chelsea exhibit was in 1992 and I have exhibited every year since then – twenty-one years.

From the first moment I stood in that floral marquee and could not see from one side to the other I felt a sense of trepidation: the thought that I could dare to exhibit my plants there with all the other experts of our generation beggared belief! The new floral pavilion structure has made life far more tolerable for both my plants and my many helpers.

My exhibits have become bolder, and sometimes larger than I realized, but my main idea for each exhibit is for the viewing public to be able to get close to the plants. This enables them actually to use many of my unusual planting combinations, as I put the plants first, following the principle of 'right plant right place'.

My best moment has to have been achieving my first Gold Medal in 1994. Since then I have achieved seventeen Gold Medals in total, making me the most successful female exhibitor of hardy garden plants.

Rosy Hardy, partner at Hardy's Cottage Garden Plants

MY CHELSEA

The sheer mention of the words 'RHS Chelsea Flower Show' makes my stomach churn with excitement. For the past twenty years it has been a huge honour and privilege to be both an exhibitor and a floral judge at the best flower show in the world.

For the first ten years, alongside many other nurseries, we used to park our caravan in Battersea car park for ten days of the show. The day started by walking over the Chelsea Bridge, arriving on site at 6.00 a.m. On entering the Great Marquee at that time of day, one was greeted by the most amazing array of scents, colours and friendship. There have been many highlights during these years: receiving our first Chelsea Gold Medal, meeting the Queen, receiving a kiss from Ringo Starr, being taken out for a meal by Jamie Oliver on the back of his moped, which did wonders for my street cred; and my good-luck gnome Borage being spotted by *The Times* newspaper – he then went on to make front-page news in the *Evening Standard*, and his picture was shown on the BBC2's *Have I Got News For You*. His luck worked, for in that year, 2009, we received our fourteenth Chelsea Gold Medal and also the Lawrence Medal for the best exhibit shown to the Society in that year.

Jekka McVicar, Jekka's Herb Farm

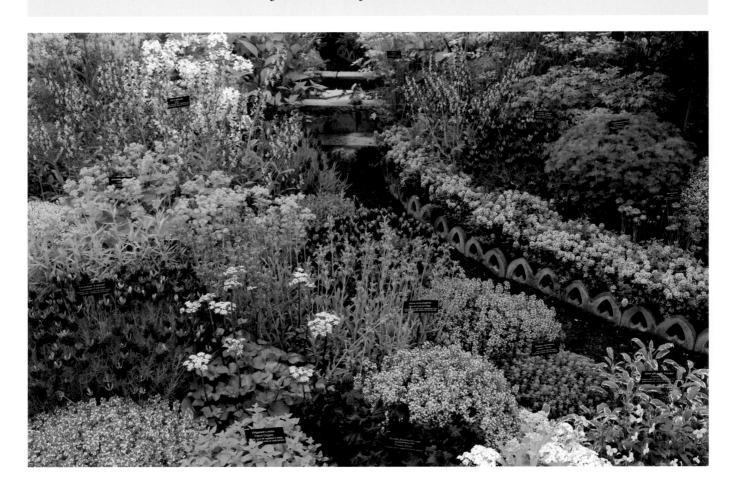

OPPPOSITE, LEFT A Chelsea exhibit by Jekka's Herb Farm.
BELOW, TOP An application, 1984, for an exhibit of gnomes, with
the RHS response revealed by the annotation. The Chelsea rules
traditionally forbade 'highly coloured figures, gnomes, fairies or any
similar creatures, actual or mythical, for use as garden ornaments'.
BELOW Borage the gnome defying the rules, on the stand of Jekka's
Herb Farm, 2009.

Royal Horticultural Society,
Horticultural Hall,
Vincent Square,
London. SW1P ZPE. 31st October 1984

For the attention of The Secretary

Dear Sir,

 Re: The Chelsea Flower Show

 For some years now, attempts have been made for various
manufacturers of Gnomes to display their wares at the Royal
Chelsea Flower Show.

 I understand that a petition with thousands of signatures
has or is being sent to you. May I at this early stage ask
if it is possible that our humble range of Gnomes (see attached
leaflet) may be allowed a small stand during your 1986 show.

P.C. Sorry but NO — A.J.S.

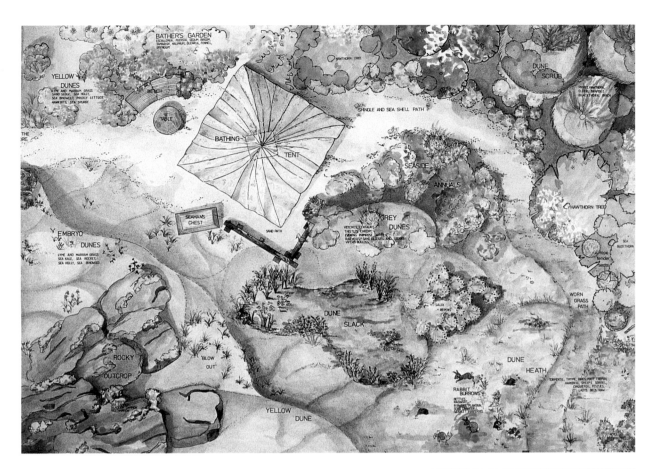

LEFT Julie Toll's seaside garden of 1993.
Above: her plan for the garden.
Below: the garden as it appeared to visitors.

THE RISE OF THE SHOW GARDEN

In 1980 there were a mere eight show gardens at Chelsea; by 1985 that figure had more than doubled. These gardens were located primarily along the Rock Garden Bank, with some distributed along the Main Avenue. As the years went on the avenue began to become more crowded with gardens; in 1988, a new class of small gardens was introduced under the heading of Courtyard Gardens, and the total number rose to 31. The venture was not altogether well received, and over a decade passed before Courtyard Gardens were tried again; the total number of gardens remained under 25 from 1989 to 2000. In 2001, Courtyard Gardens were resumed, and the total increased to 32. The following year some further categories were introduced: Chic Gardens (discontinued after 2007), City Gardens (from 2008 renamed Urban Gardens), and a group of domestic front gardens in the pavilion, arranged in two groups of four on either side of a wall, entitled Sunflower Street (renamed Generation Gardens from 2009). The total number of gardens rose to 62 as a result, and in 2003 reached a peak of 67. Thereafter it dropped to 52, and as the showground was redesigned it shrank further; since 2008 the number of gardens has been in the low forties, and this despite the addition of the new categories of Artisan Gardens (2011) and Fresh Gardens (2012).

In 1992 Pershore College staged a garden designed by Paul Cooper entitled the Greening of Industry, in the form of an abandoned quarry being colonized by adventitious plants. Julie Toll's seaside garden, which replicated a strip of coastal vegetation so naturalistically as to incur criticism for not being a garden at all, appeared the next year. The shows committee debated whether Chelsea ought to be restricted to 'real gardens', and concluded that 'this would deny the event much of its variety, interest and humour'. An alternative proposal to divide the gardens into 'real gardens' and 'creative displays' was equally resisted, because 'the public may have their views prejudiced; there is a danger that exhibitor diversity and imagination might be compromised; and the end result could be more controversy and confusion than before'. The solution was simple: from 1995 the Chelsea catalogue published the garden designers' statements of intent rather than simple descriptions, so that the gardens could be judged on their own terms. John Sales, who long chaired the garden judging panel, said: 'In such artificial circumstances no one pretends that flower-show exhibits are real gardens, which change and develop from day to day and year to year. Flower-show gardens are theatrical tableaux contrived for specific purposes – to impress, to shock, to amuse, to educate, to evoke . . . and so on.'

Sir Simon Hornby, the Society's President from 1994 to 2001, had formerly been chairman of the Design Council, and encouraged the use of show gardens to demonstrate ideas of garden design for their own sake, independently of the horticultural content that had once been deemed primary. This trend was signalled by the re-erection of Michael Balston's Reflective Garden (1999) as a model garden at Wisley.

In 2005, Tim Richardson complained that 'the show gardens . . . are compromised by the Society's judging criteria, which demands [sic] a certain level of horticultural sophistication of every garden'. One might wonder why this should be an inappropriate demand on the part of the Royal Horticultural Society, but at any rate the criteria have certainly been breached. In 2009 James May, the *Top Gear* presenter, showed a garden in honour of the inventor of Plasticine, and all the flowers were made of Plasticine. The lack of a medal seemed about to provoke a protest, but the RHS circumvented the problem nicely by presenting a special 'Gold Medal' also made of Plasticine.

LEFT Cloud topiary in Piet Oudolf and Arne Maynard's Evolution garden, 2000. OPPOSITE Michael Balston's Reflective Garden, 1999.

THE GARDEN DESIGNER COMES OF AGE

In 1928, the RHS had held a conference on garden design, accompanied by an exhibition of garden sculpture in its New Hall. One of the consequences was the formation the following year, by a group of young designers, of the Institute of Landscape Architects. Thomas Mawson, the most eminent landscape architect of the day, reportedly advised them that there was no need for an institute – his firm and that of Milner White could cope with all the commissions available. (Both firms exhibited plans at Chelsea throughout the interwar period.) Mawson was tactfully invited to become the Institute's first President. The early members – Brenda Colvin, Sylvia Crowe, Geoffrey Jellicoe – had all begun their careers designing gardens, but the postwar generation moved progressively into town planning, forestry and motorways, and the private domestic garden sank in perceived importance.

In the 1970s the revival of interest in Gertrude Jekyll, and a gradual shift of taste from the English landscape garden to the formal gardens that had preceded it, meant that the domestic garden once again became a focus of interest for students entering the profession. Garden design was becoming recognized as a career option. The Inchbald School of Design founded the first independent garden design school in 1972; Robin Williams founded the College of Garden Design in 1980; Rosemary Alexander founded the English Gardening School in 1983. There were now career channels for young designers, independently of what had now been renamed the Landscape Institute.

Chelsea proved beneficial in bringing garden designers before a wider public than would previously have become aware of them. After 1988, the Chelsea catalogues began to list the designers of the show gardens – and in the following year the names of contractors were given as well – and this helped shift public awareness. Among those whose names appeared in the catalogues in 1988–90, Jane Fearnley-Whittingstall, Richard Key, Arabella Lennox-Boyd, Roddy Llewellyn, Tim Newbury, Alan Sargent and Robin Williams all went on to write books about garden design and further fuel the public interest.

Celebrity can be a mixed blessing, though, and all the behavioural problems noted in other walks of celebrity life have appeared in the world of garden design as well. Accusations of plagiarism have been made: in 1998 the Belgian designer Jacques Wirtz claimed that Arabella Lennox-Boyd's *Evening Standard* garden, which had been declared Best in Show, had been plagiarized from one of his designs; nothing came of this in the end, however. In 2006, Diarmuid Gavin accused Andy Sturgeon of plagiarizing his design for a garden pavilion; the matter was settled out of court. Gavin became notorious for abrasive behaviour; in 2004, interviewed by Bunny Guinness, he accused her of 'snobbery, elitism, and rudeness', while describing the competition for awards at Chelsea as 'vicious'; and in 2008 he hit the press again, for writing to Cancer Research UK, urging that it drop Sturgeon as its official garden designer. Those who have described gardening as 'the new rock 'n' roll' may not have had this sort of behaviour in mind, but the analogy suggests itself.

MICHAEL BALSTON

Having studied architecture at Cambridge, qualifying in the early 1970s, Michael Balston joined Arabella Lennox-Boyd's practice, and they exhibited plans as Lennox-Boyd and Balston from 1980 to 1983, in which year he established his own practice in Wiltshire. He continued to exhibit plans for the rest of the decade. In 1999 his only Chelsea garden, the Reflective Garden for the *Daily Telegraph*, was given a Gold Medal and named Best in Show; it became the first Chelsea garden to be re-erected after the show as a model garden at Wisley. Its sail-like sunshades of steel and architectural fabric demonstrated the interest in garden furniture which he had expressed in his book *The Well-furnished Garden* (1986); he has also designed furniture for the Landscape Ornament Company of Devizes. In more recent years Michael Balston has been a Chelsea judge and an RHS Council member.

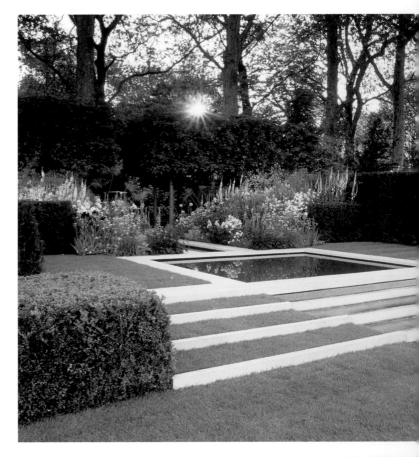

ARABELLA LENNOX-BOYD

Born in Italy, Arabella Lennox-Boyd studied landscape architecture at Thames Polytechnic, before marrying the politician Mark Lennox-Boyd in 1974. Her firm exhibited plans at Chelsea throughout the 1980s, and in the gap years between her gardens. All six of the gardens she designed at Chelsea have won Gold Medals – for the *Daily Telegraph* in 1990, 1993 and 1995, for the *Evening Standard* in 1998 (Best in Show) and 2000, and after nearly a decade's absence, for the *Telegraph* again in 2008. She is the author of *Designing Gardens* (2002), among other books.

Her gardens have tended to use traditional elements, such as herbaceous borders and devices of enclosure: yew hedges with balls and tiers of box in her 1990 English Country Garden, an old slate wall in her 1995 garden for the National Trust's centenary, a ruined stone tower in her 1993 Romantic Country Garden. In 1998 her stepped water feature was flanked by yew hedges and buttresses; in 2000 a large metal frame punctuated the view in her Garden for All Time. That garden saw her most innovative device: olive trees in watertight containers, apparently floating in canals.

RIGHT, ABOVE AND BELOW Two views of the *Evening Standard* garden, 1998.
FAR RIGHT The *Evening Standard* Garden for All Time, 2000.

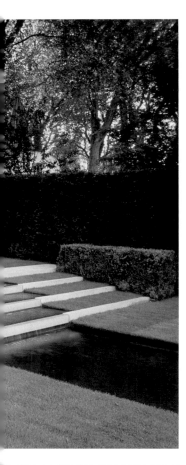

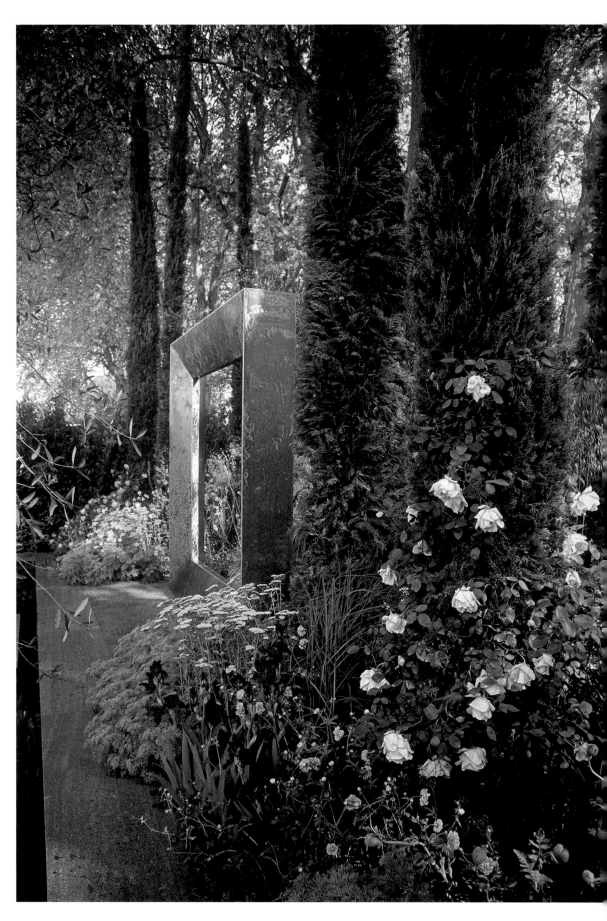

RIGHT A view in the *Daily Telegraph* Latin Garden, 1997. Notice how much gravel can be seen in the flower beds.

CHRISTOPHER BRADLEY-HOLE

Christopher Bradley-Hole's Latin Garden for the *Daily Telegraph*, in 1997, can be seen as a turning point in modern British garden design. It was intended to reflect the life of Virgil, and was divided into three stages for phases of his life: youth on his father's farm, adulthood in Rome and his retirement to the country. The ground plan was based on a concept known as the golden section; quotations from the *Eclogues* were carved into stone or etched on to glass; but the most important feature was the widely spaced planting.

Back in the 1920s, Sir Frank Crisp had drawn attention to the 'sparse planting' shown in Renaissance pictures of gardens, but this theme in garden restoration did not reach the general public until the Privy Garden at Hampton Court was opened in 1995. Now, with the additional influence of the gravel gardens of John Brookes and Beth Chatto, the gardening world was finally prepared to accept it, and critics who would have sneered at 'spotty planting' a decade earlier were loud in their praise; the garden won Best in Show. That autumn *Ground Force* started on BBC television, and helped to make sparse planting a national fashion.

A qualified architect, Christopher Bradley-Hole developed an interest in garden design under the influence of John Brookes. In 1994 he created a Chelsea garden for *Gardens Illustrated* magazine (which he later eliminated from his portfolio, as it was inconsistent with his mature style), and the following year set up his own practice. He designed gardens for the *Daily Telegraph* in 1997 and 2000, receiving Gold Medals each time, and in the years 2003–5 he staged three gardens for Sheikh Zayed bin al-Nahyan. Of these, the 2004 Hortus Conclusus was named Best in Show. He is married to the gardening writer Kathryn Bradley-Hole, and in 2000 they both published books that reflected his design practice: her *Stone, Rock and Gravel*, and his *Minimalist Garden*.

MY CHELSEA

I joined the RHS in 1985 and my first Chelsea was in 1986. I remember being alarmed by the overcrowding – RHS members had free admission to a most uncomfortable experience. As a result of a review commissioned by the RHS Council, from 1988 onwards we capped the visitor numbers and introduced a charge for members.

In 1989 I introduced a charity gala preview, working with a series of other charities to organize promotion, tickets and sponsorship. Miraculously we got the formula right, and the charity gala preview continues to be a popular social and business event each year.

A few years later, we extended the show to five days without increasing visitor volume, making each day more comfortable. With no lateral space in which to expand, we grew vertically, introducing double-decker restaurants and the new high-tech Great Pavilion, housing the horticultural heart of the show. Sponsorship extended to include the whole show and media coverage (including national television) increased, enabling the show to be enjoyed by millions of visitors throughout the world.

There continues to be great camaraderie at Chelsea between exhibitors, designers, media friends and supporters, working closely with a set of great contractors and an amazing behind-the-scenes team of RHS staff. Together they produce an outstanding show which upholds high horticultural standards and is now a leader in world-class events.

Stephen Bennett, RHS shows director

OPPOSITE, BELOW Bunny Guinness's Touch
of Paradise Garden for Wyevale Garden
Centres, 1996.

EMERGING DESIGNERS 1980–2000

In 1987 Elizabeth Banks left Land Use Consultants, where she had first become known as a garden consultant, and set up her own practice, Elizabeth Banks Associates. In 1991 she designed her first garden at Chelsea, for the *Daily Telegraph*; it received a Silver-Gilt Medal. Among the younger designers who got their start working for her firm and went on to design gardens at Chelsea were Tom Stuart-Smith and Robert Myers, who eventually inherited the practice when she retired.

Other garden designers who rose to prominence in the 1980s, and ventured into Chelsea in the following decade, included Michael Branch, Bunny Guinness, Julie Toll, Dan Pearson, Rupert Golby, Roger Platts, Lucy Huntington and the Appleton Deeley Partnership. They were followed by 1990s newcomers such as Fiona Lawrenson, Ryl Nowell, Christopher Bradley-Hole, Diarmuid Gavin and Stephen Woodhams, who received a Gold Medal for his 1994 garden for *You* magazine when he was only thirty. The publicity for Xa Tollemache's 1997 garden for the *Evening Standard* effectively launched her career. Many of these designers also published books on garden design or planting, Rupert Golby producing *The Well-planned Garden* (1994) for a series published by the RHS.

A garden at Chelsea, especially if it won a medal, became a desirable career step for garden designers abroad as well as in Britain. Designers such as Luciano Giubbilei, Francesco Decembrini and Daniele Zanzi, Piet Oudolf, Arne Maynard and most recently Ulf Nordfjell have made prestigious gardens there. They have been joined, and rivalled, by rank outsiders like Sir Terence Conran (furniture designer, founder of Habitat) and James Dyson (engineer, improver of the vacuum cleaner), who have shown that professional instruction is not the only route to success.

Traditional designers had based their Chelsea gardens on horticultural themes (rock garden, water garden, wild garden), on particular climatic demands (the 1990s saw a little flurry of Mediterranean gardens, including the variant of a Provence-style garden, made fashionable by Peter Mayle's 1990 book *A Year in Provence*) or on historic styles (most notably in the Garden History Society's Homage to Le Nôtre garden in 2000, with its *parterre de broderie* created by Tom Stuart-Smith); and the number of these sorts of gardens never diminished, whatever other fashions may have favoured. But the 1990s saw the arrival, in the climate encouraged by Sir Simon Hornby and his interest in the aesthetics of design, of what would eventually be called conceptual gardens: gardens which existed to express a theme metaphorically. The Evolution garden created for *Gardens Illustrated* magazine in 2000 by Piet Oudolf and Arne Maynard will serve as the crowning exemplification of this trend. To quote the design statement in the catalogue: 'Both wanted to create a garden for Chelsea which looked to the future but had its roots in the past. The dramatic "cloud hedge" of ancient box and the sculpted yew provide a strong structure in much the same way as evergreens gave form to classical gardens. Piet and Arne also wanted to put a new twist on the seventeenth century fascination with fountains . . .' On the ground, what this entailed was a strongly axial garden, flanked by box hedges carved into billows, with borders of astrantia and other perennials likened to the patterns of a Turkish carpet, down the central path of which lay a series of square box cushions enclosing circular fountain basins. The fountains marked the first appearance at Chelsea of 'jumping jets', in which the jet of water is cut off at the nozzle, giving an effect likened to a glass rod fired through the air; jumping jets went on to be greatly in vogue in the next decade. The garden received a Gold Medal, Best in Show and international publicity.

MY CHELSEA

I have been visiting RHS Chelsea Flower Show for the last forty years and long before I started designing gardens for the show, I found it fascinating looking at the show gardens and seeing which worked best and why. The best moment of all was getting the opportunity to do one. I had entered three designs in competitions, the prize being to have your garden built. In the first one, for the *Sunday Times*, my design was a runner-up; the second for *Gardens Illustrated* was highly commended; and finally I won the third, limited competition for Wyevale Garden Centres for 1994.

When this garden, the Wind in the Willows, won a Gold Medal it was the icing on the cake. The build-up was three weeks of rain: my 'waterproof' jacket had puddles in the pocket throughout, and the pollarded, hollow willow on to which we fitted a door to make a house, and which was sawn off at ground level, actually started to root and sprout, it was so wet. But it was enjoyable from beginning to end.

Each year gets more difficult as budgets, expectations and complexity of builds get higher, but although my husband perennially threatens to divorce me if I do another, I know I am likely to be tempted again!

Bunny Guinness, landscape architect

BUNNY GUINNESS

Bunny Guinness set up her own practice in 1986, and in 1994 designed her first garden for Chelsea: a garden for children based on *The Wind in the Willows*, reflecting the interest that led her to write *Family Gardens* (1996). This was the first of five gardens she made for Wyevale Garden Centres during the 1990s, a sequence interrupted by her Bird Garden for DGAA Homelife in 1997. In the new century she returned to make gardens for Stonemarket (2004) and M&G Investments (2011). The niece of the rosarian David Austin, she is gardening columnist for the *Sunday Telegraph*.

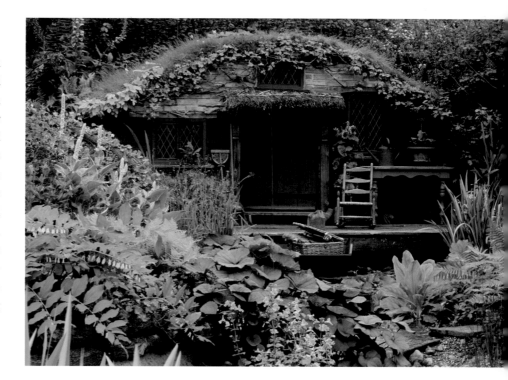

ABOVE Robin Williams's Garden of Golden Memories for Help the Aged, 1990.
BELOW Julie Toll's Edible Garden for St John Ambulance and Safeway, 1994.

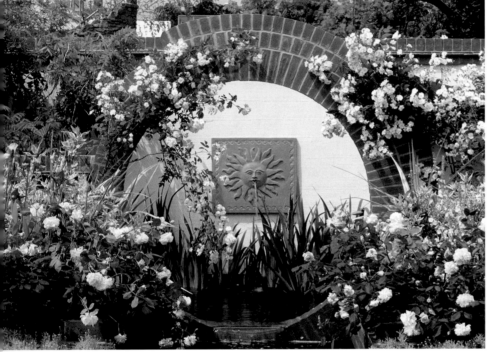

ROBIN WILLIAMS

Robin Williams set up his own practice in 1960, and later served as the chief garden designer for the long-established Jackman's Nursery in Woking, which had designed gardens and exhibited plans at Chelsea for decades. He was a regular columnist for *Popular Gardening* in the 1970s, and in 1980 he was a founder of the College of Garden Design. From 1988 to 1993 he created a garden each year for Help the Aged (and his son, by then a partner in the practice, created another in 2000). He is the author of *The Garden Designer* (1995), *Garden Planning* (1996) and other books, and was a member of the RHS Council from 1997 to 2002.

JULIE TOLL

Julie Toll began her Chelsea career working with the seedsman John Chambers on a series of gardens planted with wildflowers. From 1990 to 1993 the pair produced gardens for the benefit of butterflies, birds and wildlife generally. In 1993 their seaside garden was declared Best in Show, but also attacked for its lack of resemblance to a garden as commonly understood; David Stevens described it as 'a sand dune garden that was well planted and beautiful, but visitors said it wasn't a garden'. In 1994 she created an edible garden for the supermarket Safeway, and has since made gardens for the *Evening Standard* and Wyevale Garden Centres.

BELOW Marney Hall's Quarryman's Garden for Butterfly Conservation, 1998.

MARNEY HALL

Marney Hall worked as a scientist, managing butterfly nature reserves for the Institute of Terrestrial Ecology, for years before she became a garden designer. In 1995 she formed the Marney Hall Consultancy, and staged a garden at Hampton Court before being invited to move on to Chelsea. Her 1998 garden for Butterfly Conservation demonstrated both the rustic look that became a trademark – as in her 2011 garden for SkyShades UK, 'a log cabin for the modern era', the logs of which were left with the bark still on – and the use of wild flowers in colour blocks. In 2004 she designed the first of three successive gardens for 4Head, and described its creation in a book.

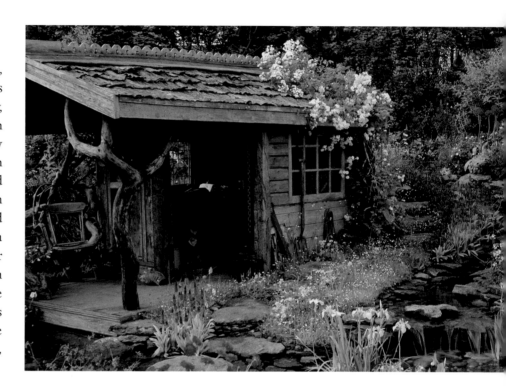

MY CHELSEA

Chelsea means to me: challenge, nervous anticipation, excitement, team work, building relationships, meeting old friends and making new ones, microwave dinners and fast-food lunches, a well-earned glass or two of wine, watching paint dry and having too much to do, shopping for plants, Steve at the gate in the early morning, first visit by sponsor, steel toe caps and high vis. jackets, nervous exhaustion, tears, Cliff Richard, meeting the Queen, never having enough tickets for clients, calls from the press, problem solving, angry birds early in the morning, making long winters short, nights spent thinking about the 'client brief', self-confidence quickly followed by self-doubt, relief, and a wondrous sense of well-being . . .

Sarah Eberle, garden designer

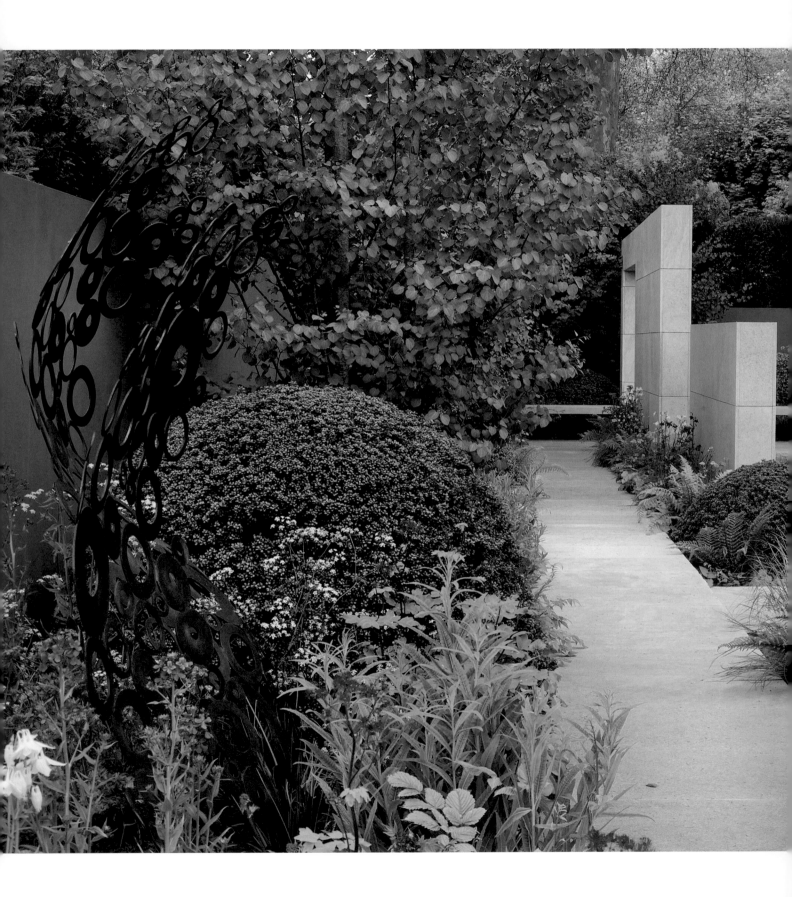

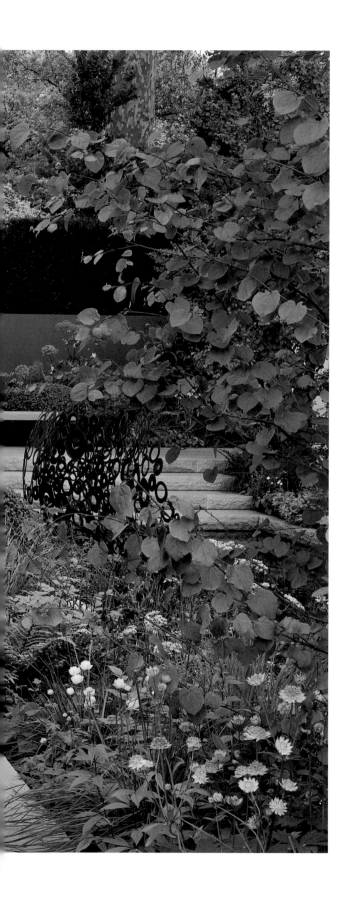

7
THE ASCENDANCY
OF STYLE
2000–2013

The year 2000 witnessed Chelsea's greatest transformation for nearly fifty years: the disappearance of the old marquee. Its remains, and those of its predecessor, altogether 5 hectares of canvas, were cut up and turned into handbags, jackets and aprons – some 7,000 of them, marketed by the Old Chelsea Marquee Company. In its place stood a new polyester pavilion manufactured by De Boer, in a modular design. (At first it was a double pavilion, its wings separated by an open avenue, but from 2004 they were amalgamated once again into a single structure.) No more tent posts to erect – only sixteen supports instead of 278; true, it took forty articulated lorries to deliver the structure to the site, but there is always room for improvement.

The number of show gardens had grown steadily, but peaked and fell back as the showground was reconfigured to meet the demands of health and safety regulations and ease of emergency evacuation. The number of sundries stands also increased, provoking a complaint in *The Garden* in 2005 that 'In recent years it looks to have become not "the *best* available" in horticulture but "*everything* available".' The number of exhibitors of glasshouses and heavy machinery declined, however, and the resulting space in North Avenue housed yet more small gardens. These restless years saw an increasing pursuit of novelty; the biggest Chelsea garden ever (Eden Project, 2010, 590 square metres) and the tallest Chelsea structure (B&Q, 2011, 9 metres) appeared within a year of each other. Like most other statements about the current state of Chelsea, this may soon be obsolete.

LEFT Andy Sturgeon's 2012 garden for M&G Investments.

LEFT, CLOCKWISE FROM TOP LEFT Plastic water bottles from the Eden Project's Places of Change garden, 2010; an insect hotel from Future Nature, 2009, by Nigel Dunnett et al; recycled oil drum in Diarmuid Gavin's 2012 garden; the B&Q garden, 2011, by Laurie Chetwood and Patrick Collins.
RIGHT Geoffrey Whiten's 2008 garden for Brett Landscaping.

SUSTAINABILITY, ECOLOGY AND RECYCLING

It could be claimed that the spirit of recycling first affected Chelsea in 1920, when George Blay offered War Office surplus Armstrong shelters and corrugated-iron tunnels as structures for the garden. But it was not until the late twentieth century that the concept of recycling developed a moral imperative, and 'sustainability' became a well-understood goal, embraced as enthusiastically as labour-saving gardening had been half a century before. The RHS responded to controversies of the past decades by introducing restrictions on the use of tropical hardwoods, surface-stripped rock from limestone pavements and invasive plants.

The use of 'grey water' had formed a theme for educational displays in the 1990s; in 2008 Bamboo Garden Design staged a garden to demonstrate urban drainage. In 2009, Marshalls used their Living Street garden to show their water-permeable paving, and Leeds City Council's garden showed ways of planting to cope with flash flooding. Thereafter rain gardens and waste-water recycling began to be featured regularly. Barry Mayled and Nigel Dunnett, in 2008 and 2009 respectively, exhibited gardens with green roofs. Demonstrating alternative energy generation, Kate Frey included a windmill in her 2007 Fetzer Vineyards garden, only to be outdone by the wind turbine in the 2011 Stockton Drilling garden. Recycled materials were promoted enthusiastically in Claire Whitehouse's Real Rubbish Garden for the RSPB in 2005, and appeared regularly thereafter.

In 1976 Brian Halliwell had planted a garden for Kew on the theme of British native plants, showing 200 species in three different environments – pool, meadow and earth. Many were nonplussed by such a deviation from normal horticulture. From 1982 the seedsman John Chambers had a regular stand in the marquee devoted to wildflowers, and during the 1990s the first efforts at planting for the benefit of wildlife were made in the show gardens: gardens for birds, bees and butterflies were succeeded in the new century by those that aimed at biodiversity more inclusively, such as Geoffrey Whiten's environmentally friendly garden for Brett Landscaping (2008).

THE RISE OF VERTICAL GARDENING

Clothing a wall used to mean planting climbing plants at its base and letting them grow up to cover it. But in the late twentieth century a new concept emerged: that of designing a wall with a series of containers for vegetation and an integrated irrigation system. Patrick Blanc made his first experimental green wall in 1988, and after the publicity given to his 'living wall' at the Musée Branly in Paris in 2004, it began to be imitated internationally. In 2008 vertical gardening made its appearance at Chelsea, in a garden by Cadogan Estates, and it has since become a regular feature in one form or another. In 2010 Laurie Chetwood and Patrick Collins, in their garden for B&Q, built the tallest (9 metres) structure yet constructed at Chelsea as the framework for an edible garden of tiered window boxes and clothed its sides with thyme. Though promoted as an aid to reducing heating demand in buildings, vertical gardening has yet to become as widespread as the green roof, of which it can be seen as an extension; but it can also be seen as a development from sculptural bedding: three-dimensional carpet bedding on an architectural scale.

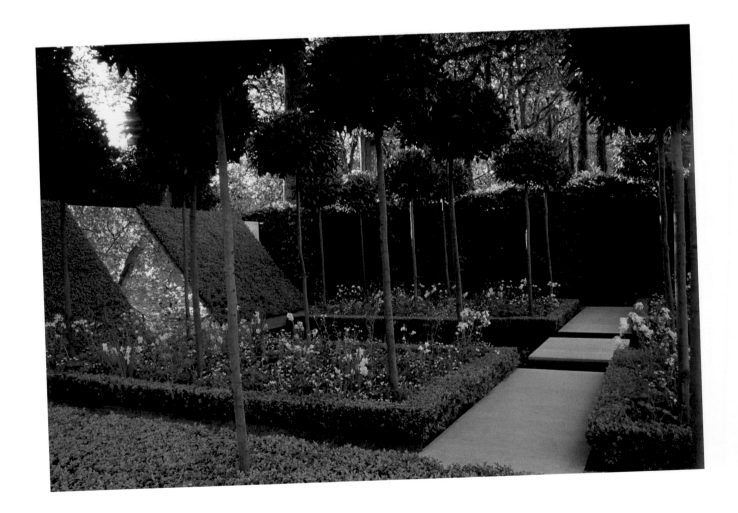

OPPOSITE Planting on inclined planes in Tom Stuart-Smith's Laurent-Perrier garden, 2008.
THIS PAGE Clockwise from top left: drought-resistant planting on a living tower, in the 2009 Future Nature garden by Nigel Dunnett et al.; a planted screen in Sarah Eberle's Monaco Garden, 2011; Diarmuid Gavin's Westland Magical Garden, 2012; moss cladding on walls in Kazuyuki Ishihara's Sotayama Life garden, 2012.

GARDEN FURNITURE

Garden furniture has been represented continuously at Chelsea over the past century, and with less discontinuity of tradition than most other aspects of the garden. Chairs and tables are still to be found that show no noticeable differences from their Edwardian predecessors; wood and canvas are still common materials. Aluminium and plastic have been the major contributions of the second half of the twentieth century.

There is an intriguing phenomenon in the history of garden furniture, however, which is little known: the recycling of wood from naval ships. Two firms in particular – Castles' Shipbreaking Company, and Hughes, Bolckow and Co. – who exhibited regularly at Chelsea until the Second World War named specific ships that they had dismantled for their timber. Hughes,

Bolckow went so far as to name lines of garden furniture after the departed ships. Castles' were to provide the timber for Liberty's neo-Tudor façade in Great Marlborough Street; one imagines that supplies of wooden battleships and cruisers were getting short by the late 1930s.

Some forms of garden furniture had largely disappeared by the postwar years: the decline of the country house reduced the market for tents and marquees, though garden umbrellas have continued to appear at intervals. And the end of the century did bring some innovations in furniture – seats that no longer resembled chairs, but instead suggested beanbags carved out of new materials; hanging and dangling seats; and finally hot baths for the garden.

THE "THUNDERER" SET

A delightful **Garden Set** ... Price £13 10 0
Seats, Chairs, Tea-Wagon-Tables, in fact every item
of furniture for the garden. OUR SPECIALITY.

GOOD garden furniture is made from Teak.
BETTER garden furniture is made from Battleship
Teak.
THE VERY BEST garden furniture is that now
being made by us in Teak from

H.M.S. "POWERFUL"

This famous First Class Cruiser is now being dis-
mantled by us at Blyth and is providing some of the
finest Battleship Teak we have handled in our 20
years' experience.
The designs and workmanship are also of the very
best.

Please call at **Stand No. H**, Main Avenue, and see.

THE HUGHES BOLCKOW SHIPBREAKING CO. LTD.

Of BLYTH, Northumberland.

MAPLE & CO., LTD., of TOTTENHAM COURT ROAD, W., are our
London Agents and always carry a stock of this furniture in their
spacious showrooms.

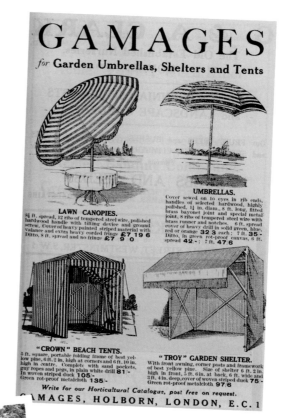

GAMAGES

for Garden Umbrellas, Shelters and Tents

LAWN CANOPIES.
8½ ft. spread, 12 ribs of tempered steel wire, polished
hardwood handle with tilting device and ground
screw. Cover of heavy painted striped material with
valance and extra heavy corded fringe **£7 19 6**
Ditto, 8 ft. spread and no fringe **£7 9 0**

UMBRELLAS.
Cover sewed on to eyes in rib ends,
handles of selected hardwood, highly
polished, 1½ in. diam., 8 ft. long, fitted
brass bayonet joint and special metal
joint, 8 ribs of tempered steel wire with
brass runner and notches. 6 ft. spread
cover of heavy drill in solid green, blue,
red or orange **32 3** each ; 7 ft. **35/-**
Ditto, in green rot-proof canvas, 6 ft.
spread **42/-** ; 7 ft. **47/6**

"CROWN" BEACH TENTS.
5 ft. square, portable folding frame of best yel-
low pine, 6 ft. 2 in. high at corners and 6 ft. 10 in.
high in centre. Complete with sand pockets,
guy ropes and pegs, in plain white drill **81/-**
In woven striped duck **105/-**
Green rot-proof metalcloth **135/-**

"TROY" GARDEN SHELTER.
With front awning, corner posts and framework
of best yellow pine. Size of shelter 6 ft. 2 in.
high in front, 5 ft. 6in. at back, 6 ft. wide and
3 ft. 4 in. deep, cover of woven striped duck **75/-**
Green rot-proof metalcloth **97/6**

Write for our Horticultural Catalogue, post free on request.

GAMAGES, HOLBORN, LONDON, E.C. 1

OPPOSITE Left: garden sofas at a sundriesman's stand.
Right: a hanging seat in Diarmuid Gavin's Westland
Magical Garden, 2012.
THIS PAGE Clockwise from top left: advertisement from
the 1930 Chelsea catalogue for the Hughes Bolckow
Shipbreaking Company, for teak garden furniture made
from the timbers of the dismantled HMS *Powerful*; lawn
tents and umbrellas from Gamages, advertised in the
1922 Chelsea catalogue; orange garden seats from the
Rainbow Children's Hospice Garden, by Second Nature
Gardens, 2012; more hanging seats, from Aralia Garden
Design's Rooftop Workplace of Tomorrow, 2012; woven
seats set into the rock, in Benjamin Wincott's Petra –
Tranquillity in Stone garden, 2012.

RIGHT One of Leyhill Open Prison's display gardens at Chelsea.

GARDENS OF SOCIAL CONSCIENCE

'Why don't Chelsea gardens ever have sheds, dustbins or washing lines in them?' asked *Horticulture Week* in 1989. This may have been a joke at the time, but within a few years the query was being answered seriously. In 1995 Terence Conran staged a Victory Garden for the Imperial War Museum, to celebrate the fiftieth anniversary of the end of the Second World War: it included a 'Dig for Victory' plot, an Anderson shelter, a homemade frame and evidence of bomb damage. A kind of nostalgia for wartime and postwar domestic gardens was developing as a horticultural form of social history, and appeared at Chelsea in such forms as the Caravan Club's 2012 garden (including an actual caravan) and David Domoney's 2009 biker's garden, incorporating a wall made from old garden tools smelted together. There had long been a tradition of ruins treated as picturesque features; at the end of the century a new sort of ruin appeared, and Chelsea gardens began to feature tumbledown or abandoned cottages (as in Geoffrey Whiten's 2005 Fisherman's Garden) and semi-derelict gardens (as in Cherida Seago's 1999 Reclaimed Garden, which was presented as only half reclaimed).

One of the most notable examples of this trend was a 2004 garden called Hope, which featured a bomb crater, dead trees and water pouring from a broken pipe. But the creators of the garden were even more remarkable than its content: it was the last in a series of four gardens made by Leyhill Open Prison. The RHS had been involved in judging prison gardens for many years; in 1998, Leyhill (which occupied the grounds of a once famous arboretum, Tortworth Court) was invited to stage a garden at Hampton Court, and won a Gold Medal. An account of this achievement, published in the *New York Times* by Paula Deitz, inspired a film, *Greenfingers*; by the time the film was released in 2001 Leyhill was making gardens at Chelsea.

Over the years, charities have found that staging gardens at Chelsea provides good publicity and fertile ground for propagandizing their aims. Help the Aged, Motability and other organizations for the disabled, Action for Blind People, Shelter, the Salvation Army, St Joseph's Hospice and Amnesty International are among those who have taken part. In 2009 the Eden Project collaborated with the Homes and Communities Agency on a garden whose plants were grown by homeless people. In the same year, Sarah Eberle created a series of three gardens on the theme of the credit crunch: gardens for an overdrawn artist, a banker and a wealthy recluse. (Not to be outdone, Mike Hinton created a Credit Munch garden in the pavilion, to illustrate the virtues at a time of financial retrenchment of growing one's own food.)

While overtly political campaigning is eschewed at Chelsea, the politics of the past can be commemorated to significant effect; in 2004 Chill Garden Design staged a garden to commemorate the Diggers of 1649 (after all, they could be seen as allotmenteers before their time). In 2005, Terence Conran and David Stevens collaborated on a Peace Garden for the Imperial War Museum, which included the word for 'peace' in various languages carved into a wall. In the same year the Royal Hospital staged its own garden for the first time, and Julian Dowle was assisted in the design by Chelsea Pensioners. And of course, every year the Army Benevolent Fund (which sponsored a garden in 1992) has its roving fundraisers collecting money at the Royal Hospital Road entrance.

A very different sort of peace garden appeared in 2012: MUUM's Quiet Time garden, which, within a barbed-wire fence, replicated the abandoned ground in the demilitarized buffer zone between North and South Korea – like those portions of Wiltshire assigned to army training and manoeuvres, a haven for wildlife and indigenous plants.

MY CHELSEA

I have been show manager since 2007, but my first experience was as a horticulture student, helping to man the University of Reading stand in 1994.

Chelsea, as a horticulturist, means being thrilled by a new or rare plant seen for the first time, the exuberance of delphiniums in coloured ranks, gardens that take my breath away with their originality or those that make me want to lose myself for the afternoon in their planted retreat. But as a person and show organizer, Chelsea has been knowing and becoming friends and partners with the exhibitors who toil for months to bring the best in gardening to the heart of London. Chelsea is like no other event in the camaraderie it engenders and the fact that anyone will pitch in to help another achieve their goals.

When I walk through the pavilion at 6.30 a.m. on the Tuesday we open to the public, I am instantly relaxed by the polished results I see, and know that nobody could have worked any harder, from the nurserymen to the plumbers, the cleaners to the show garden designers. It is also the RHS's moment, as the world's leading gardening charity, to gather the world's press and shout from the rooftops that in Britain we have some of the finest garden designers and plantsmen in the world. How often do you see horticulture stealing the front pages of tomorrow's newspapers from the calamities of the day?

I have so many best moments, as each show brings its highlights and triumphs, but a favourite was introducing His Royal Highness Prince Philip to the dedicated and hardworking shows team in 2012.

Alexandra Denman, RHS Chelsea Flower Show
manager 2007–2012

LEFT The show manager Alexandra Denman with (left) the garden designer Tom Hoblyn and (right) the television presenter Alan Titchmarsh.
RIGHT, ABOVE The Green With … Easigrass Garden, 2012.
RIGHT, BELOW Jado Goto's QR Code Garden for Scotscape, 2012.

NEW TECHNOLOGY

While there is never a shortage of gardens at Chelsea using traditional materials, there has been an increasing emphasis since the 1990s on experimenting with materials that are either new or uncommon in a garden setting: Corian, Skylar, Perspex, frosted acrylic, polypropylene string, architectural fabrics, even cork as a structural material. The most controversial of these is without doubt artificial grass, viewed by some as a contradiction of everything Chelsea stands for. Astroturf, the first commercially successful artificial grass, was patented in 1967, but although its name, like Kleenex and Hoover, has broadened from a trade name to a generic description, the original Astroturf has been succeeded by rival products like FieldTurf, most of them American in provenance. Jonathan Gallagher's Easigrass company was founded in 1994, and has been one of the most successful artificial grass makers in the UK. Easigrass first appeared at Chelsea in 2010, with a garden in which orchids were grown in a grotto, and then in 2012 with a more flamboyant garden which used their turf in vertical columns.

That year, 2012, was also the first year in which smart technology was used at Chelsea: every name board bore a QR (Quick Response) code, which visitors could photograph with their mobile phones and use to get additional information. To emphasize the point, Jade Goto designed a garden for Scotscape Ltd entitled the QR Code Garden. The principal feature was a wall panel showing a QR code, whose excerpted patterns were used to decorate the surrounding surfaces.

The QR Code Garden was one of the new category of Fresh Gardens, introduced that year. Among these gardens was Glamourlands: A Techno-folly, in which for the first time the RHS collaborated with a firm (Heywood & Condie) to punctuate the area with a series of structures using animated screens, created with the aid of the Unanico Group.

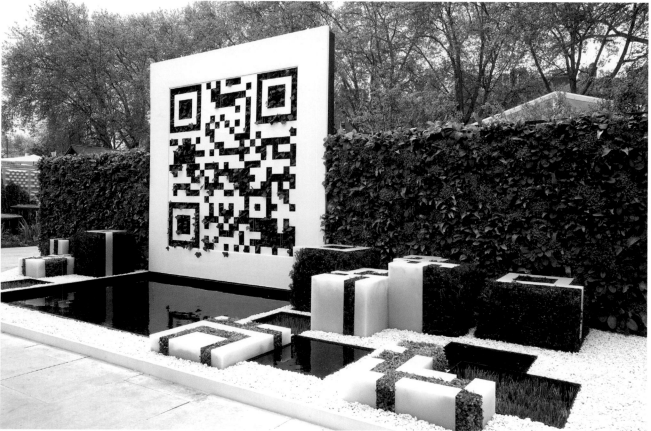

GARDEN BUILDINGS

Garden buildings of various sorts have been exhibited since the beginning of Chelsea. Few of these have been utility sheds – far more often decorative gazebos and pavilions. Utility sheds have tended to appear recently at Chelsea, usually as nostalgic reminiscences of wartime gardens – though there was an early anticipation of this trend after the First World War when George Blay offered Armstrong huts and corrugated steel shelters, collared from surplus War Office stock, as garden structures.

Among the more unusual garden buildings to have appeared at Chelsea have been revolving summerhouses, which could be turned for maximum exposure to the sun, manufactured in the 1930s by Boulton & Paul, and by C. White of Bromley; George Bernard Shaw famously had one of these installed in his garden. The concept was revived in the 1970s by Banbury Buildings of Leamington Spa.

CLOCKWISE FROM TOP LEFT George Blay, offering War Office surplus shelters, 1920; summerhouses by the Cutting Edge Collection, 2012; C. White's revolving summerhouse, 1931; J. Bradley's 'Bunty Houses', 1914; interior and exterior views of 'Needlepoint Haven', Kaffe Fassett's Artisan Retreat, 2012.

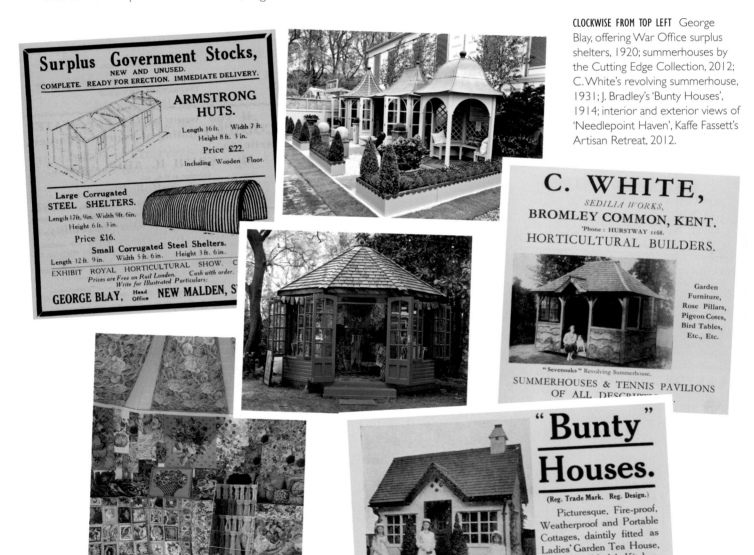

GARDEN TOOLS AND EQUIPMENT

Garden tools and machinery have been the mainstay of the sundries section since the beginning of Chelsea. How many new products have been launched at Chelsea is a more difficult question, for in many cases firms took stands at Chelsea to gain greater publicity for tools that had been introduced a year or two before, and found acceptance on a small but encouraging scale. The Atco mower Charles Pugh introduced in 1921 was first illustrated in a Chelsea catalogue in 1923. Power Specialities introduced the first rotary mower in 1933, but did not show at Chelsea until 1936. Similarly, Flymo launched the hover-mower on the British market in 1963, but did not exhibit it at Chelsea until 1965. On the other hand, when Tarpen and Danarm developed the modern strimmer in the 1970s, both firms were already regular exhibitors, so the Chelsea audience would have seen the products in their first year. Other novelties launched at Chelsea were the first electrically operated hoe, the Tarpentiller (1954), the battery-operated lawnmower (H.C. Webb, 1960), the Midgi-culto electric digger (Allen & Simmonds, 1961) and the Sheen flame gun (Hugh Prichard 1961).

After these excitements, the perceived rate of innovation fell. Roger Newman of the *Gardeners' Chronicle* reported in 1974 that 'People don't introduce new equipment here, they come to meet their customers.'

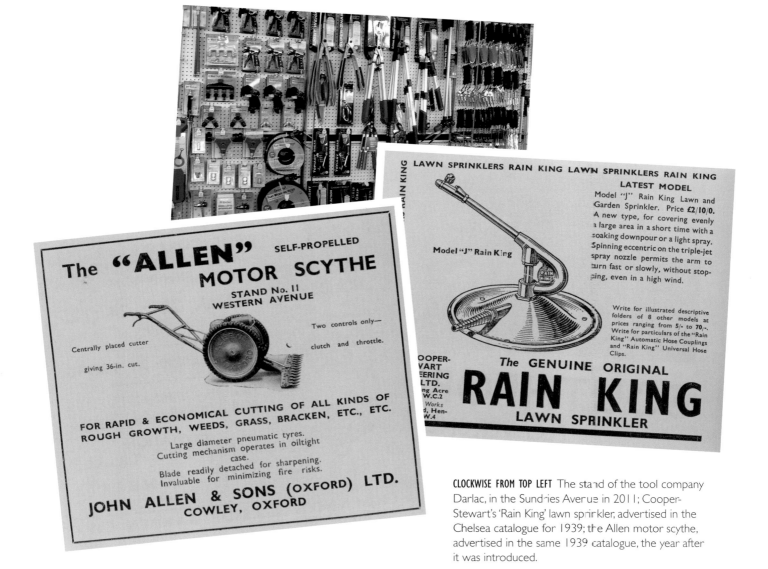

CLOCKWISE FROM TOP LEFT The stand of the tool company Darlac, in the Sundries Avenue in 2011; Cooper-Stewart's 'Rain King' lawn sprinkler, advertised in the Chelsea catalogue for 1939; the Allen motor scythe, advertised in the same 1939 catalogue, the year after it was introduced.

EMERGING DESIGNERS SINCE 2000

In 2001 the plantsman Timothy Clark wrote in *The Garden*: 'The drab gardens at Chelsea would quickly bore their owners if they actually grew plants. At present, garden design is distinctly dull. It is not the lack of money; it is the lack of original thought to create a charming surround. Modern garden design does not allow the owner time to enjoy scale, structure and materials because the plants, which are the decoration, remain subservient to the concrete.' A decade later, one may safely say that at least there is greater variety in materials than concrete.

The twenty-first century has seen the continuation of standard Chelsea themes. Historical revivalism: there have been gardens based on, or at least invoking, ancient Roman, Renaissance Italian, Victorian, Chinese and Japanese precedents; Simon Scott's knot garden for Haddonstone (2004) may represent this trend. Geographical diversity: whether it is the native vegetation or the indigenous garden styles that are copied, there have been glimpses of Australia, New Zealand, Malaysia, the Canary and Cayman Islands, even a Lebanese courtyard. Inspiration has been found in literature (Candide, Wordsworth, John Clare, Victor Hugo, Yeats, the Brontës) and modern art (Philip Nixon invoked Cy Twombly and De Kooning as sources for his 2008 Savills garden). In 2002, Prince Charles and Jinny Blom collaborated on a garden for Laurent-Perrier, based on Fibonacci numbers as described in Robert Lawlor's *Sacred Geometry*.

But there has also been an increasing tendency to base garden designs on extravagant metaphors which only become intelligible after reading the programme note. The traditional four elements (Olivia Kirk for Worcester Bosch Group, 2011) or stages of life (Christopher Pickard for Age Concern, 1997) were one thing, but the blood circulatory system (Anne-Marie Powell for the British Heart Foundation, 2011), plant cell structure (Marcus Barnett for *The Times*/Kew, 2011), shock waves (Robert Myers for Cancer Research UK, 2009) or the environment of an astronaut (Sarah Eberle for Bradstone, 2007) are not immediately deducible by the viewer. This last was named Best in Show for its tour de force of succulent planting.

The new category of Fresh Gardens requires their designers to 'think outside the box'. The 2012 selection ranged from Nicholas Dexter's Climate Calm Garden, with steppe planting and cracked earth, to Humko Bled's Soft Machine Garden, based on an analogy between the human body and a water recycling system; the Scotscape Garden with its use of QR codes for decorative effect; James Basson's Renault Garden with a dry stream bed represented by a cobbled path; Caroline Butler's Bradstone Panache Garden, inspired by kites in the sky; Easigrass's Green With . . . Garden, with turfed cylinders suggesting a prison; Benjamin Wincott's Petra Garden, with woven seats set into rock bases; and Alan Gardner's Out of the Blue Garden, a roof garden on the ground, divided by polypropylene netting.

On the following pages a few designers have been singled out to indicate the variety of designs currently being produced.

RIGHT, ABOVE Sarah Eberle's Bradstone Garden, 2007.
RIGHT, BELOW The Savills garden, 2007, by Monica Bennett and Philip Nixon.

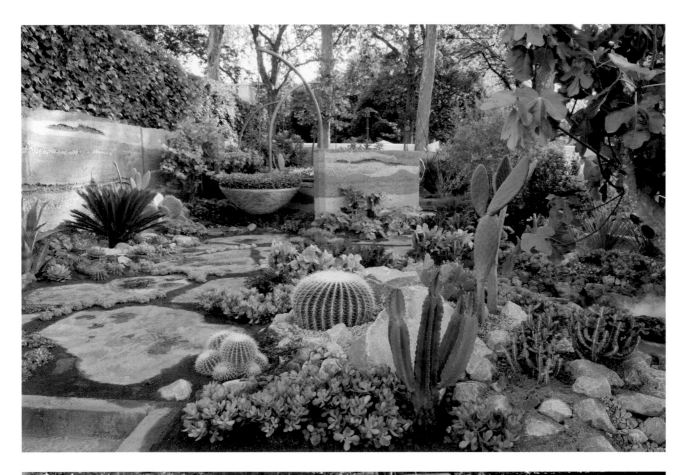

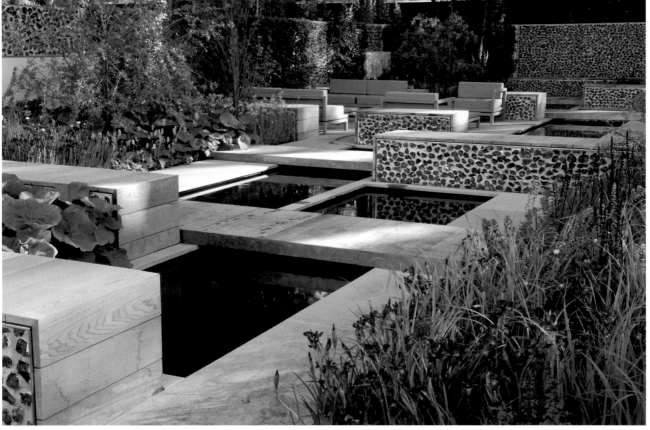

ABOVE Andy Sturgeon's Cancer Research UK garden, 2007.
BELOW Clare Agnew's Reflective Garden for Ruffers, 2008.

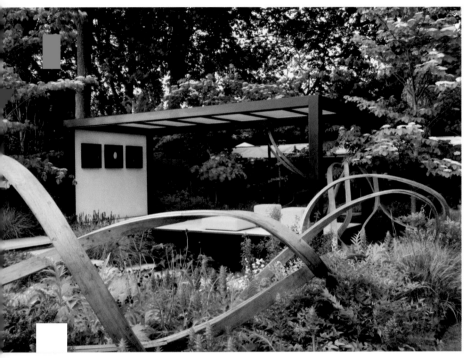

ANDY STURGEON

Andy Sturgeon had written two gardening books (*Planted* and *Potted*) by the time he designed his first Chelsea garden in 2001, for Procter & Gamble. In 2005 he designed the Merrill Lynch garden, and between 2006 and 2008 he made three successive gardens for Cancer Research UK. In 2010 his garden for the *Daily Telegraph*, with a planting list from around the world, subdivided by tall buttressed screens of Corten steel and dispensing with any water feature, was named Best Show Garden. His 2012 M&G Investments garden used an asymmetrical free-form screen composed of a network of steel circles, while in 2007 he wound 30 metres of curved oak ribbon through his garden for Cancer Research UK.

CLARE AGNEW

Clare Agnew studied at Kingston Art School, gained a Diploma from Cirencester Agricultural College and has studied the Decorative Arts at the V&A Museum. She has staged two gardens at Chelsea: for Savills, in 2005, she created a garden on the theme of the Grand Tour, using a classical façade overlooking a narrow canal and facing a line of trees pruned as a discontinuous stilt garden. In 2008 she returned to design a garden for the financial advisors Ruffers, laid out as a double row of rectangles of varying size, with rectangular planting blocks, box cubes and a screen of pleached hornbeam.

ABOVE Sarah Price's *Daily Telegraph* garden, 2012.
BELOW Thomas Hoblyn's Cornish Memories garden for Homebase, 2011.

SARAH PRICE

Sarah Price studied fine art at Nottingham Trent University and then took a course at the Oxford College of Garden Design. In 2006 she won a competition to design a garden at Hampton Court, and received a Gold Medal. The next year she appeared at Chelsea with her Bejewelled Garden, made for the digital shopping channel QVC, using deep colours and light reflected from water features to suggest jewellery. Then she was chosen to design the 2012 garden for the new Olympic Park in London. In 2012 she returned with a garden for the *Daily Telegraph*, based on the granite landscape of Dartmoor.

THOMAS HOBLYN

Thomas Hoblyn trained at Hadlow College and Kew, where his programme included a trip to North Carolina to study carnivorous plant communities. He set up his own practice in 2002. After creating three gardens at Hampton Court, he moved on to Chelsea, where he made three gardens for Foreign & Colonial Investments (2008–10), the second of which recreated the sort of wetland he had studied in the field. In 2011 his Cornish Memories garden for Homebase featured a 'rivulet path' based on coastal streams and rock pools. His interest in classical gardens and restoration was demonstrated more by his 2012 Arthritis Research UK garden, inspired by Italian Renaissance designs.

ABOVE Nigel Dunnett's Blue Water Garden for the Royal Bank of Canada, 2012.
BELOW Kate Gould's Magistrates' Garden, 2011.
OPPOSITE, BELOW Joe Swift's Homebase Teenage Cancer Trust garden, 2012.

NIGEL DUNNETT

Nigel Dunnett is a botanist who earned his PhD for research on the vegetation of roadside verges. A senior lecturer in the Landscape Department at Sheffield, he wrote *Planting Green Roofs and Living Walls* (2004) and *Rain Gardens* (2007), with Andy Clayden, and in 2008 was appointed as a consultant on the Olympic Park. In 2009, he assisted Ark Design Management with a roof garden at Chelsea, later recreated in Sheffield. In 2011–12 he designed two gardens for the Royal Bank of Canada: first a 'new wild garden', based on ideas from William Robinson and the Arts and Crafts Movement, and then a Blue Water Garden, inspired in design by the Alhambra, and planned for maximum rain capture.

KATE GOULD

Kate Gould studied at Weald College, and entered garden design without the formal training most of her peers had. In 1998 she founded the Helios Design Group. Her first three Chelsea gardens, in 2005, 2007 and 2009, were self-funded; her 2007 entry, a shady basement garden, earned Best in Show in the Chic Gardens category, as did her 2009 entry in the Urban Gardens category. In 2010, having found an independent sponsor for the first time, she created an enclosed sunken garden for Hartman UK, and in 2011, for the 650th anniversary of the Magistrates' Association, she made a garden fit to be placed atop an urban car park, with the planting in containers or with shallow rootballs.

MY CHELSEA

I first visited the RHS Chelsea Flower Show in the 1990s when I was studying garden design. I was instantly smitten by the perfection of the plants, the wonderfully showy exhibits from all over the world and the sheer drama of all the horticultural efforts in one intense space. Many of the show gardens were inspirational and opened my eyes to what could be achieved in a relatively small space; the show gardens have since become a strange form of addiction, drawing me back year on year.

One of my proudest moments was when I was asked to be on the presenting team for the BBC back in 2001. I had watched the Chelsea television coverage over the years and was thrilled to become part of it myself: it was like being a footballer and being asked to be a pundit for the World Cup final!

Last year, 2012, I finally took the plunge and designed a large show garden myself. I now know first hand how much work and care goes into every detail – it's staggering. My best Chelsea moment was getting my Gold Medal.

The Chelsea dates are now the first to go into my diary for the year. As well as looking forward to the plants, gardens and exhibits there's the 'Chelsea buzz' of meeting other gardeners, nurserymen, designers and friends, and kicking off the summer season in the best way possible.

Joe Swift, garden designer

JOE SWIFT

Joe Swift has become well known as a television gardener, appearing on *Gardeners' World* since 1998, and since 2010 has regularly accompanied Alan Titchmarsh and Carol Klein in presenting the BBC coverage of the RHS Chelsea Flower Show. He is the co-founder of Modular Garden, a garden design company, and had already designed gardens on television. In 2012 he attempted his first garden at Chelsea, for the Homebase Teenage Cancer Trust. The site was divided into four by rectangular frames of polished cedar, crossing the main axis at angles. His maiden effort was awarded a Gold Medal, prompting the question: will he try again?

DIARMUID GAVIN

The author of six books, Diarmuid Gavin studied horticulture at Glasnevin and has worked extensively as a garden designer. His first Chelsea gardens, in 1995 and 1996, were sponsored by the Dublin School of Garden Design; the 1995 garden incorporated a crumbling tower as part of an image of Ireland. In 2004 he returned to design a garden for the National Lottery, with an aerial banner of coloured balls reminiscent of those used in the Lottery programmes. This went heavily over budget, and earned a Silver-Gilt Medal, but he also became embroiled in controversy for a highly publicized row with Bunny Guinness. He was back the next year, however, with his Hanover Quay Garden, incorporating spherical rooms; in 2007, his garden for Westland Horticulture was based around a curvilinear studio – both attempts to produce gardens for non-traditional domestic buildings. In his later gardens sculptural or architectural devices took pride of place: giant daisies in metal and mesh in his 2008 Oceanico Garden; a suspended airborne pod in his 2011 Irish Sky Garden (his first Gold Medal garden), and a seven-storey pyramid in his 2012 garden for Westland Horticulture.

LEFT The Irish Sky Garden for Fáilte Ireland, 2011.
RIGHT, ABOVE The National Lottery Garden (A Colourful Suburban Eden), 2004.
RIGHT, BELOW The Westland Horticulture garden, 2007.

RHS CHELSEA FLOWER SHOW

MY CHELSEA

RHS Chelsea Flower Show is a show that has been going on for 100 years. Originally arrangements of plants and veg were the showstoppers. Today the designers get more focus than the gardeners, which reflects our time. I have been visiting the show since 1996 and exhibited for the first time in 2007 during the tercentenary celebrations of the Swedish scientist Carl Linnaeus. It was a little bit of a shock entering the international heart of gardening! But it was a great collaboration with the Linnean Society in London and I felt extremely loved and wanted. My way of trying to combine architecture and design with sustainability and horticulture was most appreciated and we won a Gold Medal. My second time in 2009 I felt at home doing the garden for the *Daily Telegraph* and I was more or less surprised when we won Best in Show. I love the range of different directions at the RHS Chelsea Flower Show. But also the fact that the standard of horticulture in the UK still makes it possible to produce this kind of show, which reflects the dream of gardening. And I am most happy to be back with the Crocus dream team in 2013 to do my very best for the Laurent-Perrier garden. Delighted and terrified at the same time!

Ulf Nordfjell, garden designer

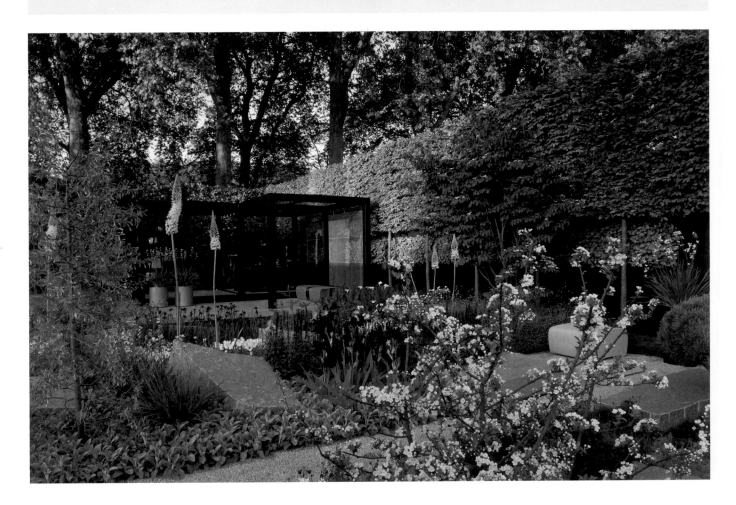

OPPOSITE, BELOW Ulf Nordfjell's 2009 garden for the *Daily Telegraph*.
BELOW Piet Oudolf and Arne Maynard in front of their prize-winning
Evolution garden for *Gardens Illustrated*, 2000.

ULF NORDFJELL

Ulf Nordfjell is a Swedish garden designer who had
already achieved fame in his native country before trying
his hand at Chelsea. He was chosen by the National
Linnaeus Tercentenary Committee to create a garden
to celebrate the 300th anniversary of the great botanist's
birth; the garden received a Gold Medal, and some
thought it might have been named Best Show Garden if
his flowering apple trees, *Malus* 'Evereste', had flowered in
time. But his second Chelsea garden, made for the *Daily
Telegraph* in 2009, received both accolades. It accompanied
an uncompromising metal-and-glass building with what
he described as a flirtation with English-style gardening:
planting in blue, white and grey.

PIET OUDOLF

Piet Oudolf is a Swedish garden designer, famous for his
promotion of what has become known as the prairie style
of planting. In 2000 he and Arne Maynard designed the
Evolution garden for *Gardens Illustrated* magazine (see
page 148). It was a strongly axial garden, flanked by box
hedges carved into billows (a 'cloud hedge'), with borders
of astrantia and other perennials likened to the patterns
of a Turkish carpet, down the central path of which lay a
series of square box cushions enclosing circular fountain
basins with jumping jets. The garden received a Gold
Medal, Best in Show and international publicity.

RIGHT, ABOVE The Merrill Lynch garden, 2004.
RIGHT, BELOW The London Roof Garden for the *Evening Standard*, 1996.

DAN PEARSON

Dan Pearson began to design gardens in his teens, and dropped out of school before getting his A-levels in order to train at Wisley, where he amazed the acceptance panel by showing an album of his already completed work. After Wisley, he trained at Edinburgh and Kew, and started his own practice as a garden designer in 1987. His first Chelsea garden, in 1992, was Urban Oasis for *The Gardener* magazine, designed to show that a vegetable garden using inexpensive materials could be stylish. He produced three gardens for the *Evening Standard*, in 1993, 1994 and 1996, and one for Merrill Lynch in 2004. He is currently the gardening correspondent for the *Observer*, and has written five books.

His Merrill Lynch garden, for the RHS's bicentenary year, featured a 'river of colour' leading to a 'sliver of dark water', amid undulating grass mounds suggesting the English landscape as modified through centuries of agricultural development. But his most striking Chelsea garden was the 1996 London Roof Garden, with its domed lightwells, which offered a model for the reclamation of derelict roofs.

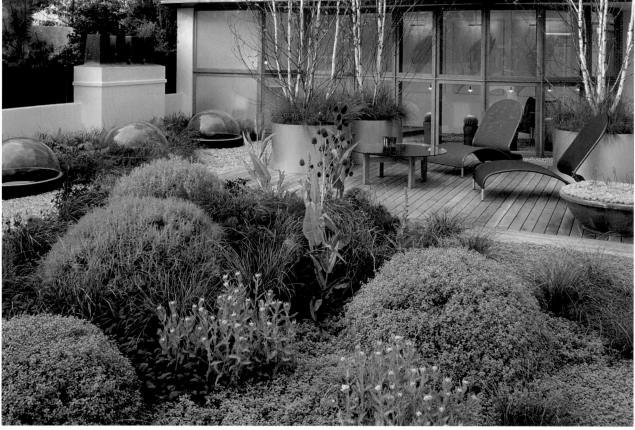

MY CHELSEA

My first experience as a designer at Chelsea was in 1991 when I was working for the now President of the RHS, Elizabeth Banks. It was fun and terrifying in equal measure. I think we broke a few rules, and we annoyed one of our neighbours so much that he threatened to take a chainsaw to our exhibit – probably with some justification. Since then I have designed eight gardens, most of them for Laurent-Perrier. They have taught me that success at the show is as much about setting a stage as it is about garden design, and I am aware that it is possible to be a great designer and not have much of a clue about how to put a Chelsea garden together. It has been a wonderful experience creating these temporary places with the same group of gardeners and nurserymen from Crocus each time. As is the case for so many of us in this country, Chelsea jumpstarted my career.

Tom Stuart-Smith, garden designer

TOM STUART-SMITH

While working for Elizabeth Banks Associates, where he began his career, Tom Stuart-Smith was first named in a Chelsea catalogue for his role in designing the *Daily Telegraph* garden, A Gothick Retreat, in 1991. In 1998, while still working for Banks, he designed the Chanel garden in collaboration with Karl Lagerfeld, featuring a *parterre de broderie* in early seventeenth-century style. He continued this theme, by now working independently, in 2000 with his Homage to Le Nôtre garden for the Garden History Society, which incorporated the first labyrinth to appear at Chelsea.

He has since designed six Chelsea gardens: for Laurent-Perrier in 2001, 2003, 2005, 2008 and 2010, and for the *Daily Telegraph* in 2006 (he reused the materials from this in his own garden). His 2008 garden, conceived as a reaction against the traditional expectations for a show garden, was based on superimposing four different patterns: brick paths, largely green herbaceous planting, hornbeams pruned in 'cloud' fashion and an arrangement of rectangular water tanks. He has described his style as 'try[ing] to make gardens in which people feel that they are not being bossed about – told what to look at and where to go'.

ABOVE The *Daily Telegraph* garden, 2006.
RIGHT The Laurent-Perrier garden, 2008.

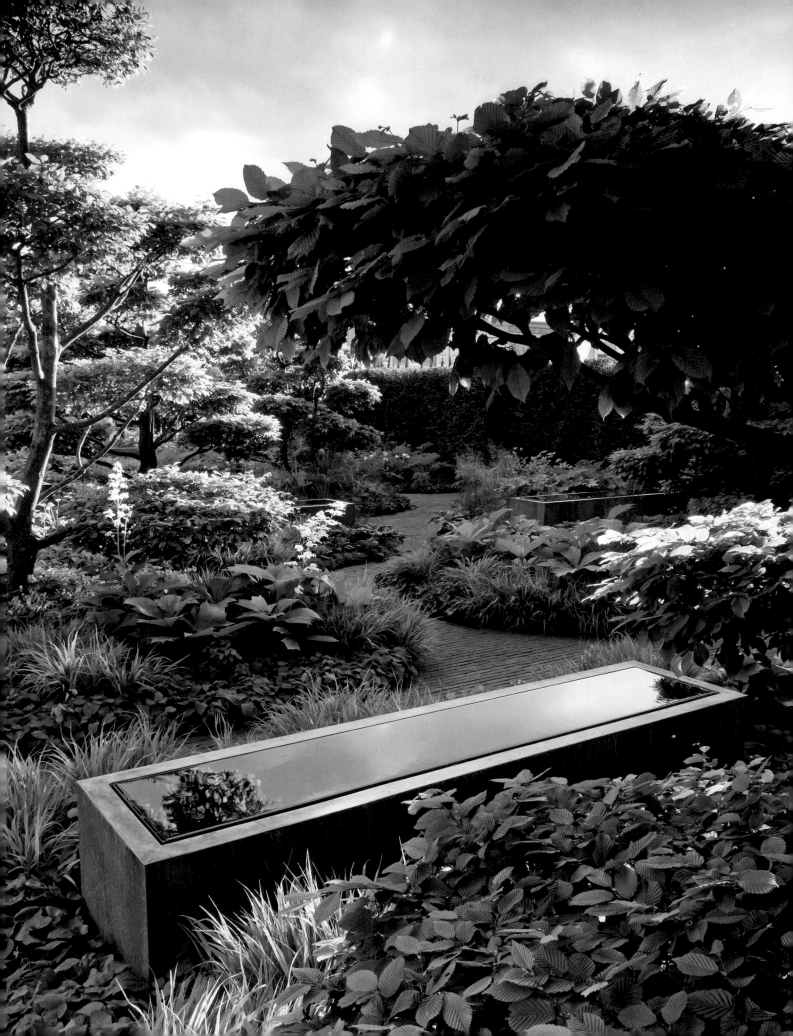

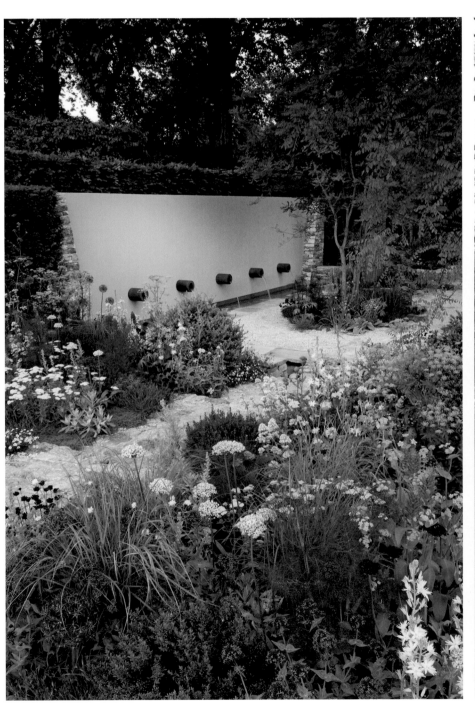

MY CHELSEA

CLEVE WEST

Cleve West trained under John Brookes in the late 1980s, and set up his own practice in 2001. In 2006 he created a garden for Saga Insurance, in part an exercise in sparse planting with drought-resistant plants; this was followed in 2008 by a garden for BUPA, which was afterwards relocated to a BUPA care home. His 2011 *Daily Telegraph* garden, inspired by the ruins of Ptolemais in Libya, incorporated sculpted columns and adventitious planting; in 2012 his garden for Brewin Dolphin used topiary and a 300-year-old wellhead mounted as a wall relief. With these last two show gardens he became the first designer to achieve Best in Show two years in succession.

You have to be a bit of a show-off to design a show garden at Chelsea. I've designed five to date and while part of me would be happy never to have to make one ever again, I know full well how it can seduce you into doing 'just one more'.

The beauty of making a show garden (aside from the publicity it brings) is that it's one of the few opportunities to create something with little or no outside influence. Of course there is a lot of pressure to get things right, not just for you but for your sponsor and your team, who work extremely hard to bring the design to life.

The trick is to make the garden look as though it's been there for some time; as though it's growing and has an atmosphere all of its own. Attention to detail therefore is key. Over the nine months or so it takes to prepare the garden, it pays to get to know your materials and plants so intimately that when it's finished you really do feel like you've given birth.

Cleve West, garden designer

FAR LEFT The *Daily Telegraph* garden, 2011.
LEFT The Brewin Dolphin garden, 2012.

TAKE-DOWN & SELL-OFF

Nurseries are not allowed to sell their produce during the Chelsea Show, but those who are so minded may sell off the contents of their stands once the closing bell has rung on the final day. There is no compulsion upon them to do so; some firms use plants of considerable antiquity or rarity in their displays, and they would naturally want to take these away again. But many firms take reservations during the course of the show, and there is a frantic surge of commercial activity after 4.30 on the last day.

CLOCKWISE FROM TOP LEFT How to carry one's plants on a bicycle without blocking one's view, 1999; two St John Ambulance members carrying plants on a hospital gurney, 1992; and the advantages of coming prepared with one's own wheelbarrow, sometime in the 1990s.

On Chelsea Bridge Road, outside the showground, the crush is equally frantic as the purchasers walk, mount buses, or try to summon taxis to bear their trophies away. Faith and Geoff Whiten recalled 'an elderly lady . . . surrounded by bags and parcels full of plants – more than she could possibly carry – and saying in a small, bewildered voice, "I've got to get the train back to Liverpool tonight."' But within a couple of hours the public have made their getaway, and it is the turn of the exhibitors themselves to dismantle their stands and begin the immense process of clearance, so that the Society's contractors can come in and return the grounds of the Royal Hospital Chelsea to their accustomed state.

INDEX

Page numbers in *italic* refer to captions

ACKNOWLEDGMENTS

AUTHOR'S ACKNOWLEDGMENTS

I would like to thank, first of all, my colleagues at the RHS Lindley Libraries for their help and support during the preparation of this work: and above all the images team, Lucy Waitt, Naomi Bristow and Armando Ribeiro, for coping with the sudden burden of searching, retrieval, scanning, photography and copyright checking for the bulk of the proposed illustrations.

Many illustrations have been provided by sources outside the RHS Libraries, and for these my thanks must go to all those listed in the picture credits. Special thanks must go to John Brookes, Jekka McVicar, David Stevens, Bob Sweet and Julie Toll for their loan of plans and photographs from their own collections.

Thanks are also due to Alex Denman and her colleagues in the RHS shows department, for information and the inside view on current practice in the show; to Bob Sweet and Stephen Bennett for much information over the years on previous years' practice; and to Rae Spencer-Jones in RHS Publishing, for handling negotiations and practical decision-making.

And, of course, the team at Frances Lincoln – Andrew Dunn, Anne Askwith, Becky Clarke and Oliver Jeffreys.

The Royal Horticultural Society, Frances Lincoln and I are grateful to Major General Peter Currie and the Royal Hospital Chelsea, not only for allowing and putting up with the show in the first place, but for contributing to the present work; and to all those exhibitors, shows department staff, photographers, presenters and others who have contributed their reminiscences of the show.

PICTURE CREDITS

The author and publisher thank the following copyright owners for permission to reproduce their illustrations on the pages listed after their names. Every effort has been made to provide correct attributions. Any inadvertent errors or omissions will be corrected in subsequent editions of this book.

l = left, r = right, t = top, b = bottom

Andrea Jones/Alamy iv, vi
Andrew Lawson 184l
Arcaid Images/Alamy 148
Beth Chatto 140b, 141
Brent Elliott 74, 97tr, 97br, 126, 171t
Cadogan Estates 67tr, 67r, 67b
Crocus 69t
Evening News/Associated Newspapers Ltd 76t
Daily Mirror/Mirrorpix 43b
David Stevens 109
English Heritage 65tr
Getty Images 70, 73b, 76b, 84, 90, 95bl, 121tl, 123br, 138tl, 138bl, 138br, 139tl, 145b, 160tr, 160tl, 160bl, 163tr, 163tl
Harpur Garden Images 63br, 69bl, 117, 123tl, 124, 132, 144b, 146b, 149, 150, 151, 152, 155b, 156b, 157t, 160br, 161, 162, 164l, 167, 173, 174t, 175, 178, 179, 180, 181, 183, 184r, 185, 186
Illustrated London News/Mary Evans 86, 95br
Jason Ingram 144t
John Brookes 107
John Glover/Alamy 156t

Julie Toll 146t
Manolo Blahnik 94 tr
Mark Bolton 116
NAFAS 75
Nick Panagakis 19r
Opi Rahman 54
PA Archive/Press Association Images 67tl, 67l, 114, 121tr, 121br, 138tl, 188l
Paul Debois 177t
RHS ii, 4, 6, 10, 13, 14, 17, 18, 20, 21, 23, 24, 25, 26, 28, 29, 30, 31, 33, 34, 36, 39, 40, 41b, 41r, 42, 43tl, 44, 45, 46, 47, 48, 49, 50, 52, 53, 55, 56, 57, 59, 60, 61, 62, 63bl, 63tr, 65b, 66r, 68, 69br, 72, 73t, 78, 79tr, 79r, 79b, 80, 82, 83, 100, 101, 105, 113br, 120, 129r, 133tl, 133r, 133l, 145t, 165tl, 165tr, 170, 171br, 171bl, 188tr, 188br
RHS/Anabelle Taylor 57bl, 97t, 133tr, 135b
RHS/Andy Paradise 96, 97bl, 110, 112, 123bl, 129t, 133bl, 129t, 133bl, 136, 138r, 139tl, 139br
RHS/Belle Photos 168
RHS/Carol Sheppard 123tr
RHS/Jon Enoch 121bl, 122

RHS/Martin Mulchinock 99, 135tl, 137
RHS/Max de Soissons 63tl
RHS/Mike Sleigh 111t
RHS/Neil Hepworth 95t,118, 133br, 158, 163br, 164r, 165br, 165bl, 165l, 169, 174b, 176b, 177b, 182, 187
RHS/Nikki de Gruchy 176t
RHS/Tim Sandall 140t, 142, 163bl
RHS/William J. Shaw 130, 139bl
Sapphire Studios 143
Sports and General Press Agency 87, 89
Stefan Rousseau/PA 113tr
Stephen Bennett 153
Sue Spielberg 111b
Tamara Peel Images 102, 103
Tessa Traeger 41t, 81, 129bl
TFL from the London Transport Museum collection 19l, 64t, 64b, 119
The Daily Telegraph 66l, 79tl, 79l, 94tl, 98t, 104, 113tl, 113bl
Torbay Borough Council 128
Whetman Pinks 135tr